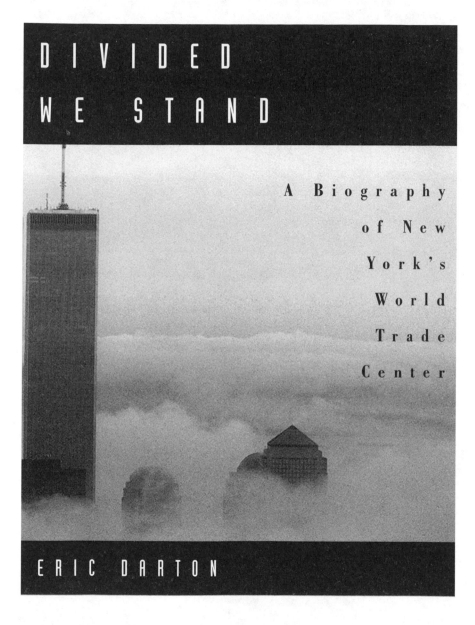

DIVIDED WE STAND

A Biography
of New
York's
World
Trade
Center

ERIC DARTON

BASIC BOOKS

A MEMBER OF THE PERSEUS BOOKS GROUP

Illustration credits
Frontispiece: Photo by Frances Roberts/NYT Pictures.
Tower in clouds. Paul Strand, *Wall Street, New York 1915*. © 1971, Aperture
Foundation, Inc., Paul Strand Archive.
Skyscrapers of lower Manhattan: From King's Views of New York, 1908–1909.
Courtesy of the New York Public Library.
Picture puzzle: Collection of author.
Gov. Nelson Rockefeller and Mayor John Lindsay with model for Battery Park
City photo: *New York Daily News*, May 12, 1966.
Construction, c. 1968 photo: Thomas Airviews. Courtesy of the New York His-
torical Society.
Tower and water, photo: Todd Watts, *World Trade Center 3*, 1972. Courtesy of
Todd Watts.
View of city photo: Eric Darton, 1999.
Bacardi Limón ad: Courtesy of Bacardi-Martini U.S.A., Inc.
The Space Between: Photo by Philip Greenberg / NYT Pictures

Published by Basic Books,
A Member of the Perseus Books Group

Designed by Victoria Kuskowski

Library of Congress Cataloging-in-Publication Data is available.

ISBN 0-465-01727-4

01 02 03 / 10 9 8 7 6 5 4 3

To Frank G. Jennings and Franklin C. Kehrig;

and to my grandfather Meyer Kroll,

who loved the utopia of the Automat.

CONTENTS

ACKNOWLEDGMENTS

This book began quite unintentionally in 1992 as a research paper written for a seminar on mass media and contemporary culture taught by Stuart Ewen at the City University of New York Graduate Center. Later, as my thesis adviser in the Hunter College Department of Media Studies, Professor Ewen provided intellectual generosity, moral support, and methodological guidance that helped advance the project to the point where it became possible to conceive of it as a book.

Serafina Bathrick, then chair of the Hunter Media Studies Department, insisted with convincing firmness—in her dual capacities as mentor and friend—that I pursue the expansion of this work into its current form. I also owe a great debt to Alane Salierno Mason, whose critical feedback cleared away much debris and raised the narrative's key elements into higher relief.

Christina Spellman contributed generously of her expertise and erudition. It was through her that I met Wolfgang Schivelbusch, whose lucid reckonings of politics and culture provided a historical matrix for the towers so tantalizingly visible through his windows.

Throughout a research and writing process whose elapsed time exceeded that of the trade towers' construction, Joe MacDowell served as a one-person urban bibliography, architectural consultant, and literary critic. Frazier Russell earned my permanent gratitude for his rocksteady and often-expressed belief that this book would eventually make a place for itself in the world. He also introduced me to the work of John Sanford, whose unflinching prose in the cause of historical rescue became my unattainable standard. Bill Gubbins kept my spirits up, urging me on with well-timed bursts of affirmation. Through their heroic feats of language, my writing students lent me the heart to press on with revisions.

Elizabeth Kandall made it possible to imagine inhabiting the unimaginable space of the trade center's basement and the dark cellars of this text. Wilma Kehrig fed my efforts at her dining room table, and Elva Kehrig sustained them with her financial generosity. If a book can be seen as a building, Paul Farhi provided the bedrock in which this one is moored.

Two cafés, Patisserie Lanciani, formerly on West 4th Street between Bank and 11th Streets, and Le Gamin, at the corner of 21st Street and 9th Avenue, provided hassle-free work space and several fortuitous chance encounters that vastly enriched this story. Distinguished faculty members of these "penny universities" included Bettina Carbonell, B. J. Jaffe, Sam Livingston, Marilyn DeLeo, and Walter Vatter.

Jenny Dixon, Richard Dandrea, Ethel Jaffe, Stanley Geller, Joseph Berridge, and Sidney Frigand, all direct participants in the extended World Trade Center drama, contributed generously of their time and personal narrations. Gary Gatza, Kiersta Fricke, George Agudow, Paul Elie, Bronwyn Mills, Michael Florescu, Elena Alexander, and Eric Borrer lent crucial support. Jay Kaplan, editor of *Culturefront,* and Marisa Bartolucci and David Brown of *Metropolis* caused extracts of earlier drafts of this book to appear in print. Bettina Schrewe helped guide it to its publisher.

To Gloria Loomis, the Demeter of literary agents, much gratitude is due. Her assistants, especially Katherine Fausset, did wonders for my sense of well-being. John Donatich, my editor at Basic Books, remained dedicated to the spirit in which this biography is told. Consequently, his interventions remain transparent, yet the text is everywhere marked with testaments to his fine ear for language and his eye for structure and detail. Thanks are also due to his assistant, Caroline Sparrow, for engagement and enthusiasm above and beyond the call.

I will never run out of gratitude toward my wife and *compañera,* Katie Kehrig, and our daughter Gwendolyn Helena Kehrig-Darton, whose presences made this book's odyssey a joyous game, well worth the candle.

E.D., New York City, May 5, 1999

As an architect, if I had no economic or social limitations, I'd solve all my problems with one story buildings. Imagine how pleasant it would be to always work and plan spaces overlooking lovely gardens filled with flowers.

—*Minoru Yamasaki, architect of the World Trade Center*

PART I

ONE

FAIR
WARNINGS

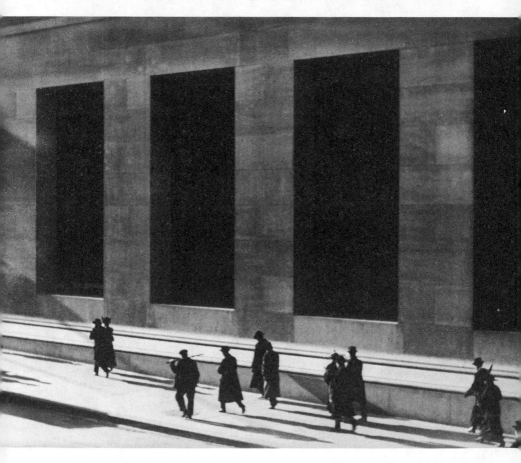

Paul Strand, Wall Street, New York, 1915. *Human sundials cast early morning shadows in front of the Morgan Bank.*

ILLUMINATION, AT THE FOOT OF THE TOWERS

When you're heading downtown to visit the World Trade Center (WTC), you nearly always make a detour through Century 21. Around you echoes a hum of languages, familiar and unknown, as you join the lunchtime crowd of office workers and tourists streaming through the doors. Walking along aisles lined with racks of belts, ties, and umbrellas, you zero in on the designer shirts. Not many years ago this building—a big, blocky deco-detailed affair stretching along Church Street between Cortlandt and Dey—was a savings bank branch. Now, cobbled together with the adjacent building, it's been transformed into a shopper's mecca spanning two-thirds of a city block at the foot of the twin towers. Ah, the shirt shelves have just been restocked. Bingo. Two minutes in line for a cashier and out onto Dey Street you go, shopping bag firmly in hand. Inside it: three chambray shirts and a leather belt, all bought for 30 percent off.

Shopping whets the appetite, it seems, so what to eat and where to eat it? This first part is easy. You buy a hot dog from a vendor on the corner of Liberty and Church—mustard and sauerkraut, please—and skip the $1.50 bottled water they get $3 for at the concession stand on the WTC's observation deck 110 stories up. Now, where to sit amid the surging crowds? Of course! You're on Church Street, and St. Paul's Chapel is only a block away.

St. Paul's is the oldest building on the island—a survivor still standing where New York City began—with a beautifully proportioned Georgian facade of brownstone Ionic columns facing Broadway. But it is St. Paul's ancient cemetery behind the church that you're heading for, where anyone who navigates the serpentine slate path among the headstones can find a bench to sit on and eat in complete tranquillity, just yards from the rush of pedestrian traffic on the other side of the palings. Even with the canyon walls rising around you, on a clear day you may find a patch of sun.

Here, you stare up at the tapering spire of the church, topped with its golden ball and pennant weathervane. A slight shift of your head, and you take

in the massive square towers of the trade center, rising in parallel lines for a quarter mile until they simply stop.

A hot dog lasts only so long, and it is the World Trade Center you came to see, up close. So you leave the graveyard and walk diagonally across Church Street, past the pushcarts selling trinkets and souvenirs, past the huge concrete planters that are supposed to guard against car bombs, and up the steps into Austin Tobin Plaza, to where you encounter an entirely different WTC.

From here you can see the Gothic detailing of the towers' closely massed, aluminum-faced columns, stretching upward to what seem impossible heights. Even the skyscrapers surrounding these twins seem paltry by comparison. You look two blocks northeast, toward Woolworth's soaring "cathedral of commerce," relatively modest in its proportions, yet once regarded as the city's most awesome exercise in skyscraper engineering. West and south lies the harbor, but your view is blocked by the twin towers that stand in between. You look up at them again. There is no denying the power of their mass and sleekness. But how much more clearly you could see the city, with its layers of accumulated history, if only these two vast and imposing structures weren't here.

The trick, then, is to make the World Trade Center disappear. This is not as difficult as it seems. Nearly anyone can do it. You don't have to be a terrorist, a demolition expert, or a photo retoucher. You just have to go to the plaza and stand in the right spot. Choose either Tower 1 or Tower 2 and walk right up to it—not to one of its broad sides, but instead, to one of its narrow, beveled corners. Stand about as close as if you were going to have a conversation. Then look straight up. Four million square feet of office space stacked a quarter mile into New York's skyline have been transformed into a thin gray ribbon of highway, stretching into space. With a subtle shift of perspective, you have caused one of the most massive buildings of the modern era to perform its built-in vanishing act.

But if one of the WTC's secrets is that it can be made to disappear, what other kinds of knowledge might the towers hold? If you are going to find out, you will have to explore them, get to know their origins, their habits. You will have to ask them questions about what they are, and would be if they could. And you will have to talk with other people who have lived with and around them. To start by making the trade center disappear, though, seems a good way to begin. Because if you are going to get to know the WTC well—make it part of your own space and time—you must unbuild the towers, cause them to vanish from the

landscape. Then it will be possible to rebuild the World Trade Center, story by story.

Suddenly, without warning, the paving stones of the plaza heave up beneath your feet, and a blast of warm, acrid air buffets your cheek. Then comes the sound of the explosion. Seconds later, the streets fill with panicked workers rushing out of their offices, and before long, streams of dazed, soot-streaked survivors begin staggering mutely past. Then sirens shriek as ambulances arrive and medical personnel begin to attend to the hundreds upon hundreds of injured. Police cordon off the blast site as fire engines from every corner of the city converge. The mayor, obviously shaken, steps out of his limousine and is immediately surrounded by reporters. At the perimeter, you take your place among thousands of spectators, peering in mute astonishment.

Before you a familiar scene unfolds, yet different in its details from the traumas of your own time. It is as though by unbuilding the World Trade Center in your mind, you have entered a city that came before it: the Lower Manhattan of September 16, 1920, where a massive bomb, hidden in a horse-drawn carriage, has just blown up in front of J. P. Morgan's Wall Street bank. And here you find that the blast of February 20, 1993, had a long-forgotten twin.

SITE

The southernmost tip of Manhattan, encompassing the World Trade Center, Century 21, and Morgan's bank, was and remains a site for the dramatic convergence of elements: earth, air, water, and fire. With the beginning of European settlement in 1626, this play of elemental forces found parallels in the workings out of the city's social development: immigration, slavery, trade, shipping, manufacturing, finance, insurance, real estate speculation. In the early twentieth century, a city of towers—architectural containers for financial institutions and industrial monopolies—grew up on this site, visited more than once by acts of horrific violence.

For centuries before the Dutch bartered with local native Americans for pasturage and water here, the depopulation of the European countryside was already causing people to gather in ever greater numbers in ever vaster cities. With this movement, and its dramatic acceleration in the industrial age, came a definitive shift in the social valuation of land. In the farming economy, buildings had counted for little, for it was in the fields surrounding them that the source of all productive value lay. But in

the modern city, land became the launching pad for new vertical economies—derived from the acreage beneath but multiplied by the number of square feet that could be built above. Here wealth turned increasingly mobile and intangible as it wrested itself free from the earth-bound limitations of agricultural or even factory production.

In New York City on the cusp of the twenty-first century, the social imagination had definitively exchanged the symbols of the agricultural economy for a new visual language of wealth and abundance. In Lower Manhattan's city of towers, one gives no thought to the mythic emblems of the earth's limitless fecundity: cornucopia bursting with sheaves of grain, vegetables, and ripe, edible fruit. Instead we imagine bounties of debt, harvests of financial instruments. No longer fortresses or cathedral spires, our towers have transformed into urban silos, overflowing with disembodied commodities.

The rising of this city of towers makes visible the stages in our ascent toward ever more heady strata of finance. As early as 1906, the popular periodical *King's Views of New York* boasted that "eighteen downtown skyscrapers have an aggregate value of $26,290,000." Already, Lower Manhattan's speculative real estate had taken its place as the commonly recognized bar chart of the city's—and by extension, America's—wealth.

In the nearly hundred years since then, converging economic and political forces have autographed downtown Manhattan's skyline with increasingly ambitious buildings. We may think of their collective mass, soaring from the bedrock, as expressing an outward-turned, supremely extrusive power, urging us higher with unearthly feats of engineering wizardry. Yet our tall buildings, and not least the World Trade towers, also serve as containers for our interior lives: shelters, habitations, and silos of dreams. And each embodies in its particular form the social imagination that gave it license.

Within the compass of their spectacular thrusts, our skyscrapers hold an accumulation, story by story, of the city's strivings, conflicts, and contests for survival and domination. In their design and materials, their scale and proportions, their financing, their intended purposes and ongoing consequences—in the sorts of human interactions that do and do not take place within, among, and around them—Manhattan's commercial spires offer themselves up as a living language of the city's struggles, writ large.

In the aftermath of the explosion in the bowels of the World Trade Center, this language spoke a new story of explicit vulnerability, in which the skyscraper's overawing height merged with the image of the

terrorist's bomb that at any moment might detonate in the cellar's depth. Having survived the attempt to destroy it, the World Trade Center added an urgent new layer of meaning to its previous identities: high-visibility business address, sightseeing destination, and tristate landmark. Its towers, proximate yet standing apart, came to embody the irreconcilable yet inseparable relationship between seemingly random, eruptive, and sociopathic energies and the financial district's aspirations toward the realm of limitless profit.

Through its association with terrifying images of ravaged bodies, of mangled steel and concrete, the World Trade Center presents itself as a window blown open into its own biography. What sort of narrative will it offer? To find out, we must sift through the materials that built the twentieth century's city of towers.

MATERIALS

The World Trade Center's roots lie enmeshed in the great horizontal thrust of the railroad. From the beginning of its spread in the mid-nineteenth century, the railroad furthered the transformation of land into real estate, linking key intersections within a new matrix of economic importance. Cities located at the convergence or terminus of rail lines experienced explosive economic growth and upbuilding. Towns bypassed by the railroad withered. And the steam locomotive's theretofore unthinkable speed radically accelerated the fracturing of geographic continuity, bringing with it a definitive shift in the experience of moving through space over time. In 1885, Robert Louis Stevenson found ambivalent and urgent cadences in the dazzling field of motion visible "From a Railway Carriage":

> *Faster than fairies, faster than witches,*
> *Bridges and houses, hedges and ditches;*
> *And charging along like troops in a battle,*
> *All through the meadow the horses and cattle;*
> *All of the sights of the hill and plain*
> *Fly as thick as the driving rain,*
> *And ever again, in the wink of an eye*
> *Painted stations whistle by.*
> *Here is a child who clambers and scrambles,*
> *All by himself and gathering brambles;*
> *Here is a tramp who stands and gazes;*

And here is the green for stringing the daisies!
Here is a cart run away in the road
Lumping along with man and load;
And here is a mill and there is a river;
Each a glimpse and gone forever!

But if the railroad blurred the countryside, it brought the topography of the city into sharper visibility. In 1851, Joseph Paxton's Crystal Palace, built for the London Exposition, gave prototypical form to the coming together of the railroad and skyscraper. And the glass and iron structure invoked, sixty years ahead of the game, the aesthetic of transparency that would become a hallmark of modern architecture. Throughout the second half of the nineteenth century, the matrix of horizontal steel successively overcame the most daunting geographic obstacles.

Driven by rapidly developing markets, a confluence of advances in metallurgy, industrial production, and engineering made possible stunning examples across Europe's landscape of the skyscraper's horizontal precursor: the railroad bridge. Gustave Eiffel, best known for his eponymous tower, cantilevered prefabricated iron structures across previously unbridgeable chasms. And from the early 1870s, Eiffel lent his engineering genius to the French government's colonization of Cochin China, now Vietnam. To facilitate rapid troop movements across river deltas, Eiffel's firm produced scores of lightweight iron bridges. Designed like giant Erector Sets, these bridges could be assembled in a single day by a dozen workmen using hammers and wrenches. In less than a decade, the French bureau of native affairs built two and a half miles of these modular spans. Eiffel's *prêt-à-porter* bridge soon found a ready international market among railroads, armies, and public works administrations.

But even as they networked horizontally, metal framed structures were preparing to extrude vertically at the great rail and shipping junctions. Essentially rigid tubes laid flat, Eiffel's spans were just one step removed from the giant office towers soon to come. Reengineered and stood on end, his bridges would grow into skyscrapers.

ACTION, REACTION

In 1889, the year the Eiffel Tower opened for business, its twin automatic elevators carried 200,000 visitors upward to witness the breath-

taking panorama of greater Paris spread below. Designed to be demolished after the Universal Exposition for which it was built, Eiffel's soaring iron lacework has since established itself as a permanent symbol of French technical prowess articulated through graceful lines and structural resilience. That same year, more modestly but with no less significance, New York City began its own vertical extrusion on a vacant lot between Beaver Street and Exchange Place on lower Broadway.

Realizing to his chagrin that a tall building with standard, thick masonry walls would yield small, low-rent offices, John Stearns, a young silk merchant with real estate dreams, hired Bradford L. Gilbert as architect for the aptly named Tower Building. In the interest of boosting his client's speculation beyond marginal profitability, Gilbert turned to an untested method—employing a steel girder cage as the building's structural support. When "topped out" at thirteen stories, the Tower Building ran away with the title of New York City's tallest. More important to Stearns, it encompassed a higher-than-average ratio of rentable space to load-bearing structure.

In the face of public belief that his experiment would topple over in a stiff breeze, Gilbert moved his own offices into the top floor of the proto-skyscraper that popular skepticism had renamed the Idiotic Building. Soon afterward, a full-scale hurricane descended on the city. In its aftermath, reporters rushed to write up the ruins. But not a brick of the Idiotic Building had fallen. The Tower Building's survival conferred a competitive edge on steel frame office construction and threw open a new vertical terrain for the speculative imagination. New skyscraping office towers sprouted by the dozens at the turn of the century as a frenzy of industrial consolidations culminated in 1901, yielding J. P. Morgan's U.S. Steel—the first billion-dollar corporation—headquartered in Lower Manhattan.

TREMORS OF THE COMING AGE

Within a few months of the grand opening of the Tower Building, William Norcross, mad as a hatter and bearing a dynamite bomb, entered the nearby offices of railroad and real estate baron Russell Sage. Stopped at the door, he demanded the immediate cash payment of $1.2 million. Rebuffed by Sage's secretary, Norcross shouted "Here goes!" and hurled his explosive. The secretary was killed outright, and eight other employees were injured, but the target of Norcross's mania escaped unscathed. Within a year of the bombing, the office block was

voluntarily demolished by its owners, and in 1893, the Empire Building, a Classical Revival–style skyscraper, rose on the site of the Sage office bombing. The new tower would serve for many years as headquarters for J. P. Morgan's U.S. Steel Corporation.

Likewise, the revolutionary Tower Building fell victim to its own success. It was soon torn down and replaced by a taller office block as Lower Manhattan skyscrapers continued to vie for dominance. But in 1913, the Woolworth Building's heroic sixty-story ascent shut down the competition for nearly two decades. On July 4, 1914, as the Woolworth tower's new tenants watched a fireworks display in the harbor below, four members of the International Workers of the World (IWW) accidentally blew themselves to bits in their East Harlem flat. They had been assembling a bomb intended for John D. Rockefeller, the chairman of Standard Oil and Chase National Bank's largest shareholder.

If the Wobblies had succeeded, would John D.'s eldest son, known as Junior, have assumed the role of master builder and left his indelible mark on midtown Manhattan in the form of Rockefeller Center? Would Junior's sons, David and Nelson—in their respective roles as chairman of the Chase Manhattan Bank and New York State governor—have jointly "fathered" the World Trade Center?

MORGAN'S BEDROCK

On the better part of a block between the World Trade Center and the Woolworth Building stands a 1920s office tower, the headquarters of Moody's Investors Service. Otherwise nondescript, the building boasts a Church Street entrance that is surmounted by a gilded bas relief showing a frontiersman and a factory worker clasping hands amid a scene of spectacular agricultural and industrial abundance. Chiseled into the stone at their feet is a prophetic epigraph of Daniel Webster's dating from the 1830s. Long before the coming of the "cathedral of commerce," the Empire State Building, or the World Trade Center, Webster exalted:

> CREDIT
> *Man's Confidence in Man*
> *Commercial credit is the creation of modern times and*
> * belongs*
> *in its highest perfection only to the most enlightened and*

best-governed nations.
Credit is the vital air of the system of modern commerce.
It has done more, a thousand times more, to enrich nations
than all the mines of the world.

This encomium to the superior virtues of a symbolic economy might well have inspired J. P. Morgan, who, like John D. Rockefeller, Russell Sage, and Henry Clay Frick, escaped assassination and died of natural causes. In 1912, when he was advanced in years but still very much in control, Morgan was called to testify before the House Committee on Banking and Currency, then investigating the growth of monopolies. Though hard pressed by the brilliant trial attorney and political reformer Samuel Untermeyer, the seventy-five-year-old banker—whose personal wealth had averted the federal government's bankruptcy in the Panic of 1893—contemptuously dismissed accusations that he controlled the elite Lower Manhattan "money trust." Instead, he diverted his examiner onto the subject of commercial credit. Questioned as to his criteria for making loans to a prospective borrower, Morgan replied that "the first thing is character."

"Before money or property?" Untermeyer asked.

"Before money or anything else. . . . Because a man I do not trust could not get money from me on all the bonds in Christendom."

However disingenuous his statement, and for all his enmeshment in leverage and credit, the legendary financier, when building the enduring symbol of the House of Morgan, chose to remain close to the earthbound stratum of mundane toil and accumulation. In 1913, he opened the Wall Street bank building whose walls would be scarred by explosive shrapnel seven years later. The austere white Classical Revival structure stands today, officially protected as a landmark. Its stark marble facade broken only by narrow, deeply recessed windows, the Morgan Bank resembles a fortress, frozen while mutating into a mausoleum. But it does not appear to be built on top of anything. Rather, it conveys the impression of having been extruded out of the subterranean rock—less a constructed building than the surface outcropping of a far deeper mass, whose topmost peak has been sculpted into a bank.

Morgan's name appears nowhere on the facade—an explicit statement, under the circumstances of the time, of the impossibility of doubting whose bank it was. Morgan chose to build a four-story structure, instead of the skyscraper he might have, on one of Lower Manhattan's most valuable parcels of real estate.

In 1913, the year that Morgan built his fortress, F. W. Woolworth's neo-Gothic cathedral of commerce topped out a few blocks to the northwest, its structural steel forming a matrix for the euphoric ascent of sixty stories of granite and terra cotta cladding. The Woolworth Building exceeded all previous conventions of skyscraper engineering, demanding the invention of special elevators, scaffolds, and hoists. Its construction required systems of unprecedented scale—sewage pipes wide enough to accommodate a horse and carriage, and a generator churning out electrical power for a city of fifty thousand. Had it been built in the 1950s, Woolworth's tower might well have been sheathed in glass, but in the style of the time, it still paid homage at surface level to the bedrock in which its foundations were moored.

The building's enduring nickname was bestowed by the popular evangelist Samuel Parkes Cadman, whose 1916 pamphlet strongly implied that the celestial architecture of the Book of Revelation had come to rest in the financial district. "When seen at nightfall bathed in electric light or in the lucid air of a summer morning, piercing space like a battlement of the paradise of God, which St. John beheld, it inspires feelings even for tears. The writer looked upon it and at once cried out 'the Cathedral of Commerce'—the chosen habitation of that spirit in man which, through means of change and barter, binds alien people into unity and peace."

By virtue of their formal disparity, the Morgan Bank and Woolworth Building articulated a mixed metaphor in the architectural language of America's wealth. Morgan's fortress protected money by symbolically walling it in. The manifestations of its workings—railroads, mines, and factories and their manufactured products—might be appropriate for display, but bank credit was not some vulgar commodity to be displayed in an arcade window or promiscuously flaunted in public. In the language of Morgan's culture, money represented the sacramental oil of the Trust—financial covenants sealed by handshakes among the Christian worthy—to be defended at all cost.

Woolworth's tower, by contrast, celebrated the economic enfranchisement of the masses, the direct and reciprocal exchange of newly disposable income for factory-produced goods. It gave tangible form to the spiritual ennoblement of a billion hard-earned nickels and dimes. Woolworth's shrine to the people's currency anticipated the moment when the *Wall Street Journal* might proclaim, as it did in 1930, that "the wage

earner has as much right to do business on credit as the millionaire."

Though the Woolworth Building enjoyed a long reign of unsur-passed height, the next major office project to leave its mark on Lower Manhattan's skyline would eclipse anything previously imagined in terms of sheer mass. Seeking to secure sufficient profits for its investor syndicate, the developers of the Equitable Building at Broadway and Cedar Street built more than forty stories straight up, as high and sheer as the cliffs of the Jersey Palisades—without a single spire or setback. Viewed from below, the Equitable towers resemble nothing so much as immense twin filing cabinets rising from a common pedestal.

Together, the Equitable's base and towers yielded a multiple of thirty-nine times their land area in rentable space—double that of the Woolworth Building. Even in a city inured to nearly thirty years of ex-ponential increase in the scale of its office towers, the Equitable's sky-obliterating mass set off furious protests. The threat of even greater Equitables to come turned popular sentiment in favor of the enactment in 1916 of New York's first comprehensive zoning code, a system that regulated land use and specified approved structural forms.

The new provisions encouraged office buildings to incorporate ziggurat-like setbacks that would admit more daylight into the canyons below. Ironically, though, alongside these obvious benefits, the zoning laws encouraged the further concentration of denser, even taller sky-scrapers. And they legally enshrined a formula for the relationship of height, mass, and rentable floor space, a formula that, in its subsequent incarnation, gave form to the Equitable twins' grandnephews: Towers 1 and 2 of the World Trade Center.

LEVELING, 1920

The force of the September 16 Broad Street blast pitted the marble fa-cade of J. P. Morgan's bank, and shattered windows blanketed Lower Manhattan "like snow." The *New York Times* headlined an article "Sky-scrapers of Financial District Appear to Have Been Shelled."

Junius Spencer Morgan, the great financier's son and present in the building at the time, was slightly cut on the hands by flying glass. Dazed and wandering among the corpses strewn about Wall Street, a messenger boy patted his intact body in disbelief and discovered the hundred shares of Anaconda Copper he'd been carrying in his back pocket burned to a crisp. Thirty people lay dead at the scene and more than

three hundred injured. Eventually, the death toll would rise to over forty.

A Rockefeller institute chemist called to the scene found fragments of what he suspected had been a twenty-pound container of TNT. This the *Times* reported as "Piece of Metal Pronounced Part of Infernal Machine Taken from Dead Boy." Swiftly, blame flowed along the lines of maximum political expediency: "Red Plot Seen in Blast." And though no evidence implicated him, IWW leader Big Bill Heywood was arrested as a "general precautionary measure."

Widely publicized "public outrage" over the bombing served as a timely pretext for the mass roundup of radicals—particularly foreigners—followed by a cycle of deportations, extraditions, indictments, false confessions, and jailhouse suicides. In the tragedy's increasingly carnivalesque aftermath, a Democratic U.S. senator cast responsibility on Republicans who had voted to reduce Justice Department appropriations for fighting the Reds. And a popular Protestant minister accused the Vatican of "creating the atmosphere." From inside a sanitarium, a psychic who had predicted the blast offered to guide investigators to the plotters by telepathy.

After four years of painstaking investigation, a mental defective confessed to having driven the horse cart to the site. Finally, in 1930, the massive ten-year manhunt ground to a halt, petering out in a maze of blind alleys. None of the authors of the Broad Street massacre was ever identified. Considered by investigators at the time, but deemed unworthy of pursuit by law enforcement authorities, was the possibility that the blast was accidental in origin: a shipment of excavation dynamite routed on a precipitous shortcut through Wall Street, detonated by a careless spark.

ILLUMINATION. TRANSPARENCIES

It is a very different order of bank from the House of Morgan that you glimpsed from the window of the double-decker bus while riding down Fifth Avenue with your mother one afternoon in 1954. Somehow, even at the age of four, you realized you were experiencing an extraordinary moment. There, at the corner of Forty-third Street, after months of construction, the plywood hoardings had finally come down to reveal—in plain view, not hidden deep inside as anyone would think—a safe! It was a circular polished steel and brass Mosler safe, embedded in a wall of black marble and framed in the bank window like an immense Tiffany jewel.

Even today, when you pass by, you recall the delight and almost scandalized amazement with which you first gazed upon the conspicuous revelation of the bank's "heart." Brendan Gill gave a critic's voice to your youthful infatuation, observing that "the bank appeared to be beckoning suggestively to the passersby to come and borrow money and in the passersby came, not awestruck and humble as in times past but eager to be caressed and seduced." The mystique of the seraglio shattered, the secret receptacle of wealth had burst triumphantly, and with haute couture style, into the domain of public spectacle.

Of Gordon Bunshaft's revolutionary bank design—a boxy, low-rise structure surfaced in huge sheets of glass—the *New York Times* editorialized: "According to the architects, the idea is to make complete transparency provide for other people's money in the bankers' charge the protection for which steel and concrete vaults have been the traditional reliance." Transparent walls "broke up the masonry-fortress psychology of branch banks up to then. . . . From then on, banks all across the country became friendly." The see-through bank, born a century after Paxton's Crystal Palace, implied that the mechanisms of exchange—now that they had been made visible—might soon be rendered publicly manipulable. It was now possible for Gill's passersby to imagine that they had, as the advertising slogan ran, "a friend at Chase Manhattan."

In 1956, two years after encasing the bank vault in a glass display case, Bunshaft designed One Chase Plaza, the first high-rise office tower to be built in the financial district in a generation. Unlike the Woolworth building, Chase Plaza did not evoke religious sentiment in its beholders. Bunshaft's sixty-story, International Style steel and glass slab—anchored in Manhattan schist yet shunning reference to it—embodied a notion of spatial form, and an understanding of wealth, radically different from that represented by J. P. Morgan's blockhouse or Woolworth's cathedral.

Described by its publicists as "a powerful and superbly equipped machine for handling commerce," One Chase Plaza proclaimed the bank's emergence at the forefront of a new, streamlined, globalized finance that leaped adroitly over the outmoded barrier of national frontiers. Chase's tower also marked David Rockefeller's opening gambit toward reshaping Lower Manhattan and leveraging the value of his family's real estate holdings there. Fifteen years later, the enduring monument to David's ambitious plan would soar to 110 stories—times two—casting Chase Plaza, quite literally, into shadow.

Chase Plaza—as the Equitable Building had in 1916—spurred changes in New York's zoning codes. Its massive slab design was permitted because Chase built on only 30 percent of its site, with the remainder comprising widened streets and a broad public plaza. Following on the heels of two prestigious International Style structures in midtown—Bunshaft's Lever House and the Seagram Building, a Mies van der Rohe and Phillip Johnson collaboration—One Chase Plaza provided the final push needed for enacting the next generation of regulations in 1961. Encouraged by new height and bulk provisions, the dense, stepped clusters of midtown and the financial district soon began giving way to a transfigured urban landscape: tall towers set in vast paved plazas.

As the marble walls of the fortress bank turned transparent, so too did finance rip itself away from J. P. Morgan's idealized bedrock of "trust" and strip the Gothic ornamentation from Woolworth's heavenly tower of dimes. From its inception, the skyscraper had allied its form to the leveraging of finance from the assumed productivity of land. The office tower had served both as an emblem of and a concrete vehicle for the practice of speculative finance. Seventy-five years after the Tower Building shot the rental expectations of downtown Manhattan's property owners thirteen stories into the stratosphere, the revised building codes came together with revolutionary engineering to produce a new, exponentially denser skyscraper form.

Reckoning the profits to be had from ten million square feet of office space, architect Minoru Yamasaki posed anew the old real estate conundrum Bradford L. Gilbert had solved with the steel cage. To extract the greatest value from your land, Yamasaki concluded, you must abandon the anachronistic structure of the old skyscraper. Instead, emulate the hollow, fibrous structure of the bamboo stalk. Shape your tube into a square. Then you can build prairie upon prairie of columnless stories, as high as you want to go. No limit.

ILLUMINATION, CANYONS, AND HARBOR

If you're riding down to the Battery on a bike, you're with your father, and you almost always pass through the Washington wholesale market and Radio Row before making a detour east through the Wall Street canyons. On weekends, the financial district is utterly deserted, and

you can pedal, staring upward for blocks on end, without worrying about crashing into anything. What river, you ask yourself, made these cuts?

You can hear the ships' horns echoing from the harbor as you pedal down Broadway and into the salty open air of Bowling Green. From the railing of Battery Park's esplanade, you count tugboats by the score—some nudging ships through the bay, the bigger ones heading out to sea—each trailed by its retinue of gulls.

The freighters are easier to keep track of. At any time a dozen or more stand in the distance, lined up in the narrows, with as many headed out toward the Atlantic. One day the great Cunard sisters, the *Queen Elizabeth*, with two red funnels, and the *Queen Mary* with three, glide past each other in the bay, to a great cacophony of horns and fireboats spraying arcs of water. You can't believe you're watching this happen. What a place this harbor must be, where two Queens can cross paths to such accompaniment.

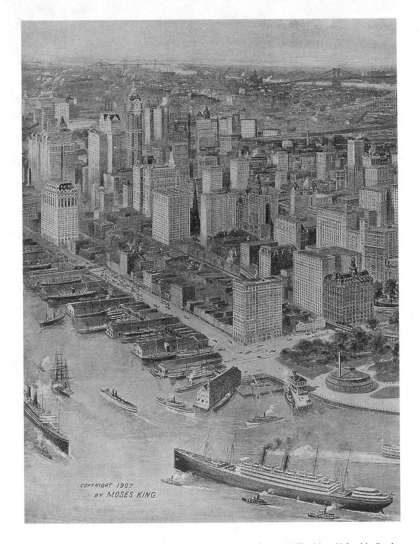

King's Views of New York, 1908–1909. *Mountains to the sea: "The Most Valuable Real Estate in the World" meets "The Greatest Port in the World." At upper left, the world's largest office blocks, the twin Hudson and Manhattan Terminal Buildings (2 million square feet), occupy a portion of the future World Trade Center site.*

"THE GREATEST PORT IN THE WORLD"

With $1,916,934,800 foreign trade in the year ended June 30, 1914, New York surpassed London by $125,000,000, Hamburg by $242,000,000, Liverpool by $279,000,000, firmly establishing its position as the greatest port in the world. With 392 miles of developed waterfront and 978 miles altogether, measured around the piers, New York is unrivaled in its facilities for shipping. On its waters in 1913, 175,000,000 tons of freight were carried, the value exceeding $12,500,000,000. New York is the home port of 3,637 vessels of 1,770,137 tons and 4,223 foreign vessels of 14,464,161 tons trade here. The state canals deliver 2,602,000 tons of freight valued at $36,865,451. Its strategic location makes the port the focus of the great trade coming through the Panama Canal, and it is the centre of the intracoastal waterway of which the Cape Cod Canal, Long Island Sound and the proposed ship canals across New Jersey and Delaware are links.

—from *King's Views of New York,* 1915

CITY OUT OF WATER

The transformation of Lower Manhattan into a city of towers valued in multiple billions of dollars had humble beginnings. It is rooted in the transformation of land into real estate: an asset that can be rationally divided, owned, transferred, and profited upon. This understanding of property, though still emerging in the early seventeenth century, would not have seemed alien to the officers of the Dutch West India Company or to its director general, Peter Minuit, whose savvy deal-making has since been celebrated in a thousand schoolbooks.

Any child exposed to these primers will have no trouble recalling that in 1626, in the interest of securing fresh water and pasturage for the New Netherlands colony, Minuit successfully negotiated with the Algonquins the settlement's right to occupy 14,000 acres of what is now Lower Manhattan.

Land around natural harbors, like New York's, has traditionally served as a favorable site for a city's growth, particularly given the proximity of a river like the Hudson. The land's strategic value lies in its proximity to water, the vital medium of commerce. In the case of New York, it took more than three centuries for an ever more abstract, economic consciousness to complete the transformation of the city's water linkages into a real estate amenity valuable chiefly for its spectacular "harbor views."

From the early growth of Nieuw Amsterdam until the mid-1960s, the harbor and the city's waterways were generally acknowledged as key factors in New York's development. Major public investment in support of New York's waterborne commerce began in the early nineteenth century with the construction of the Erie Canal. Opened in 1823 and initially called "Clinton's Folly" after the state governor who initiated the massively expensive and seemingly misconceived project, the canal system linked the city to the fertile heartland via the Great Lakes. Soon augmented by railroads, the Erie Canal channeled the Midwest's foreign trade through New York's port and provided the economic basis in trade for the concentration of financial activities in Lower Manhattan. Auguring the symbiosis between waterborne transport and the city's economic cycles, the opening of the Erie Canal launched New York's first real estate boom—an exponential leap in Manhattan lot values.

A hundred and fifty years later, the rise of the World Trade Center coincided with the decline of the port that, by virtue of being a day closer to Europe by ship than any major harbor in North America, had helped leverage New York into the global center of finance. During the time span of the planning and building of the World Trade Center, New York lost much of its port and manufacturing capacity, crippling the city's ability to simultaneously finance, manufacture, and distribute goods and products. It lost the vital flow of materials that had sustained its many-chambered economic heart.

New York City's port, while moribund, is not clinically dead. Container facilities still operate in Staten Island, and cruise ships dock midtown at Manhattan's remaining West Side piers. But with dramatic reductions in its traffic and freight volume, the port's contribution to the city and regional economy has similarly diminished. Culminating a process that began in the late 1950s, the great harbor described in *King's Views* has now given way to a virtual port, supplied with a thriving nostalgia industry: tall-ships festivals, a seaport shopping mall and theme park, and an aircraft carrier aerospace museum.

Poetic tributes to the city's maritime glory days by Walt Whitman and Frank O'Hara decorate the wrought iron railings along the Hudson River waterfront at the foot of the World Financial Center (WFC). Today, the vast majority of incoming ships, whose cargoes once flowed through the docks of the Hudson and East Rivers or into the mammoth terminals of south Brooklyn, now make a sharp westward turn after passing beneath the Verrazano Narrows Bridge and head into the shipping channel toward the Port of Newark-Elizabeth in New Jersey. But even this presumably "regional" port is now in severe decline. Built to replace and augment New York City's dilapidated freight-handling operations, Newark-Elizabeth has, for many years, been losing its share of traffic to more efficient East Coast and Canadian facilities.

The dispersal of shipping activity from New York's waterfront was neither accidental nor inevitable. And the origins of the city of towers may be traced by following a series of political and economic maneuvers that began with the nineteenth-century urban reformers, carried forward with the regional planning movement, and leaped exponentially ahead in the 1920s with the establishment of the Port Authority and the Regional Plan Association.

Although they differed in many ways, the men who engineered the dispersal of the port broadly concurred in the belief that the well-being of New York City depended on the development of a comprehensive, rationally ordered regional plan. They were convinced that if such a plan were implemented, it would generate a level of prosperity that could not help but translate into widespread social good. But beneath this assumption lay the contradictory principle that a city exists for the maximum capitalization of its real estate. This is the core article of faith around which New York's financiers, developers, politicians, and planners have repeatedly organized their efforts. As a result, an unprecedented eruption of commercial real estate emerged out of Lower Manhattan's bedrock in the early twentieth century, moved northward into midtown, and, with the advent of the World Trade Center, returned to its roots at the harbor's shore.

REVELATION AND REAL ESTATE

When New York State Governor Nelson Rockefeller delivered his triumphant dedication speech on April 4, 1973, he could not, and did not, describe the World Trade Center as the ultimate distortion of an anarchist utopian planning legacy whose origins lay obscured in the

smoke and fog of the late-nineteenth-century metropolis. Nor could he say that the proud new towers, aimed as they were at the twenty-first century, represented the monstrous outgrowth of a hundred-year-old attempt to alleviate the miserable conditions of the industrial city—conditions we have come to call "Dickensian" after one of their most ardent and articulate narrators.

By the time Fagan was teaching Oliver Twist a light touch with a pocket watch on the streets of London, New York had grown explosively too, and with such horrific consequences that both cities were described in nearly identical language, using terms borrowed from the anatomist's table and the pulpit. Would-be urban reformers of every stripe, whether planners, social scientists, novelists, or theologians, wrote of the industrial city as "congested" and labeled its atmosphere "suffocating" and "miasmic." Insistently repeated, in scientific and religious journals and the popular press, these terms drew their imagistic power from the contemporary stream of tubercular metaphor. The association between urban density and asphyxiation achieved its greatest linguistic effect when an appalling concentration of tenements on New York's Lower East Side became known simply as the "Lung Block." At the level of language, the city had been transformed into a body—its life threatened by diseased organs.

A related stream of images depicted the industrial city as an immense festering sore, a site of "rot," "tumescence," "suppuration and sepsis"—a necrotic member that, left untreated, would poison the entire nation. Framed as such language was by the values of Victorian-era Protestantism, the city's affliction did not remain confined to its body alone. Malady of the body still carried with it an inescapable moral implication; therefore the corruption had also invaded the city's soul. For those who narrated the city's agony in the interest of relieving it, the industrial metropolis appeared, quite literally, as a vision of hell on earth: a vast factory for the production of poverty and vice.

In 1880, in his *Letters to the Clergy on the Lord's Prayer and the Church*, John Ruskin described "the great cities of the earth" as "loathsome centres of fornication and covetousness—the smoke of their sin going up into the face of heaven like the furnace of Sodom; and the pollution of it rotting and raging the bones and souls of the peasant people round them, as if they were each a volcano whose ashes broke out in blains upon man and upon beast."

Twenty years later, the men at the vanguard of New York's reform movement, Robert De Forest and Lawrence Veiller, moderated Ruskin's apocalyptic language yet maintained the linkage between vice and phys-

ical disease. In their groundbreaking survey *The Tenement House Problem: Including the Report of the New York State Tenement House Commission of 1900*, De Forest and Veiller described "the tenement districts of New York" as "places where thousands of people are living in the smallest place in which it is possible for human beings to exist—crowded together in dark, ill-ventilated rooms, in many of which the sunlight never enters and in most of which fresh air is unknown. They are centres of disease, poverty, vice, and crime, where it is a marvel, not that some children grow up to be thieves, drunkards and prostitutes, but that so many should ever grow up to be decent and self-respecting."

For Ruskin, the city's conditions made it the source of a plague that threatened to vomit its evil beyond all boundaries. But for De Forest and Veiller, and the generation of scientific planners who came after them, quarantining urban contagion and ameliorating its worst symptoms constituted the paramount goal. The overcrowding of impoverished districts could be relieved through rational planning. A systematically ordered regulation of urban life emerged as the reformers' prescription for the industrial city's social and economic survival.

Zealous as De Forest and Veiller were in advocating improved housing for the poor, their careers also exemplified the uneasy juxtaposition of social science and civic-minded reform set against the demands of corporate-minded real estate logic. After his collaboration with Veiller, De Forest became a director of the Jersey Central Railroad and, later, chairman of the Regional Plan Association. Veiller, for his part, went on to author the 1916 zoning regulations, mentioned earlier. Ostensibly enacted to prevent the recurrence of monstrosities like the Equitable Building, the zoning laws were almost immediately used to conserve midtown real estate for its most profitable uses.

LOCATION, LOCATION, LOCATION

The cultivable fields of profit that zoning advocates envisioned had their origin in an 1811 plan by New York's city fathers—then known as the Common Council—to plow Manhattan Island above Fourteenth Street into a real-estate-friendly grid. The as-yet-undeveloped northern reaches of the city were to contain twelve straight north-south avenues and 155 perpendicular streets—approximately two thousand blocks of uniform size, each divisible into dozens of lots.

Though the stated purpose of the plan was to facilitate "the buying, selling and improving of real estate," the Common Council nonetheless

hoped that the arrangement would not "furnish materials to the pernicious spirit of speculation." Today, Broadway's diagonal cuts against the rectilinear grain, and Central Park forms an immense backyard for its surrounding neighborhoods, but one has only to walk through midtown Manhattan to experience firsthand how definitively the 1811 gridiron plan stamped the future development of the city.

Despite Marx's prescient observation that a market economy demands modes of spatial organization, for the remainder of the nineteenth century New York's oligarchs took no further formal steps to regulate the city's dramatic growth. It was not until the early years of the twentieth century—by which time New York's five formerly autonomous boroughs had been welded into a unified political entity—that they adapted the emerging practices of comprehensive city planning toward maintaining the highest possible values in Manhattan's central business district (CBD).

The opening gambit in this power play was the use of the new zoning laws to disperse "congestive" manufacturing from midtown. The same regulations, however, encouraged uses for the area that created even greater net density in the form of office towers. From a real estate perspective, this practice made consummate sense. It still does, given the nearly 1,000 percent spread in rents between factory and class A office space. Through the alchemy of zoning, value of a property may be multiplied many times over, merely by changing its designated use.

Even in its infancy, New York's zoning movement united the city's wealthiest downtown merchants, bankers, and real estate figures around an issue of common concern. But publicly, the movement was represented by several reform-minded planning activists, among them Edward Bassett (the putative "father of zoning"), Nelson Lewis, and George McAneny. Later in their careers, the latter two would play significant roles in the influential work of the Regional Plan Association.

In 1907, zoning enthusiasts formed a civic association to preserve the value of established high-priced midtown business locations threatened by the expanding garment industry. Four years later, then Manhattan Borough President McAneny created the Fifth Avenue Commission to study the area's problems. The commission's report found dangerous health hazards, ostensibly caused by the density of industry and overpopulation by workers who would "swarm down the avenue for the lunch hour," then at the close of the day, "pour out upon the sidewalk . . . and congest the side streets with a steady stream of humanity."

The commission reported its findings to the Board of Estimate—then popularly known as the "forty thieves"—and won approval for the

creation of a Committee on City Planning. The new committee, the city's first municipal planning body, at once initiated a Zoning Commission, upping the ante in the midtown power play.

Not surprisingly, garment manufacturers resisted these efforts to restrict their expansion, and in response, the Fifth Avenue Commission's rhetoric grew increasingly alarmist. "Shall we save New York?" queried the commission's full-page ad in the *New York Times*, "from unnatural and unnecessary crowding, depopulated sections, from being a city unbeautiful, from high rents, from illy . . . distributed taxation." The commission backed its publicity appeal with bare-knuckled economics. One of the commission's directors, the comptroller of the Metropolitan Life Insurance Company, warned garment manufacturers that they would be denied credit if they sought to expand north of Thirty-fourth Street. By the spring of 1916, Met Life and fifty-three other financial institutions had signed a resolution in "hearty support" of the work and plans of the Zoning Commission. When enacted, the new regulations achieved a containment of manufacturing that the real estate market had been unable to accomplish on its own. And New York City had taken a defining step toward formalizing its planning process along the lines laid down by its financial elite.

UTOPIAN ROOTS

Although zoning organizes the space of the metropolis into rational, economically practicable functions, it does not deal with the city's role as an integral component of a geographically defined region. This large-scale conception requires a broader, more encompassing view, best taken in from high in the air. The first organization to survey New York City and its environs comprehensively was the still-extant Regional Plan Association (RPA), which issued its most recent report in 1996. Founded in 1922, the RPA is a creature of checkered ancestry with a methodological lineage that may be traced back further still, to two visionary "amateur" planners who shared a distinctly utopian bent: Ebinezer Howard and Patrick Geddes.

Howard was a London-born eclectic and professional shorthand writer fascinated with the conundrum of uncontrolled urban growth. In his book *Garden Cities of To-Morrow* (1898), Howard outlined a bold and highly influential proposal to halt the growth of overcrowded industrial cities and relieve their crushing density. Circling the metropolis, a series of new linked, semiautonomous satellite cities, each

populated by no more than thirty thousand residents, would be built within a wide swath of agriculture and forest. Decentralization of industry and dispersed populations would allow for plenty of breathing room. Administration of the new garden cities was to be carried out by public authorities: popularly elected bodies whose function would be to regulate land use and prevent speculation. Howard saw governance by economically disinterested agencies as a means of checking free-market tendencies and neutralizing political corruption. The joint planning and administrative bodies Howard proposed were the conceptual forerunners of the New York region's Port Authority.

Strongly influenced by the anticapitalism and technological aversions of John Ruskin and William Morris, Howard's thinking informed the scientific land reform and city planning ideas of anarchist geographers Elisée Reclus and Peter Kropotkin. Key aspects of their theories were, in turn, adopted by Patrick Geddes, a Scottish biology teacher and paper folder, who in 1915 published a book that would open up a vast new territory for the practice of regional planning. In *Cities in Evolution,* Geddes proposed the bold notion that the river basin formed the natural geographic and social basis for the development of a metropolitan region. The key precondition for planning and administrating a sustainable city, Geddes argued, was a comprehensive survey of the region in all its complexity.

With Geddes, planning ascended above the city to take in its surroundings and observe the entire region's processes from a great height. In Geddes's utopian vision, the survey laid the scientific groundwork for a symbiotic, nonexploitative relationship between a city and its surrounding region. For progressive planners like Geddes, and his brilliant American disciple Lewis Mumford, the purpose of the regional survey was not to parcel the region into a real estate hierarchy of land use. Rather, it was the means by which a socially egalitarian city-region could be designed in harmony with its natural resources. The survey itself marked only the first, crucial step in a scientific, rational, and eminently humane planning process intended to benefit the region as a whole.

When uncrated on American shores by the Regional Plan Association in the late 1920s, Geddes's theory was found to have been badly damaged in transport. For the RPA, the only salvageable part was the technique of the survey. In booming, fiercely capitalistic, pre-Crash New York, the notion of land, rivers, and seas as resources to be shared for the common good smacked not only of political subversion but also of fiscal lunacy. Thus the RPA planners set about restoring the utopian social pyramid to its customary top-down posi-

tion and concentrated their efforts on transforming the regional survey into a tool for zoning the entire region into categories of more or less profitable real estate.

ZONING THE NEW YORK REGION

In large measure, the institutional makeup of the Regional Plan Association was coextensive with that of New York's regional oligarchy. The initial work of the RPA, including its first regional survey, was funded by the Russell Sage Foundation and the similarly real-estate-invested Rockefeller and Pratt families. The project's first director was Charles Norton, an officer of the First National Bank, treasurer of the Russell Sage Foundation, and former head of the Commercial Club of Chicago. Serving on the RPA board was Robert De Forest, who owned thousands of yet-to-be-developed acres on Long Island. Other board members included George McAneny, former chief lobbyist for the Pennsylvania Railroad. An anti-Tammany reformer, McAneny had also held a management position at the *New York Times*.

Representing the Morgan Bank was Dwight Morrow, also a director of the New York Central railroad and a financial backer of the Interborough Rapid Transit line. Rounding out the RPA's quorum of political and economic heavyweights was Frederick Delano, director of a half dozen railroads and uncle of future president Franklin Delano Roosevelt. The lone nonfinancier on the board was an officer of the Otis Elevator Company, who undoubtedly entertained more than a passing interest in the building of skyscrapers.

The RPA's first survey of the New York region took as its model a 1907 survey of Pittsburgh, Pennsylvania, also funded by the Russell Sage Foundation. The Pittsburgh survey aimed at finding methods to control the steeltown's wildcat industrial development and ameliorate its nightmarish housing conditions. It brought together, for the first time on American shores, a multidisciplinary panel of scientific and social professionals in the interest of articulating a unified plan for civic improvement. In the July 1913 issue of *Harper's Monthly*, Frederick H. Howe, an American proponent of Ebinezer Howard's Garden City concept, lauded the advances of the new discipline in phrases that for the next sixty years most urban planners would regard as axiomatic:

> City planning treats the city as a unit, as an organic whole, . . . it antici-
> pates the future with the foresightedness of an army commander so as to

secure the orderly, harmonious and symmetrical development of the community . . . [it] makes provision for people as well as industry. . . . It means a city built by experts, in architecture, landscape gardening, in engineering and in housing; by students of health, transportation, sanitation, water, gas and electricity, by a new type of municipal officers who visualize the complex life of a million people.

But compared with Pittsburgh, a regional survey of the largest city on the continent offered an exponentially greater challenge in terms of scale and breadth of territory embraced. Nor could New York be regarded as an industrial slagheap in need of controlled development alone. Planning the future of the commercial capital of the country—long renowned as its "great emporium"—also demanded that the city be treated as a vast public work of art.

THE BOLD AND THE BEAUTIFUL

It was this "City Beautiful" philosophy that Charles Norton, the RPA's first leader, had cultivated as president of the Chicago Commercial Club and that he now brought to New York's much larger regional stage. Under Norton's tenure, the club had provided sponsorship for a 1909 master plan for Chicago. This scheme sought to extend to the city as a whole the monumental aesthetic principles invoked by architect Daniel H. Burnham in his Beaux Art "White City," built for the World's Columbian Exposition of 1893.

It would be difficult to imagine an approach to city planning more divergent from the grassroots-based utopian regionalism of Howard and Geddes. In this view, the ideal city did not emerge as a natural consequence of integrating the economic functions of its region. Urban unification would be achieved by creating morally uplifting architecture on a cyclopean scale. The chaotic agglomeration of old structures needed to be demolished wholesale and the city rebuilt according to a vast, centralized plan.

The realization of this scheme would open up urban vistas of theretofore unimaginable beauty—unimpeded sightlines along colonnaded boulevards toward magnificent, templelike edifices rising at each of the city's multiple hubs. In Burnham's ideal, the haphazard metropolis was to be leveled and resculpted into an immense stone-faced monument to civic order. But this visual spectacle aimed beyond the aesthetic, or rather it invoked the aesthetic in the furtherance of the

social mission of his patrons: to overawe and dazzle the masses—to stun them into a mute, quivering civic pride.

Such grand, centralized planning sought to freeze urban life into a *tableau vivant*. To this end it offered an architecture to serve as the built manifestation of a rigid social order—an architecture whose success rested upon the aestheticized immensity of its staging. "Make no little plans," Burnham's famous dictum reads, "for they have no power to stir men's blood and probably will not themselves be realized. Make big plans; aim high in hope and work, remembering that a noble, logical diagram once recorded will never die. . . . Let your watchword be order and your beacon beauty."

THE RPA SURVEY

Between 1927 and 1931, the Regional Plan Association published its *Regional Survey of New York and Its Environs*, a comprehensive analysis of land use, zoning, population, and transportation. But the *Survey*'s authors went much further than a description and analysis of existing conditions. They laid down in prototypical form many of the ambitious public works projects later attributed to the vision of Robert Moses. These included a massive arterial highway network and multiple bridges and tunnels for motor vehicles. For building types, the *Survey* advocated widely spaced skyscrapers set in swaths of greensward as a means to ameliorate the city's density. And on paper, half a century before the event itself transpired, the *Survey* removed the Port of New York to Elizabeth, New Jersey.

Over the course of the *Survey*'s seven volumes, the RPA planners proposed a detailed set of prescriptions for making the region's "centers and sub-centers healthy, efficient, and free from congestion." Read today, the *Survey* presents a chronicle of planning disasters foretold. The rationale for expanding the central business district—sealing the fate of New York's maritime and manufacturing cultures—and even the language in which future arguments for clearing the World Trade Center site and building the twin towers would be articulated—all appear in Volume II, *Population, Land Values and Government*.

For the RPA, the task of combating the region's industrial density entailed "breaking up unwieldy centers and creating new centers and sub-centers, as well as dispersal of some industry from its overcrowded centers to those that have space to permit of economic functioning and expansion." But the dispersal of concentrated economic activities was

to be selective and based on a real estate hierarchy of values. The goal therefore ought not be decentralization per se but rather "a *reorientation* of centralization." [Italics mine.] Carried out correctly, the planners predicted that

> the economic benefit will be certain and considerable if, in promoting the right kind of dispersal, the city succeeds at the same time in arresting the wrong kind. For instance, if it were practicable for New York to *encourage the movement to outside areas of those industries that are the least valuable to it, it would probably prevent the removal of others that are of greater value.* [Italics mine.]

Effective planning for the region had therefore to seek the dispersal of the "congestion caused by such industries as remain in Manhattan." Those industries that occupy "cheap space in obsolete buildings" are "injurious to the industries that must remain for sounder economic reasons." From this, it naturally followed that the port must go, since "one of the fundamental causes of congestion . . . is the convergence of too many transportation facilities, including harbor extensions, at places already congested."

Besides, the RPA concluded, "much of the . . . waterfront cannot be connected efficiently with the railroads without prohibitive cost; and much of it, in any event, should be reserved for recreation, in the interests of commerce itself." Once pushed out of Manhattan and Brooklyn, "the greatest opportunities for [the port's] future growth appear to lie in the New Jersey counties adjacent to the waterfront."

But what were the fundamental reasons for intentionally dispersing some industries from the city's overcrowded center? And why was it necessary for Manhattan's core to be so dense with activities "of greater value"? What was the source of such hostility to manufacturing and such idealization of the high-dollar high-rise? In Volume I, *Major Economic Factors in Economic Growth and Arrangement,* the RPA planners communicated their articles of faith with stunning ideological candor. For them, "the root of all urban problems" stemmed from "the manner in which land is used and in which the functions and bulks of buildings on land are distributed." A great inequity obstructed the natural order of land use—an inequity they fervently desired to redress.

> Some of the poorest people live in conveniently located slums on high-priced land. On patrician Fifth Avenue, Tiffany and Woolworth, cheek by jowl, offer jewels and gimcracks from substantially identical sites.

Childs Restaurants thrive where Delmonico's withered and died. A stone's throw from the stock exchange, the air is filled with the aroma of roasting coffee; a few hundred feet from Times Square, with the stench of slaughter houses. In the very heart of the "commercial" city on Manhattan Island south of 59th Street, the inspectors in 1922 found nearly 420,000 workers, employed in factories. Such a situation outrages one's sense of order. Everything seems misplaced. One yearns to re-arrange the hodge-podge and put things where they belong.

Having staked out their territory and confessed their yearning to radically redistribute urban functions, the RPA planners declared, with characteristic sangfroid, the credo that would largely determine New York City's future economic and social development—their Land Use Order of Precedence: "1) the financial district, 2) the best retail business, 3) the best residence, 4) inferior retail business, 5) wholesaling and some industries, 6) other industries, residences for low-paid workers."

Robert Murray Haig, author of the *Survey*'s first volume, saw in the "competitive struggle for urban sites . . . the outlines of an economically ideal pattern or plan." But if it were to succeed, the natural selection process of real estate Darwinism required the planner to take nature into his own hands. Citing H. Paul Douglass's influential contemporary book *The Suburban Trend,* Haig proposed that "in the process of deliberate decentralization, *science* is ultimately to decide what elements in the present city ought to remain and what ought to go." And it is a strange science indeed that permeates the *Survey*—one that moors its ideological edifices time and again in the RPA's bedrock "law of urban rent."

At the close of the nineteenth century, Chicago's makeover artist Daniel Burnham had asserted that "beauty has always paid better than any other commodity and always will." Though New York's aesthetic "hodge-podge" could never aspire to Burnham's neoclassical ideal, the city might yet seek its own form of beauty in reordering its real estate along the lines of maximum value.

MASTER OF MASTERS

The urge to shape the world around the vision of an ideal city is hardly new. In *All That Is Solid Melts into Air,* his bittersweet appreciation of the rise of modernity, Marshall Berman traced two centuries' worth of pyrrhic impulses toward the perfected urban form. In his essay on "pseudo-development," Berman appropriated Goethe's Faust as his fic-

tional prototype for the twentieth-century master builder, who must also make a bargain, if only metaphorically, with the forces of darkness. In Berman's version, Faust roams unchecked, drunk with power and bent on a global campaign of relentless modernization. Urged on by Mephisto, Faust has succeeded in bending nearly the whole of the world to his will. But at last he comes upon a pious old couple who, from time immemorial, have lived by the seashore, aiding shipwrecked mariners.

Because it stands in the way of his all-encompassing scheme, Faust obsessively desires the old couple's small plot. On it he plans to build his ultimate edifice: an observation tower, from which he will "gaze out into the infinite" and revel in the sight of the gleaming new world he has created. But time and again, the old couple rebuffs Faust's offers of riches and relocation. Having no use for wealth, they wish only to die a natural death where they have always lived.

After exhausting every worldly blandishment, Faust gives vent to his frustrated rage. He orders Mephisto to remove these last stubborn obstacles to progress, and his servant dutifully obliges. But later, seeing the ruin of the old couple's cottage, Faust deduces their fate and recoils in horror. Seized with remorse, he curses Mephisto and dispatches him back to Hell. In the end, Goethe's fictional master builder cannot bring himself to face the material consequences of his own enacted desires.

In twentieth-century New York City, unseen by its tugboat men and stevedores, cabdrivers, secretaries, filing clerks, and factory workers, a shadowy presence, part Mephisto, part Faust, whispered in the ears and urged the hands of New York's master builders. His presence hovered above the port and the tangled cityscape as Robert Moses, David and Nelson Rockefeller, Austin Tobin, and scores of less powerful city-shapers exercised their will and moved toward their next conquest. This shadow-presence was Le Corbusier: architect, visionary of automobile-age planning, and "father" of the superblock, the composite unit of land on which every large-scale modern development project—from Rockefeller Center to the United Nations, Lincoln Center, and the World Trade Center—is based.

Christened Charles Édouard Jeanneret, Le Corbusier was born in 1887 into an established family of Swiss watchmakers. But his life's work took him far beyond the bounds of traditional craftsmanship. Often applied in an opportunistic and highly selective fashion, Le Corbusier's planning precepts imprinted the form of the contemporary city more deeply and enduringly than those of any other modern architect. Though

he remained an éminence grise on this continent, Le Corbusier was, if indirectly, as important a character in the narrative of the World Trade Center drama as were David and Nelson Rockefeller or Austin Tobin.

Le Corbusier lived as a genuine artistic luminary, and because of this, his purity of vision was presumed to be incorruptible. His prescriptions for the city sprang forth seemingly untainted by either pecuniary interests or sentiment. He could, and therefore did, express with breathtaking directness the precepts of an urban order that the RPA and other official planners had to couch in far more modulated language. Like Ruskin and Howard in the nineteenth century, Le Corbusier saw the modern city as hopelessly suffocated by its own toxic effluvia. But unlike them, he had no interest in a democratic cure. Instead he proposed that the city's salvation lay in the brutal yet healing interventions of *grand seigneurs*—a race of superbuilders "without remorse"—since "the design of cities [is] too important to be left to the citizens."

But though his ideas dovetailed neatly with those of the real-estate-invested planners, Le Corbusier cannot be considered a mere puppet of the elite. Like other artistic enfants terribles, his creative energies manifested at a truly Faustian level, and the business of planning remained, for him, a supremely personal, godlike act. "I have always had this devouring curiosity," he wrote, "to look into the effects of a positive action."

Arriving in New York by ship in the early 1930s, Le Corbusier sighted Lower Manhattan's massed skyscrapers and proclaimed, "I am an American!" But upon returning to Europe, he disparaged the city's buildings: "The skyscrapers of New York are too small and there are too many of them." Nevertheless, he cherished one image from his travels in America: grain silos rising out of the prairie. And it is not difficult to see why, since the image presents such a strong visual parallel to his own groupings of soaring skyscrapers set in a swath of urban parkland.

In *La Ville contemporanie* (translated as *The City of Tomorrow and Its Planning*), 1922, and *La Ville radieuse (The Radiant City)*, 1933, Le Corbusier argued that the concentrated tumult and disorder of the modern city could be cured, paradoxically, by exponentially increasing urban density. This would be accomplished by erecting very tall buildings on a small portion of the total ground area. Le Corbusier's preferred scenario called for an entire obsolete city to be demolished and replaced with ranks of high-rise towers in a park. The Radiant City would then unfold as a landscape of massive spaces and breathtaking

perspectives—of repetitive, uniform structures and the preeminence of absolutely straight lines.

But if, as his capital letters insisted in *The Radiant City,* "THE PLAN MUST RULE," then the street—the cause of urban congestion—must yield before the conquering superblock: "Our streets no longer work. Streets are an obsolete notion. There ought not to be such things as streets; we have to create something to replace them. . . . To breathe! TO LIVE! . . . The present idea of the street must be abolished: DEATH OF THE STREET! DEATH OF THE STREET!"

The first encounter between New York's financial district and the superblock came in 1958 with the relatively modest creation of One Chase Plaza. The elimination of a single block of Cedar Street between Nassau and William Streets provided a platform upon which David Rockefeller's sixty-story bank headquarters could rise. A decade later, the pedestal for the World Trade Center engulfed sixteen blocks to the northwest. The combined force of these two projects opened the floodgates to a tidal wave of office and residential superblock developments in Lower Manhattan.

No comparison of "before" and "after" maps can adequately demonstrate the quality of this transformation. The texture of the superblock city of towers is best appreciated at street level and preferably on foot. No longer can Lower Manhattan be experienced as a unified geographic whole. It has been refracted into a series of discrete, strategically isolated zones—multiple centers lacking any sort of connective, animating scheme. Short of being there, the next best thing is to try to imagine reading a book from which all the verbs have been extracted, leaving only the nouns and the gaps in between.

VANISHING UTOPIAS: DEMOCRACITY

Running parallel to Le Corbusier's autocratic urban ideal stand two contrasting populist visions emanating from the American and European planning movements of the first half of the twentieth century. With the passage of sufficient time, it has become possible to see their utopian reflections, distorted as if in a fun-house mirror, in the architecture and social spirit of the World Trade Center.

When it was built as an exhibition for the 1939 New York World's Fair, Democracity—a scale model of the ideal future metropolis—brought key elements of Howard's Garden City dispersion together with Le Corbusier's high-rise concentration. The Democracity plan was the work of Henry Dreyfuss, a brilliantly innovative and wide-ranging industrial designer with a gift for aestheticizing the functional—whether

his object was a T-54 tank or the thermostat control for a split-level ranch house. The stainless steel artificial arm Dreyfuss designed for the Department of Defense after World War II possessed a Brancusi-like grace, and his mobile ICBM system with its nuclear warhead was proportioned so as to appear toylike and innocent of all destructive energy.

Dreyfuss came to the task of envisioning Democracity's vest-pocket utopia fresh from creating a new standard of fast-moving luxury for the New York Central Railroad: the magnificent, streamlined Twentieth Century Limited. Besides being a superbly engineered industrial machine, the Limited aimed far beyond the functional necessities of conventional train travel. Riding the Limited was intended to be experienced as no less than a sensation of absolute motion itself. And its fluid, dynamic lines proclaimed the final victory of the technological mind over geography and time, whose dawning moment Robert Louis Stevenson had glimpsed "from a railway carriage" a century before.

But more than this, the Limited conjured up the vision of the passenger's imminent arrival at the gates of a new, ideal city. Though the project was never achieved full-scale, within the giant dome of the World's Fair Perisphere, Dreyfuss presented fairgoers with a breathtaking apparition in miniature of "a perfectly integrated, futuristic metropolis."

The Democracity model, painstakingly crafted and dramatically illuminated, spread to a horizon line fifteen scale miles in the distance. Standing on a platform rotating above this tableau, viewers gazed down upon a greenbelt incorporating twenty-five satellite towns, surrounding a city two miles in diameter. Zoned into districts separated by spacious parklands freely adapted from Howard's Garden City and Frank Lloyd Wright's Broadacre City, Democracity's 11,000 square miles were to house 1.5 million inhabitants in suburban "Pleasantvilles" or in mixed industrial-residential "Millvilles." At Democracity's nucleus, the intersecting point of its vast radial arteries, a single square-sided tower of immense height loomed over a ring of smaller high-rise buildings. This tower was the pillar of "Centeron," the great office complex to which a quarter million Democracitizens would commute each weekday.

For Dreyfuss, Democracity was not an "impossible dream of a Jules Verne or an H. G. Wells" but rather a city that "could be constructed tomorrow with the technological knowledge we have." It served, above all, as a new "symbol of all city planning." It gave idealized form to the yearned-for planning order of simultaneous dispersion and concentration. The life promised by Democracity consisted of rapid and completely regulated motion around a core of utter stasis: a mockery of democracy.

The other unbuilt ghost presence of early-twentieth-century utopian planning reflecting off the skin of the twin towers is the *Stadtkrone:* the "crown" of the ideal metropolis. At a time when Europe's great armies were still mired in the trenches of World War I, the German designer Bruno Taut and his circle of techno-utopian and Expressionist architects had already anticipated the coming of a new urban order in a world that, at long last, had definitively renounced national conflict. Taut's vision of the future city relied on the liberating potential of new industrial forms, especially glass architecture.

The social aspect of his ethos called for the restoration of a city center to the sprawling, fragmented modern metropolis, whose soul had been crushed by speculative development. Proposing *Die Stadtkrone* (1919) as an antidote to this endemic alienation, Taut identified the most detrimental consequence of the modern, bloated metropolis, or *Grosstadt*, as "the loss of the center"—the symbolically charged, cultural nucleus around which the city had originally formed. Accordingly, Taut envisioned a new, integrated urban utopia, organized around a single crowning structure embodying the collective secular and sacred needs of the entire community. By virtue of its inclusiveness, the *Stadtkrone* would take the place held by the cathedral in the bygone urban order and remedy "the obliteration of the borderline between big and small, sacred and profane from which our time suffers."

One of Taut's contemporaries, Martin Wagner, celebrated the *Stadtkrone* as the "we-symbol" *(Wir-Sinnbild)* of the future city in which "only *one* building shall rise above the level, earth-bound city houses and as a *city-crown* dominate the whole city-form, and the we-symbol of the new city . . . with its ceremonial plaza . . . shall produce a city forum of the highest artistic form."

UTOPIA AND BUST

By the second half of the twentieth century, New York's planners and master builders could draw upon a rich vocabulary of public architectural spectacle, with roots reaching back to Ebinezer Howard, Patrick Geddes, and the anarchist geographers. And in the heyday of Robert Moses, the planning gigantism that had long sounded a common chord among diverging approaches to restructuring the city left in its wake an awestruck and largely acquiescent mass audience.

But one of the profound ironies at the heart of the World Trade Center is that by the time it was completed, the drive for large-scale urban planning projects had begun to stall. Within little more than a decade of David Rockefeller's 1958 plan for the wholesale bulldozing of much of Lower Manhattan, massive renewal schemes had come to be widely viewed as either unattainable, undesirable, or both. And the social and institutional conditions for the realization of megadevelopments like the trade center had been largely undercut.

Implicit in what Douglas Lee called the "requiem for large-scale planning" came the realization that the modern city was too complex and diverse an organism to be subjected to an overarching order imposed from the top down. It was in this moment that Jane Jacobs, and those who would follow her in promulgating community-based planning, raised their voices, voted with their feet, and turned militant. Even before the ink dried on the final stamp of approval for the World Trade Center, mobilized community opposition halted Moses's long-planned river-to-river Lower Manhattan Expressway—a project that would have obliterated much of Chinatown, Little Italy, SoHo, and Tribeca. And two Greenwich Village mothers with school-aged children successfully organized neighborhood resistance to a Moses-proposed highway that would have blasted through Washington Square Park, connecting the midtown and downtown poles of Manhattan's central business district. Given the rapid evolution of a more politically savvy and preservation-minded public, it is possible that had the proposal to build the World Trade Center come only a few years later, the twin towers might have been either shelved or rescaled.

Eventually, after decades of almost limitless power, Robert Moses—New York's most truly Corbusian *grand seigneur*, who, by his own description, had hacked his way through the city with a meat ax—was dethroned in an epic power struggle with Nelson Rockefeller. And in the politically charged 1960s, even the Regional Plan Association, responding to the tenor of the times, moderated its language, if not its underlying values, in an attempt to generate plans more responsive to the needs of communities. But the World Trade Center germinated in the climate of the 1950s, when the credo of the previous generation of planners still held sway.

Build wide roads, they urged, and they will hum with traffic. Build bridges and highways to your towers, the better to fill them with workers. Build your towers as high as you may—they will always overflow with value.

T H R E E

P O R T A U T H O R I T Y
R U L E S

Triumph of the automotive planning order, c. 1950. The puzzle of the overcrowded city solved at last!

ILLUMINATION, PUBLIC WORKS

There are days when the World Trade Center lies shrouded in mist, invisible from your living-room window three miles to the north. Here, twenty stories up, in one of the taller buildings in the "valley" between the downtown and midtown towers, a hundred years of development vanish from sight. On a clear day, though, you can see the visible evidence left by New York's master builders in their headlong rush through the twentieth century. Far to the southwest, beyond a sliver of Hudson, you can make out the bold arch of the Bayonne bridge, rising above the horizon like a half-buried, cyclo-pean Ferris wheel. At night the Bayonne's bow of lights might be the diadem of a vast odalisque reclining across the industrial heartland of New Jersey.

This is the first bridge that Othmar H. Ammann designed for the Port Authority. Linking New Jersey and Staten Island by highway, Ammann pushed arched metal as far as physics would allow. So strikingly beauti-ful is its form that Berenice Ab-bott shot a series of giddy, nearly rapturous portraits soon after it opened to automobile traffic in 1931. That same year, Ammann delineated the stunning propor-tions of the Port Authority's George Washington Bridge, link-ing the Jersey Palisades with the northern tip of Manhattan and gesturing eastward toward the Bronx and Long Island.

As you look southeast over the roofs of Greenwich Village, SoHo, Little Italy, and China-town, the massed skyscrapers of Wall Street rear their impenetra-ble collective curtain wall. Be-yond them lies Ammann's greatest engineering triumph: the Verrazano Narrows, a ribbon of motor vehicles spanning the strait between Brooklyn and Staten Island, stretching over freighters passing into the bay or out into the Atlantic. Built by Robert Moses in the mid-1960s, the Verrazano finally completed the automotive link between New Jersey and Long Island that the RPA planners had called for thirty years before.

Twenty square blocks of resi-dential Bay Ridge crumbled be-fore Moses's bulldozers to clear the way for the Verrazano's Brooklyn anchorage. When built, the Verrazano, like the Bayonne bridge had in its day, extended the limits of metal engineering

with masterful delicacy. So long is the span that its twin vertical piers are not built perfectly parallel to one another. To accommodate the curvature of the earth, they veer an inch and five-eighths farther apart at their tops than at their mooring in the Narrows mud seventy stories below. Ammann had learned over a lifetime of engineering that great strength does not require great mass. His vision for this last great New York bridge was of "an enormous object drawn as faintly as possible."

THE RIGHT MIX

If one pillar of the World Trade Center's gleaming irony lies deep in its anarchist roots, another emerges by way of its institutional parent, the Port Authority, the public agency founded to channel private money into port development and guard against its misuse for speculative ventures like office towers. Called into existence in the early 1920s by joint fiat of New York and New Jersey, the Port Authority's mission was to provide regional planning and oversight for the entire port district. But the structure of the organization and its role as a mixing chamber for private and public resources also represented a new answer to a long-standing economic conundrum—one that had existed ever since the country gained its independence from Britain.

When the government formulated its first economic policies after the Revolution, no regulatory barriers were imposed between public and private moneys. The corporation did not yet exist as a purely private enterprise but rather as a quasi-public institution chartered by government statute. Likewise, the state was deeply implicated in private business. The federal government held a substantial minority interest in two of the country's major financial institutions, the First and Second United States Banks, as well as majority stock in the Bank of North America. At the level of national infrastructure, the precursors of today's interstate highways were built by hybrid private-public corporations in anticipation of profits from toll revenues.

Although the mingling of money streams generated revenue for the state and federal governments, catalyzed economic activity, and stimulated capital investment in development and westward expansion, it also enmeshed governments in a web of risky business ventures. During Andrew Jackson's presidency, this scheme unraveled with disastrous results when a high-flying combination of land speculations, silver hoarding, and wildcat banking spun out of control and returned forcefully to earth. Within months, the country was plunged into the Panic of 1837, a severe contraction from which it did not fully recover until well into the 1840s.

The prolonged economic paralysis pushed hundreds of thousands of Americans into poverty and unleashed a wave of violent unrest. In New York City alone, fifty thousand people—a third of the labor force—lost their livelihoods. Many who remained employed found their wages drastically reduced. An outbreak of rioting and the threat of widespread famine threatened to implode the social promise of the new nation. So severe an economic setback, together with the popular fury directed against the Panic's profiteers, spurred legislation aimed at preventing direct financial collusion of private and public interests. New laws placed strict ceilings on state borrowing and permitted, for the first time, the incorporation of exclusively private corporate ventures.

To prevent a disastrous repeat of 1837, the direct involvement of governmental bodies in business deals was firmly regulated, and the state sought and achieved other means of raising revenue and stimulating economic activity. But in a system based on the free flow of capital and constant expansion of markets, the imposition of a hermetic seal between public and private realms was neither economically viable nor ideologically desirable. Governmental and private economies would remain interdependent. Ultimately at issue was not whether they would mix, but how.

AUTHORITY DAWN

When the Port Authority was founded in 1921 as the country's first regional planning body, it became in the same moment the country's first public corporation—a promising mechanism for channeling private funds into public works. In the 1930s, the PA served as the prototype for scores of similarly structured corporations chartered by federal, state, and municipal governments. The national proliferation of agencies modeled on the PA was not triggered by a need for public works as such but rather by the bursting of yet another speculative bubble. The public corporation movement was a strategic response to the catastrophic social and economic conditions of the Great Depression.

Public corporations were a cornerstone of the New Deal economic recovery policies that President Franklin D. Roosevelt invoked to fill the vacuum left by the nearly total collapse of private enterprise. According to historian Annmarie Hauk Walsh, this was the moment when the federal government took over as "the country's largest electrical power producer, the largest insurer, the largest lender and the largest borrower, the largest landlord and the largest tenant, the largest holder of grazing land and timberland, the largest owner of grain, the largest

warehouse operator, the largest shipowner, and the largest truck fleet operator." A century after the 1837 panic, government had not merely gone back into business; it had *become* business.

Washington's coffers bankrolled a network of domestic planning and development agencies to stimulate economic activity and provide jobs. Popularly known by their three-letter acronyms, the PWA, TVA, CCC, and dozens of lesser-known authorities undertook the task of constructing a vast nationwide system of bridges, tunnels, roads, dams, and parklands. In his essay "Modernism in New York," Marshall Berman observed that these projects were also intended to "speed up, concentrate and modernize the economies of the regions in which they were built." Taken together, the work of these agencies would "enlarge the meaning of 'the public,' and give symbolic demonstrations of how American life could be enriched both materially and spiritually through the medium of public works." Administered by regional public authorities, the great New Deal projects, through their unprecedented scale, their boldness, and their technological innovation, "dramatized the promise of a glorious future just emerging over the horizon."

For Roosevelt and the army of technocratic planners coordinating the recovery, the depths of the Depression offered a historic opportunity to weld a nation of diverse regions into a centralized, unified, industrial power. Though the New Deal and its web of authorities proved incapable of generating an economic turnaround prior to World War II, Roosevelt's public works, like Burnham's big plans, nevertheless possessed the power to "stir men's blood" and quickened the cultural imagination.

Inspired by the Grand Coulee Dam, a project that drew hydroelectric power from the river wilderness of the Pacific Northwest, Woody Guthrie articulated the hopes of millions for whom the work of public authorities augured the recovery of the nation. Writing in 1940, under a grant from the WPA, Guthrie composed one of his most anthemic yet subtly voiced ballads. "Roll on Columbia," he urged the great, now-domesticated river, "your power is turning our darkness to dawn—so roll on Columbia, roll on."

TWO BEAUTIES

All but invisible beneath the drama of the authority as a mythic builder of public works runs a more mundane story: that of its function as a political-economic mechanism. Historically, this mechanism has served to carry out projects that could not be profitably undertaken by private enterprise, opened up to public debate, or subjected to scrutiny

at the ballot box. It is a story, therefore, fraught with contradictions.

The work of authorities is carried out in the name of the public. Yet the deliberations of an authority's executive board and committees remain screened from public oversight, as do the details of its finances, which frequently generate a bonanza of private capital flows. Projects undertaken by authorities purportedly yield a public good. But an authority's board is under no legal obligation to undertake a project it deems unfit, however demonstrable its public value may be.

The enormous flexibility and power of authorities derive from the confluence of the public corporation's mission with the workings of private-sector finance. Given this linkage, it is not surprising that the development strategies driving an authority's activities frequently dovetail with the financial interests of its bondholders. This tendency holds true whether the authority's projects are the sorts of bridge, highway, and tunnel constructions recommended by the patrician visionaries of the Regional Plan Association, or the building of a World Trade Center, largely at the behest of the city's most influential banker and his brother, the state governor.

The financial beauty of a public corporation like the Port Authority is that it capitalizes its projects through the sale of bonds. This allows for enormous public investments that do not directly raise taxes, since the debt an authority incurs never appears on the state budget's balance sheet. The state, however, is obligated to pick up the tab in the event of a default, making taxpayers potentially liable for projects they never had an opportunity to examine, much less vote for. Thus the public unwittingly collateralizes authority projects. At the same time, it pays directly—through tolls and fees—the interest on bonds the authority may reissue ad infinitum.

The political beauty of public authorities is that they are subject to influence only at the highest levels of state control. Authority decision-making remains hermetically sealed from direct public participation. In an unusually candid radio interview, given in 1996 after he left public office, former New York State Governor Mario Cuomo defined public authorities as "something above democracy, absolutely, that's why it was invented by politicians, to keep the people away from the operation, and to insulate the politicians."

WHAT ROCKY KNEW

Chief among those politicians insulated by the authorities' air lock was New York State Governor Nelson Rockefeller. Taking full advan-

tage of their potential to leverage immense amounts of cash while sidestepping voter approval, Rockefeller used public corporations to push forward a vast array of development projects he deemed essential to the state's future. Knowing a rare talent when he saw one, Rockefeller hired the brilliant New York City bond lawyer John Mitchell—later attorney general in the Nixon administration—to create a model for what eventually became forty-one new state authorities. To fund the governor's public works extravaganza, Mitchell invented the "moral obligation" bond, a clever retuning of a venerable financial instrument that shifted the ultimate obligations for authority debts onto the taxpayers.

During Rockefeller's tenure, New York State's on-the-books debt grew exponentially. But its authority borrowing had become truly spectacular. When Rockefeller left office in 1974, the amount owed by public authorities exceeded $12 billion—nearly four times the state's general obligation and nearly a thousand percent higher than the 1962 figure of $129 million. Throughout his tenure, the governor channeled billions of public dollars toward development in Lower Manhattan, including the World Trade Center and several ancillary projects proposed in brother David's 1958 Lower Manhattan Plan.

But long before Nelson's ambitions as a master builder were unleashed on New York State, the Port Authority had already become the region's sole institution capable of leveraging a project on the massive scale of the World Trade Center. Only a public corporation with a fifty-year track record would be capable of raising a billion dollars to replace Lower Manhattan's piers with immense twin silos of office space. A private firm or consortium could not have attempted, nor would it have dared, to undertake such a feat. But an entity shielded from risk by public subsidies and the taxpayers' "moral obligation" could do it. With the World Trade Center, the Port Authority became the institutional mechanism for redeveloping Lower Manhattan and leveraging property values throughout the financial district and beyond—without private investors having to risk a nickel.

How did the Port Authority—chartered to safeguard the economic health of New York's regional maritime commerce—become the agent, a half century later, of the port's displacement and decline? And what caused America's most venerable planning and development agency— once imbued with the high-minded public service doctrines of Woodrow Wilson—to transform itself into the world's biggest real estate speculator?

Wherever you venture, travel to, or arrive at, the built city surrounds you. In the subway, in a taxicab, on foot, bike, or bus—or in some quiet spot, perhaps at home, in a café, or on a park bench—you see the city as it is. But in moments of reflection, even walking through the mall beneath the World Trade Center plaza and toward the towers' elevator banks, you find yourself thinking that in order to navigate its spaces intelligently and efficiently, you have turned the city into a landscape of foregone conclusions—an architecture of the inevitable. The city that appears constantly before you tells you nothing of the cities that came before or the myriad others that might have come to fruition—if. The built city is an expert at keeping mum about the cities it foreclosed. But by looking toward the unbuilt, you begin to discover traces of the *possible* city—one not yet cast in concrete but latent within urban materials as yet untested and untried.

For a moment, you leave your stomach in the sky lobby while the rest of you ascends by high-speed elevator to the fifty-fifth floor and the Port Authority library, where you spend the rest of the morning poring over documents that make it clear that for the Port Authority, the World Trade Center stands as the crowning achievement in its long tradition of scientific planning and rigorously engineered public works. But what other great projects might the Port Authority have carried out in its stead? What was abandoned in exchange for what was realized? Is it possible that the structures left unbuilt have shaped the city as enduringly as have the great towers the PA brought to completion?

THE RAILROAD NOT TAKEN

The agency that built the World Trade Center owes its existence to an acrimonious turf war between New York and New Jersey that flared anew in the early years of the twentieth century over rail freight rates and other long-simmering boundary issues. In 1916, responding to a lawsuit initiated by New Jersey, the federal Interstate Commerce Commission ordered that "the great terminals of the Port of New York be made practically one, and that the separate interests of the individual carriers . . . be subordinated to the public interest." The two states formed a joint advisory body, the Harbor Development Commission, in an attempt to implement this injunction. The following year, after due

deliberation, the Harbor Commission issued its *Joint Report with Comprehensive Plans and Recommendations.* Foremost among the *Report*'s recommendations was the creation of a bistate agency to oversee the efficient economic development of the port district, an area of approximately 1,500 square miles encompassing 17 counties and 108 towns. Thus the Port of New York Authority, an entity without legal precedent, received its charter in 1921 by fiat of joint New York and New Jersey legislative action, even as the states continued to spar with each other in the courts. The Port Authority's formation represented a bold attempt to address the problems of the entire port region from a scientifically objective planning perspective that would take into account, as the *Joint Report* put it, the "best interests of all." The two governors would alternate appointing the chairman and executive director and an equal number of commissioners.

The Port Authority's compact recognized that "the commerce of the Port of New York has greatly developed and increased" and held that "a better coordination of the terminal, transportation and other facilities of commerce in, about and through the Port of New York will result in great economies, benefiting the nation as well as the states of New York and New Jersey." But it acknowledged that future development would "require the expenditure of large sums of money and the cordial cooperation of the States of New York and New Jersey in the encouragement of the investment of capital and in the formulation and execution of the necessary physical plans."

The compact therefore vested the new agency with "full power and authority to purchase, construct, lease and operate terminal, transportation and other facilities of commerce within the port districts as defined by law." PA projects were to be financed with the issuance of its own bonds. The terms of the charter were not intended to give the PA carte blanche to engage in real estate speculation, but the phrase *other facilities of commerce* formed the tunnel-sized loophole through which the agency eventually drove the World Trade Center. Nevertheless, the twin towers are only the most visible evidence of the gulf between the *Joint Report*'s directives and what the Port Authority subsequently did.

Since the PA's first chairman, Eugenius Outerbridge, had served on the Harbor Commission, it might be assumed that the new agency's policies would reflect the planning perspectives articulated in the *Joint Report.* But early on, the PA struck off on a course of its own. Viewed in the light of its future actions, a review of the issues of primary interest to the authors of the *Joint Report*, and even of the language in which

their concerns are expressed, is particularly telling.

First and foremost, the *Joint Report* saw the "irregular flow of goods" through the port district as a "situation needing immediate correction." Though at the time New York was deemed "too well fortified with natural advantages" ever to face a serious threat to its dominance as the center of international maritime trade, the *Report* warned that lacking a comprehensive plan, the port would prove unable to "absorb the increase of the country's trade which is bound to come as the country continues to grow" or to "draw new industries because of the alleged lower costs of doing business at [other] ports."

To Outerbridge and the other authors of the *Joint Report,* planning for the port district was of concern not merely to "public officials, directors of railroads, steamship companies and other terminal enterprises." The condition of the port also represented "a great sociological problem of chief concern to the public at large" because "a heavy burden is thrown upon the commerce of the Port and adds to the cost of living. The public feels the oppressiveness of this burden but is unable to analyze its causes, which, however, can and should be removed." Despite their occasionally patronizing tone, the authors of the *Joint Report* maintained the notion that economic planning existed to meet the needs of people rather than vice versa.

But the *Joint Report* went beyond sounding an alarm for the port and expressing sympathy with public needs. It spelled out the mechanisms "required to carry on the business of the Port and to sustain the life and health of its inhabitants." These were "railroad lines, railroad stations, piers, ferries, tugboats, lighters [rail freight ferries], motor trucks, warehouses, markets and other facilities." Given the hierarchical organization of planning documents, the primacy of railroad lines over motor trucks must be accorded particular significance.

Without a systematic and comprehensive plan, the *Joint Report* argued, a great threat to the "general public" was posed by "the effect of inadequate terminal facilities on the merchants and manufacturers of the district [who] employ heads of families by the hundreds of thousands. If their costs of receiving and delivering goods are excessive . . . their ability to pay their employees adequately is lessened. Shrinking margins of profit may force employers out of business, or more favorable opportunities for doing business elsewhere may impel them to leave the port district. In either event, the local employees suffer."

The *Joint Report* noted that "our port problem is primarily a railroad problem. . . . A complete reorganization of the railroad terminal system is the most fundamental physical need of the Port of New

York." The first and most essential task the *Joint Report* urged upon the new Port Authority was therefore "*connecting New Jersey and New York . . . by tunnel under the Upper Bay*" and building "an underground railroad system . . . connecting with all of the railroads of the Port, serving virtually all of Manhattan." [Italics mine.]

The harbor commissioners' emphasis on rail freight did not, of course, result from their civic-mindedness alone. The *Joint Report's* planning arguments moved smoothly along a rhetorical track laid down by the interests of the region's powerful railroad directors, who were already in the process of shifting their capital from rolling stock to real estate. But the manner in which the commission articulated the economic and social needs of the New York region brings into sharp focus the gulf between the directives of the *Joint Report* and the projects the Port Authority ultimately carried out. The agency's earliest actions, as well as its abdications, helped lay the groundwork for New York City's current state of abject dependency on an economic monoculture of finance, insurance, and real estate (FIRE). Today, the Harbor Commission's report reads as nothing less than a prophetic warning against the city that the Port Authority had so important a role in building—a city divided into seemingly unbridgeable realms of crushing poverty and astronomical wealth.

In 1980, a decade after the trade towers became a strange vertical surrogate for the piers they buried, the Port Authority at last conducted a feasibility study of the cross-bay rail tunnel the agency had been chartered to build in 1921. Projected into the 1990s, estimates were that the tunnel would result in 1,700 fewer trucks each day clogging the region's highways and greatly reduced traffic jams, accidents, air pollution, and road maintenance. Though building the tunnel would cost an estimated $1 billion—ironically, the final price tag for the WTC—the project would generate an estimated annual $600 million in wages, $250 million in business income, $54 million in sales tax, and $163 million in federal tax revenues. Understandably, the report's conclusions have never been publicly released.

In recent years, the PA's port development activities have centered on maintaining deep draft freighter access to Newark-Elizabeth. PA and Army Corps engineers have blasted a ship channel through the Kill Van Kull at an estimated cost of $350 million. Unfortunately, the Kill is too narrow to allow two large ships to pass each other, and the channel's depth, even if increased to forty feet, is insufficient to accommodate fully loaded modern freighters. But New York does not lack for a site that can accommodate even the next generation of

cargo "superships." It has been there all the time—in Red Hook, South Brooklyn.

THE BRIDGE AND TUNNEL CROWD

If the newly formed Port Authority wasn't building a rail tunnel, what then was it doing? Initially, and for several years after its founding, the Port Authority made sporadic attempts to coordinate port district rail transport along the lines mandated in the *Joint Report.* Almost immediately, however, a host of obstacles arose, not least the intransigence of the rail carriers themselves. Blunted in its desultory efforts, the PA turned its back on the coordination of the port's rail freight and the cross-bay tunnel. Instead, PA planners looked toward projects that could be more readily accomplished and that carried with them the stamp of a distinctly more modernist ethos. The agency began constructing a series of bridges, tunnels, and depots to augment the spreading arterial network of automotive transport. And it began raking in tolls and rents.

The PA's first span, Outerbridge Crossing, eponymously named for the agency's first director, linked Staten Island with Perth Amboy, New Jersey. The agency miscalculated traffic projections, and the bridge proved a financial disaster. But the two states, having established the PA, remained committed to showing up its fiscal viability. In 1931, they provided the agency with a credit base by giving it title to the profitable Holland Tunnel, which had been built under the Hudson between New Jersey and lower Manhattan by an earlier bi-state commission. The states also rewrote the PA's charter to allow it to support deficit-generating projects with funds from profitable ones. This provided the legal framework for the 1962 legislation that enabled the PA to build the World Trade Center—in anticipation of rental profits—while simultaneously acquiring the bankrupt trans-Hudson commuter railroad.

Thus, two intertwined yet often competing demands shaped policies of the PA from its inception. As a public agency, its raison d'être lay, as the *Joint Report* mandated, in promoting "the best interests of all." But its function as a bond-issuing agency dictated that the public good be subjected to the disciplines of modern business practices. After World War I, as motor vehicles rapidly became the national travel and transport standard, American businesses were adopting a new credo of scientifically minded, rigorously hierarchical corporatism.

For the Port Authority, the strange grafting of twentieth-century business practices onto reform-era "civic patriotism" was accomplished by adopting the public administration tenets espoused by Woodrow Wilson. A Princeton history professor prior to becoming president, Wilson exemplified the belief that, as Annmarie Hauk Walsh put it, "the educated man of goodwill could be expected to rise above his own narrow interests to perceive and achieve the general good." Besides the ideal of scientific professionalism, with its presumed indifference to political or economic influence, the Port Authority's leadership borrowed from Wilson a belief in centralized administration, based on the assumption that democracies are best governed through a centralized, concentrated executive power.

Though the operating philosophy of the Port Authority was to remain peculiarly conflicted, the agency's leadership tirelessly promulgated the notion that it was possible to run a public agency along the lines of an efficient, modern business. As the PA's executive director for thirty years, Austin Tobin ultimately presided over the rising of the World Trade Center. In his 1947 manifesto *The Why and Wherefore of the Port of New York Authority*, Tobin eulogized the hybrid corporation he had meticulously built into a multibillion-dollar enterprise, a virtually sovereign power straddling the interests of two states:

"Though it is created as a political subdivision of the States and has many of the powers and immunities of a municipality, [the PA's] form is more closely that of a corporation, and its management, its methods and its techniques are those of a modern business corporation." Thus, through the workings of a public agency, the future of the world's preeminent port was placed squarely in the hands of "a Board of Directors of the best business brains in the community."

WHAT'S IN A BRAIN?

The Port Authority's founding directorship brought together New York's intersecting cultures of old and new money, high finance, real estate, and Progressive reform. Its first chairman was the patrician elder statesman of regional planning Eugenius Outerbridge, who, in addition to his role on the Harbor Commission, had served as chair of the Chamber of Commerce committee on shipping. Others in the leadership included men like Irving Bush, an upstart developer whose immense warehouse complex, built on the South Brooklyn waterfront, still bears his name. From the PA's inception through the opening of the

trade center fifty years later, the economic and political profile of the board remained remarkably consistent. Of the seventy-three commissioners serving during that period, nearly half were directors or officers of banks. Twenty-nine were high-level executives of insurance companies or brokerage houses. Twenty-two were government officials, and ten were corporate lawyers.

In *The Why and Wherefore*, Tobin had lauded the business acumen of the PA directorship. But the idea of a powerful public corporation blatantly under the control of the region's financial elite raised such disturbing questions that in 1952 Congress formally urged the agency to diversify its board in the interest of reducing the dominance of moneyed interests. However, the PA has historically repelled any challenge to its policies or attempts by parties other than the states' governors to tamper with its organizational structure.

During the period of the trade center's planning and development, and as late as 1992, when a bomb literally shook the foundations of its flagship project, the PA's directorship remained a hermetically sealed demographic of the regional power structure. Serving as chairman was longtime commissioner Richard Leone, a past president of the New York Mercantile Exchange and former managing director at the brokerage house Dillon Read and Company. Also on board was Robert Van Buren, head of the bank holding company Midlantic Corporation. The political wing was represented by William T. Ronan, a longtime associate of Nelson Rockefeller, and former New York City mayor Robert Wagner. Wagner and Ronan also served as directors of the same bank.

BONDS AWAY!

Though the Port Authority's directorship attempted to replicate the structure of a modern corporation, the agency's finances remained well fortified against the slings and arrows of the marketplace. Tobin proudly asserted that the PA was "the first government enterprise in this country required to be self-supporting or fail," but had the states not contributed $200,000 annually—the maximum legal subsidy—the PA would indeed have folded. And until 1935, PA construction projects were financed not through bonds at all but by state loans.

Issuing its own debt, however, meant the end of direct government subsidy—more or less. When Arthur Kill Bridge skidded toward default in the late 1930s after pulling in only one-tenth of its projected revenue, the federal Public Works Administration floated the PA a timely loan.

Had tolls from the Holland Tunnel not provided the PA with a steady stream of revenue, it would have had to suspend debt service on several works-in-progress, among them the George Washington Bridge.

Throughout its history, the PA has enjoyed a level of state nurturance far beyond that of a self-sustaining business competing in the open market. Few start-up ventures, for example, find themselves granted legally protected monopolies—in this case over the port district's airports, and the connecting bridge and tunnel links between the two states. But what enables the PA to leapfrog beyond the wildest dreams of entrepreneurial enterprise is its indenture pledges. These are, in effect, contracts assuring bondholders that New York and New Jersey will honor the PA's debt obligations in the event of a default.

Even from the outset, the Port Authority's leaders grasped and exploited the rhetorical value of publicly comparing their agency's workings to that of a modern corporation. Julius Henry Cohen, a young attorney of exceptional intelligence and mental flexibility had consulted on the Harbor Commission's *Joint Report* and subsequently drafted the PA's founding contract. Appointed the PA's general counsel, he advocated stamping the nascent agency with the recognizable features of a profit-making enterprise, based on the shrewd assumption that the investors would feel most comfortable lending to folks who thought as they did.

Cohen knew that for the PA to grow into an organization powerful enough to shape the region's future, it would have to emerge from behind the skirts of state subsidy and into the marketplace. In *They Builded Better Than They Knew,* his 1946 encomium to the public corporation movement, Cohen reminisced about the PA's salad days, when its yearly six-figure state income amounted to "chickenfeed." To build an agency on the scale he and Outerbridge envisioned, "we needed millions of dollars. Hundreds of millions." Fortunately for Cohen—and for Austin Tobin, the future Port Authority titan waiting in the wings— "through Outerbridge's influence we made contact with pretty nearly every one of the leaders in the financial world." It was this financial leadership that saw in the Port Authority a public agency that would carry forward their interests as "the best interests of all."

TOBIN TAKES ALL

Austin Tobin joined the Port Authority in 1928, just as it was definitively abandoning its efforts to move the region's fractious railroad in-

terests into alignment and supervise the coordination of their freight lines and terminal facilities. A real estate attorney freshly graduated from Columbia Law School, Tobin would spend his entire career at the PA, assuming directorship in 1942. During his three-decade tenure, Tobin placed his ineradicable stamp on the Wilsonian model of centralized executive style: The PA whose power radiated out across the entire port region had Austin Tobin for a hub.

Brooking no insubordination but quick to spot talented underlings and promote them, Tobin was invariably described, whether in tones of awe or outrage, as supremely autocratic. He demanded, and frequently inspired, intense loyalty, both to himself and the PA, for which he set the personal standard. Those who worked under him, from his right-hand man Julius Henry Cohen to the engineers who surveyed the sixteen leveled blocks of the World Trade Center site, viewed him as a daunting but Solomonic paterfamilias at the summit of an incorruptible meritocracy. Tobin's charisma beguiled even the independent, journalistic mind of James Morris when the two met in the late 1960s: "He was not how I imagined a New York harbor man. He was a small solid lawyer, weathered but cherubic, like an American Buddha. His voice was gentle but there was a steeliness to his eye, imperfectly disguised in humor. I had been told that he was one of the most powerful men in New York, and it seemed to me that while he would be a mellow and witty dinner host, he might be an awkward opponent to handle, face to face across a conference table with any flaming issue in between."

Such descriptions are rare, since Tobin, true to his Wilsonian credo, scrupulously avoided personal publicity. But when the PA came under attack or a stalled project required public support, Tobin proved an able media tactician—and a formidable political adversary. In 1947, the year he issued *The Why and Wherefore,* Tobin definitively secured his reputation by outmaneuvering Robert Moses in a battle of public authority titans over control of LaGuardia and Idlewild (now Kennedy) airports.

During Tobin's long leadership, the PA grew into a public agency of tremendous political and financial power. When he was forced into retirement by Nelson Rockefeller in 1972, Tobin left behind him an agency whose staff had mushroomed from 300 to more than 8,500, an annual budget exceeding $3 billion—and the potential to issue another $1 billion's worth of bonds at any time.

Like any responsible CEO, Tobin zealously guarded the value of the Port Authority's investments. Believing that an obligation to bondholders constituted the PA's paramount duty, Tobin repeatedly steered

the agency clear of what he termed the "bottomless pit" of freight and commuter rail projects. Often called upon to reiterate publicly the agency's "why and wherefore," Tobin once reached for an analogy and described the PA board as "a directorate . . . responsive to their stockholders." Since Tobin was well aware that the PA had no stockholders, it seems doubtful that his phrase represented a slip. More likely, he was stretching a metaphor, one he could not have invoked more tellingly. For Tobin, "stockholders" would have meant neither individual bondholders nor the public at large. Most probably he was thinking of the bond market itself.

ASPHALT, FISHER BODIES, AKRON RUBBER

During the Port Authority's early years, as it unsuccessfully sought to integrate the port's rail facilities, American planners and industrialists were busy piling their chips on the automotive future. Over succeeding decades, Tobin and other PA executives would attempt to justify, in scores of internal and public documents and speeches, their abandonment of the cross-bay rail tunnel and terminal links. In his *Why and Wherefore*, written thirty years after the Harbor Commission had mandated the cross-bay freight tunnel, Tobin still seemed compelled to dispel the unquiet ghost of the PA's great unbuilt project: "Thus in New York the original recommendation of an underground automatic electric system for the distribution of railroad freight from the New Jersey yards to Manhattan was made obsolete by the tremendous development of the motor truck."

Time and again, in phrases of striking similarity, Tobin and his spokesmen repeated the credo invoked by Le Corbusier and echoed by the regional planners of the RPA: Inexorably, the metropolitan region was being built around the automobile. In a 1955 speech before the Philadelphia branch of the American Bar Association, Tobin exulted at the prospect of burying the region's archaic train tracks under a free flowing tide of asphalt: "Our own planning in the field of arterial highways for the New York metropolitan area accepts the fact that the structure of our surging metropolitan areas today is being shaped almost entirely by the motor vehicle. With mass production of the auto, the truck and the bus, the suburbanite has been freed from his absolute dependence upon fixed rails with their inflexible routes."

Within Tobin's dialectic of transport modes nestled a fast-germinating seed of ideology that would soon prove self-fulfilling. The

goal of the Port Authority must be to liberate the modern, mobile individual—"the surburbanite"—by hacking new arteries into the heart of the congested city.

Legend has it that centuries before, when he learned that the Visigothic armies were closing in on Rome, the emperor Honorious, then ensconced in Constantinople, cried, "Let the Cantons defend themselves!" In the mid-1960s, when Tobin caused the twin sentinels of the PA's "vertical port" to rise at the water's edge, the moment to defend the integrity of New York's maritime trade had long since come and gone. The port, like the Cantons, was up for grabs.

RIPPLES OF THE UNBUILT

Under the PA's stewardship of the region's port, the Manhattan Transfer, the legendary freight-ferry link across the Hudson memorialized by John Dos Passos, languished—finally ceasing operation altogether in the early 1970s. Caught up in schemes more dynamic and profitable than scouring the rust off their rail connections to a failing port, the Penn Central and other regional carriers, rather than investing in "piggyback" (or TOFC, trailers on flatcar) facilities, converted their holdings into real estate investments.

But despite decades of systematic neglect, New York's port dispersed only after several plans to revive it in situ had been derailed. The rehabilitation projects fell victim to a combination of bureaucratic snags and opposition of the finance, insurance, and real estate interests that had long sought the port's removal. As early as 1922, several years before the RPA survey, the *New York Times* dismissed the idea of a cross-bay rail tunnel and advocated moving the port to New Jersey: "It is plain that Newark has the railways in greater competitiveness than the city has the ships. Newark's competitive effort is to get access to the ships, just as the competitive effort by the City Administration is to get access to the railroad feeders of its docks. Newark has better access to deep water than New York City has to the railways across the Hudson."

As late as 1963, when the legislation authorizing the WTC had already been enacted, a final attempt was made to save at least some of the port. The city's Department of Marine and Aviation proposed rebuilding the Manhattan piers as part of a long-term redevelopment of the Hudson River shoreline from the Battery to Seventy-Second Street. The proposal was killed by the City Planning Commission, which cited its "grandiose" $200 million price tag.

But fifteen years prior, in 1947, another scheme for reviving Lower Manhattan had raised a flurry of interest in business quarters. The plan linked a revitalized port to the rehabilitation of the Washington wholesale market. And it called for a new downtown entity of an entirely different order: a World Trade Center.

FIRST IT WAS, THEN IT WASN'T

However high its towers loom, the city feeds on trade, and this has been true since cities began. Within the confines of the market square, commerce and carnival mingled in the raucous spectacle of the medieval trade fair. Here, in the open space beneath cathedral spires, systems of trade emerged and were nurtured. As the market took root in the relative stability of the walled towns, its sporadic energies were domesticated, its practices regulated, its standards of weights and measures made uniform. Here commercial values began to weave themselves, over centuries, into the fabric of everyday life. And it is from the multiplication of widely dispersed local trading centers that the world-embracing web we recognize today as the global market descends.

In recent years, an annual summer "Buskers Fare" has swirled around the feet of the World Trade Center and wended its celebratory path through the canyons to other notable downtown plazas. Sponsored by banks and brokerage houses and administered by the nonprofit Lower Manhattan Cultural Council, roving bands of stiltwalkers, jugglers, fire eaters, dancers, and acting troupes pay homage to the long-forgotten linkage among market, carnival, and passion play.

Odd as it may seem to juxtapose New York's rigid twin neo-Gothic towers with the medieval market square, the connection is not as improbable as it might first appear, since the World Trade Center took for its first model Germany's Leipzig fair dating to the 1300s. In a 1955 memo to Austin Tobin, PA Director of Port Development Roger H. Gilman discussed in detail the feasibility of a New York World Trade Center, to be financed "on the basis of revenue from the continuous exhibits of merchandise."

The idea had first been floated a decade earlier by David Scholtz, a real estate investor and a former governor of Florida. Scholtz's notion of a publicly subsidized, commercial development venture keyed to Lower Manhattan port activities apparently intrigued "several influential citizens of New York City" so much that they brought the proposal to Governor Thomas E. Dewey. The venerable Leipzig fair had enjoyed,

after all, a seven-hundred-year history of state subsidy. Why not create a Leipzig-on-Hudson, in the heart of New York's booming postwar manufacturing and transport economy?

Dewey thought enough of Scholtz's proposal to forward it to the Port Authority for further study. In early 1946, PA Chairman Howard S. Cullman—who in addition to his agency post was a partner in his family's investment house and served on the boards of several banking and insurance firms—blandly informed Dewey that although the trade center might serve a useful purpose in the economic life of the city, it appeared in Scholtz's proposal to be "primarily an extensive real estate operation." On that basis, Cullman concluded that it was not a viable project for "administration through a self-perpetuating public benefit corporation," such as the Port Authority.

Soon afterward, Tobin wrote Dewey himself, advising the governor that though he saw "nothing wrong with the idea of a World Trade Center in New York," it could not, as proposed, be "self-supporting either as a private or self-liquidating enterprise" and would require extensive subsidy. In Tobin's comment lies the germ of the two-decade-long transformation of the WTC from a subsidized "trade fair" into ten million square feet of vertical office space.

Later that year, at Dewey's urging, the state legislature authorized creation of a World Trade Corporation that would "establish and develop a World Trade Center to be located within the State of New York for exhibiting and otherwise promoting the purchase and sale of products in international trade." To the board, along with Scholtz, Dewey appointed several of the "influential citizens" who had backed the idea, among them David Sarnoff, chairman of NBC, and Winthrop W. Aldrich, David Rockefeller's uncle and mentor at Chase Manhattan, the family bank.

According to the received history of modern Lower Manhattan development, the idea of Dewey's trade center, as proposed by the World Trade Corporation, was vetoed along with its port rehabilitation component by the city's Board of Estimate in 1949. In this version of the downtown fable, the idea of a trade center was pronounced officially dead, only to be resurrected miraculously a decade later as the key component of David Rockefeller's Lower Manhattan Plan. But the Gilman-to-Tobin communiqué demonstrates that the trade center concept, though screened from public debate, was entertained all along within the precincts of New York's master planners and financiers.

According to the Gilman memo, between 1949 and 1955 the PA continued to study and refine the concept of a world trade center de-

signed to function as a port development facility. The agency's efforts were spurred in this direction by the development of several International Houses, International Trade Marts, and World Trade Centers in the competing ports of New Orleans, Philadelphia, Boston, San Francisco, and Miami. These projects all viewed "port enhancement" through the lens of real estate development and were generally capitalized by a mix of public and private sources. The memo noted that one PA commissioner's investment firm, in partnership with Lehman Brothers, was underwriting a syndicate to float a $60 million bond issue for a Miami World Trade Center.

Although the PA had abandoned the Lower Manhattan piers, it was neither willing, nor as yet able, to leap into outright real estate speculation. Gilman opined to Tobin that "there is little likelihood that we can stimulate substantial interest in a . . . Trade Center without some means of dramatizing its possibilities." But it was entirely possible, if the push came from outside the PA, that a World Trade Center might "form the nucleus of a coordinated port effort by private and public agencies."

. . . . THEN IT WAS

The "means of dramatizing" the WTC's possibilities were not long delayed in coming. In 1956, soon after he committed Chase to building its bold new corporate headquarters in the financial district, David Rockefeller formed the Downtown–Lower Manhattan Association. The DLMA was to become the high-profile, civic-minded face of Rockefeller's bank allied with a score of finance, insurance, and real estate firms—all having a mutual interest in the upswing of Lower Manhattan's property values. David's gamble on One Chase Plaza, already under construction, entailed extraordinary personal risk. If it were not supported by positive momentum throughout the whole Lower Manhattan real estate market, the first financial district office tower to be built in a generation could well prove a disaster for Chase and a serious blow to the family fortune.

Accordingly, David mobilized the downtown business elite around a high-profile strategy for redeveloping the entire district in the image of international corporate modernity. Among those entering into the ranks of the new organization was Banker's Trust president S. Sloan Colt, a longtime PA commissioner soon to be appointed chairman by David's brother Nelson. Rounding out the DLMA board were Fred Ecker of Met-

ropolitan Life, the company that held the mortgage on Rockefeller Center; G. Keith Funston, head of the New York Stock Exchange; J. Victor Herd of Continental Insurance; Robert Lehman of Lehman Brothers; Henry S. Morgan of Morgan Stanley; and Henry Alexander of Morgan Guaranty Trust.

As the 1950s waned, a striking unanimity of interests—as well as close personal and professional ties—began to interweave the efforts of Chase Manhattan, the DLMA, the Port Authority, and, soon, city hall and the New York statehouse, as New York City's economic and political spheres moved into an unusually powerful conjunction. The conditions favoring this unified effort were specific to what may be called the World Trade Center moment. They had never existed—and would not occur again.

In 1957, the year after David Rockefeller founded the DLMA, Robert F. Wagner was reelected as mayor on an "independent" slate. This left the entrenched, infamously corrupt Tammany-backed longshoremen's locals—now the port's last line of defense—without their traditional support in city hall. The Roth and Tishman construction dynasties, along with a host of ambitious upstart developers, concluded a strategic alliance with union boss Harry Van Arsdale and his powerful building trades constituency. If the construction industry provided plentiful work, Van Arsdale promised there would be no strikes or slowdowns. Then in 1958, Nelson Rockefeller was elected governor of New York. From the statehouse in Albany, he would become the Port Authority's most powerful influence. Once in place, this alignment of forces moved swiftly to consummate the planning goals proposed by the RPA thirty years before.

In the World Trade Center moment, it became possible to further dispense manufacturing from downtown, move what remained of New York's port to New Jersey and bury Lower Manhattan's rundown piers under virgin real estate. Also immured were any lingering hopes for a cross-bay rail freight tunnel. But New Yorkers, and everyone else who lived or worked in the region, would soon see a double 110-story "port enhancement" rise in its place. As David Rockefeller and the PA unfurled their billion-dollar mainsail to catch the winds of the real estate market, they lowered the boom on the port of New York.

BILLION-DOLLAR BABY

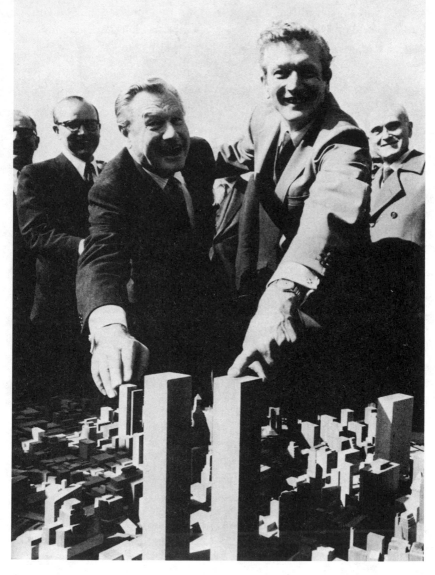

Why are these men laughing? "Nelson and John Lindsay divide the twin towers of the World Trade Center." New York Daily News, *May 12, 1966.*

ILLUMINATION, ON THE HOMEFRONT

In May 1947, Beauford Delaney witnessed your parents' marriage at the Municipal Building. He'd been painting since early morning and was running late, but he had only a few blocks to walk from his loft on Greene Street, in the heart of what is now called SoHo.

Preceding by more than a decade the wave of artists who would venture south of Houston Street seeking large, light, affordable spaces in which to live and work, Delaney rented a floor in one of the cast-iron-fronted nineteenth-century buildings being vacated as manufacturers began their post–World War II exodus from the center city. But even in the late 1950s, when you'd grown old enough to bicycle from the Village to the Battery by yourself, the old industrial district still bustled on weekdays, and the trucks backed up into the loading docks with their cabs sticking out into the street made for a challenging obstacle course.

One day your father made you a present of one of these trucks, in the form of a blueprint—front, side, top, and bottom views—that he had drawn on his lunch hour. This was when he was working at Yardney Electronics, a start-up venture that designed and manufactured electrical systems for the aerospace industry. Located south and west of SoHo, in the now-residential district called Tribeca, Yardney sponsored an amateur softball team captained by Julio Colón, the draftsman who sat at the desk next to your father, and provided its thirty-odd workers with annual Thanksgiving turkeys and Christmas bonuses.

Each weekday morning, you watched your father tuck in his tie and clip his rapidograph pen into his shirt pocket. The steel-toed boots he had worn in his previous job as a pipefitter in the Jersey shipyards had now become your playthings. You remember stepping into them, then dropping a two-pound sledgehammer on your foot—delighted by the wondrous sensation of impact without pain.

As your father walked downtown to work, the thoughts of Julius Edelstein, Mayor Wagner's right-hand man for economic development, were trending in the same direction. Many years later, Edelstein

would tell you that it was toward South Greenwich Village and its adjacent nineteenth-century industrial district that the forces pushing downtown "slum clearance" first turned in the mid-1950s.

But the resistance led by Jane Jacobs and the neighborhood organizations that rallied to save the Village and SoHo proved so fierce that Robert Moses's plans to level several square miles of manufacturing buildings and tenements south of Washington Square Park were either modified or shelved altogether. Under landmark protection, SoHo's industrial buildings were converted to residential and retail uses, and the district transformed itself into a late-twentieth-century-style version of the "great emporium." Also spared was most of the South Village, including the four-story tenement you grew up in; 540 West Broadway, now 540 LaGuardia Place, still stands, bookended by two manufacturing buildings converted into luxury co-ops.

A miss, they say, is as good as a mile. And it was only a mile downtown from where you lived to Radio Row, where steel-toed boots and sledgehammers would soon play out a billion-dollar game.

BIG PLANS DOWNTOWN: PUBLIC RELATIONS HIGH AND LOW

On June 5, 1958, four months before David Rockefeller unveiled his billion-dollar plan, the *New York Times* ran the headline "2 Units Aim to Rebuild Downtown" over an article positioning the DLMA as the chief arbiter of Lower Manhattan's future.

> The new organization will be called the Downtown–Lower Manhattan Association, Inc. It will present to public officials later this year a series of proposals on zoning, street widenings, slum clearance, private housing, shopping and entertainment area development, and relocation of some industries including the Washington Wholesale Produce Market, the Fulton Fish Market, coffee roasters and tanneries. The Committee on Lower Manhattan engaged the architectural firm of Skidmore, Owings & Merrill last year to make studies of land use, traffic improvement and street and waterfront development. . . . The new organization will begin with a membership of 225 business and financial concerns and individuals. . . .
>
> The area is now a daytime enclave of 350,000 employees who disperse at nightfall to other parts of the city or the suburbs leaving the area lifeless except for a few policemen, countless wharf rats and the

residents of the fringe of tenement houses. New housing near the Hudson River would bring a walk-to-work population to lower Manhattan.

The apartment developments, with accompanying retail shops and places of entertainment, would bring round-the-clock activity to the district around some of New York's most expensive real estate.

Positioning downtown for the coming boom proceeded from ground zero as well. Adopting the informal style of a community newspaper, the *Downtown Manhattan Courier* served as David Rockefeller's chief local PR vehicle. An article titled "Form 'Electronic City' in Cortlandt St. Area" in the September 15, 1959 issue recast the consumer electronics district known as Radio Row in the image of the DLMA's upscale plans. Two years later, Radio Row was redlined as the site of the future WTC.

Electronic City as a definite entity in New York, comprising the Cortlandt Street and Greenwich Street Areas, became a reality last month with the organization of a new Chamber of Commerce, Cortlandt and Greenwich Street Retail Merchants, Inc.

With Oscar Nadel acting as chairman, representatives of leading electronics manufacturers, parts distributors, and hi-fi equipment gathered at the Piccadilly Hotel to create a permanent organization for the promotion of the area as a center of electronic equipment. Represented at the meeting were General Electric Company, R.C.A., Philco, Emerson, Zenith and a score of local merchants.

Max Pecker is acting as president and co-treasurer with Leo Marks of World Happiness Company. Julie Davis was made chairman of the executive committee.

The group plans an extensive campaign to create an awareness of the area among residents of the City and surrounding communities.

THE BIG ONE

In 1958, as they sought a respite from fears of nuclear annihilation, American television viewers tuned in each week to watch three attractive young women, roommates in a Greenwich Village apartment, plotting strategies for *How to Marry a Millionaire.* For most New Yorkers, no less than for other Americans, the concept of a million dollars still ranked as the supreme emblem of economic power. The *thousand* mil-

lion dollars David Rockefeller proposed to spend downtown represented a concept almost beyond imagining. But the bold leap from a seven-to an eleven-figure ideal carried with it a certain exhilaration. After all, the greater the payload of dollars invested, the greater the payoff.

In the postwar United States, popular mythology abounded in examples of the healing power of big money, especially when linked to big plans. Had not the millions spent on public works lifted the country out of the Great Depression—modernized, electrified, and fused it into a vast network of suburban utopias? Was not the largesse of the Marshall Plan responsible for raising from its ashes a free and prosperous new Europe to stand against the tide of communism? Weren't even the world's most intractably backward nations racing into the modern era fueled by hundreds of millions in foreign aid?

Like the old saw about the patient who reasons that if one pill is good for him, then the whole bottle will cure him even faster, large-scale urban renewal schemes came with their own prejustified logic. If millions were capable of working wonders, then a billion dollars pumped into New York's decaying historic core promised nothing less than the city's renaissance as the epicenter of the modern world.

David Rockefeller adopted this premise, and he chose his words and symbols carefully. For a society still reeling from the Depression and World War II and now living in the shadow of the mushroom cloud, a billion-dollar plan could be invoked as a generative counteremblem to the destructive potential of the hydrogen bomb. Rockefeller liked to call his vision for the new Lower Manhattan an exercise in "catalytic bigness." But as with any big plan, it needed to obliterate before it could renew.

THE FEDERAL BULLDOZER

David Rockefeller's 1958 billion-dollar Lower Manhattan Plan, from which the twin towers of the World Trade Center would spring, hit at the peak of the national urban renewal movement. In that year Harvard University's Department of City and Regional Planning reckoned that in the coming twelve years, nearly $2 trillion would need to be "expended by public and private enterprise . . . to meet the needs for new construction, rehabilitation, conservation and maintenance" in the United States as a whole. Three years earlier, the Twentieth Century Fund had estimated that $125 billion would be required for the improvement of urban residential neighborhoods alone.

But these staggering figures were, in and of themselves, merely arithmetic descriptions of a massive reshaping of American cities that had begun in earnest with congressional enactment of Title I urban renewal legislation in 1949. The studies signified, in the language of statistical gigantism, the ongoing reign of what historian Martin Anderson, in his book of the same name, called "the federal bulldozer." For more than two decades, well into the 1970s, large sections of American cities where properties were deemed "undervalued" had become fair game for federally subsidized clearance and redevelopment plans. In many cases, these areas included viable—even vibrant—residential, industrial, and business districts.

Renewal legislation placed new, unprecedented powers in the hands of municipal governments and of public agencies like the Port Authority. Typically, renewal projects were initiated by a state, municipality, or public corporation, but private organizations such as the DLMA might also put forward proposals with funding and administration being channeled through local public agencies. Once a project received official approval, the local sponsor then either persuaded the owners in the renewal site to sell their land voluntarily, or it ousted them by invoking eminent domain: the legal mechanism by which governmental bodies are empowered to seize private property for a "public purpose."

The renewal movement brought together often-competing urban agendas. Renewal projects delivered a political bonanza for local officials. Favored constituents got patronage jobs, and the general public witnessed a heroic vision of the future being built in their own backyards. But the movement as a whole constituted a huge public subsidy program for private developers, who generally bought up renewal sites for about 30 percent of what it had cost the city to acquire, clear, and improve them. Renewal provided developers with plenty of incentive to speculate but few if any obligations to make a long-term commitment to the communities they were presumably rebuilding. Very often, plans were drawn up, land was cleared and improved, and for years nothing got built at all. Nor was it unusual for a renewal site designated for one purpose to evolve into something quite different, as the developers angled to maximize the return on their investments.

Foremost among the savvy breed of developers availing themselves of the strategic advantages afforded by renewal financing was the legendary William Zeckendorf. At the height of his career, Zeckendorf was juggling nearly a billion dollars in construction projects in New York, Washington, D.C., Chicago, and Los Angeles. For Zeckendorf, the main attraction of renewal was "maximum leverage": the

smallest equity compared to gross project cost. As his projects peaked in value in the late 1950s and early 1960s, Zeckendorf sold his renewal interests to the Aluminum Company of America. He used the profits to buy properties in Lower Manhattan just west of the financial district at the core of what he was certain would soon become the "New Wall Street."

But though renewal afforded the shrewd developers who worked the system unparalleled opportunities to cash in on the public's nickel, its broader purpose remained that of reconfiguring the city along the idealized lines of regional planning. Thus, it also functioned as "Negro removal"—a cynical contemporary wordplay unfortunately supported in fact. It is generally estimated that Robert Moses, in his dual capacities as chair of the Committee on Slum Clearance from 1948 to 1960 and New York City construction coordinator, displaced more than 100,000 people, 40 percent of them black or Latino, under Title I renewal legislation. Less than 10 percent of those evicted were subsequently found "qualified" to live in the housing built on the sites of their old homes.

According to Moses's own descriptions, an effective tactic for encouraging tenants to "self-relocate" was "spot demolitions," carried out on the site slated for renewal before it had been completely vacated. A wrecking ball crashing through the building next door, he had discovered, often provided holdout tenants with an incentive to pack up and move on. But Moses's methods, however brutal, were not driven by greed. Rather, they emerged from a zeal to improve the city according to abstract ideals.

"He loves the public, but not as people," said Frances Perkins, a longtime Moses associate who had previously served as secretary of labor in the Roosevelt administration. In his purity of purpose, Moses sought to obliterate all evidence that poverty had ever claimed its share of the city. In 1968, as Nelson Rockefeller nudged him into unwilling retirement, he offered this defense of his renewal policies: "The critics say we are bulldozers. Well, bulldozing is just exactly what the ghettos need. They must be ruthlessly torn down and not a vestige of them left to remind us of their infamy."

COLLATERAL DAMAGE

Whether the motives behind any given renewal plan were high-minded or venal, the laws themselves—and in particular the provisions that

streamlined rezoning—afforded whoever invoked them with a fully operational mechanism for transforming one kind of neighborhood into another. On newly cleared land, blocks of old nineteenth-century tenements might give way to vast Corbusian public housing complexes. Or apartment towers might supplant a former industrial zone. All of it, however, was done in the name of improving the life of the communities thus "renewed."

In part due to the distinction, conveniently left hazy, between renewal for the public good and for private profit, many Title I projects fell short of their optimistic predictions. Some failed abysmally, visiting devastating consequences upon the communities they were supposed to revitalize. Even some of the most idealistically conceived renewal plans, untainted by pecuniary motives, at times accomplished results quite at odds with their intentions. Social trauma cannot be quantified, but the economic damage wrought by the renewal movement over the long term was studied extensively, and its effect on small businesses has been particularly well documented.

Eminent domain condemnations mandated payments for relocation costs, but the amount offered rarely proved sufficient to reestablish a displaced business at an equivalent level elsewhere. One study conducted for the federal Small Business Administration in the early 1960s found that many firms in urban renewal sites never relocated at all—they simply folded. The SBA analyzed twenty-one renewal projects in fourteen cities and found that 40 percent of the affected businesses had disappeared.

In an effort to gauge the impact on local area employment, Brown University undertook a study of renewal projects in Providence, Rhode Island, and found that although the majority of displaced workers eventually reentered the workforce, they experienced a decline in earnings. Surviving firms that relocated near their old sites paid about twice their previous rent—a reflection of the increase in property values rippling outward from the renewal area. Another federal study concluded that urban renewal projects were responsible for "destroying small businesses and jobs and contributing to our unemployment problems."

As evidence of the collateral damage mounted, some urban renewal administrators found themselves backpedaling strenuously on their promises of an urban miracle cure. In 1961, David Wallace, the former director of the Philadelphia Redevelopment Authority, admitted that "we have made a botch of urban renewal to date. By and large, people don't understand what we're after—or even what we're talking about. This is fortunate, for if they did, we'd all have to run for cover."

The World Trade Center stands as the enduring monument to one of New York City's last great renewal schemes, though the movement rippled on in fits and starts for a decade after tenants began moving into the twin towers in 1971. That year, photographer Rick Stafford captured this unsigned verse taped to a chain-link fence surrounding a vacant, rubble-strewn lot:

> No war declared
> No storm had flared
> No sudden bomb so cruel
> Just a need for land
> And a greedy hand
> And a sign that said
> "URBAN RENEWAL"

ROCKEFELLERS AND THEIR CENTERS

Against such bleak language of betrayal and abandonment, the Rockefeller brothers counterposed a more optimistic and stirring vision: renewal for the advancement of urban civilization. This ideal had been incarnated firsthand by their father, John D. Jr., when his Rockefeller Center complex replaced eight decaying midtown blocks and the city tore down the Sixth Avenue El, long despised as an eyesore, a noise nuisance, and a barrier to the westward march of high-rent commercial real estate.

Learned at their father's knee, the drive to tame the urban wilderness by assembling superblocks and building "centers"—the United Nations, Lincoln Center, the World Trade Center, and Albany's South Mall—emerged full-blown in the next generation of male Rockefellers. When the time was ripe for the Lower Manhattan Plan, much of it had already been rehearsed in strategic maneuvers elsewhere.

Morningside Heights, Inc., the first renewal program headed by one of Junior's sons, was begun in 1947 by David and lasted for two decades. During the first round of Morningside renewal in the mid-1950s, the bulldozers displaced 6,000 tenement residents of the Harlem neighborhood adjacent to Columbia University to make way for the General Grant Houses, a huge superblock cluster of grim, institutional high-rises.

Next, brother John D. III cleared "San Juan Hill," the neighborhood engraved in the popular imagination as the turf of *West Side Story*'s latter-day Romeo and Juliet. On its ruins were built Lincoln Center and, eventually, Fordham University's Lincoln Square campus, an expansion of Roosevelt Hospital, and several clusters of luxury high-rise towers. Besides the fabled Sharks and Jets, the San Juan Hill renewal displaced scores of small and midsize manufacturing companies and twenty thousand mostly Puerto Rican residents.

A relic of their vanished neighborhood may be viewed on permanent display in the Albany State Museum, in the South Mall complex constructed by brother Nelson in the 1970s. Here, among other nostalgic artifacts of New York's bygone eras, stands a complete barbershop storefront, transplanted intact from Manhattan's Tenth Avenue. Visible through the shop window is a row of white enameled pneumatic chairs set into a checkered ceramic tile floor, leather razor strops hanging from their arms. Jars of pomades, cans of talcum powder, and glass cylinders filled with blue antiseptic line the marble shelf below the mirrors. On a chair against the opposite wall, a copy of the *Police Gazette* lies open, as if dropped there by an invisible customer who at this very moment feels the buzz of a trimmer against the nape of his neck. In the museum hallway, a red and white striped barber pole rotates in perpetuity, advertising the sealed and empty shop.

In the August 1958 issue of *Architectural Forum*, an article titled "Lincoln Center: 'A New Kind of Institution'" extolled the urban wilderness–taming of which John D. III's barbershop trophy stands as a preserved vestige:

> The New York Slum Clearance Committee's plan for the Lincoln Square redevelopment project embraced eighteen blocks of squalid west-side slum territory. ...[In the] construction of the most concentrated, and expensive complex of cultural facilities in the world...neither Barnum nor [movie mogul Michael] Todd could have out-performed Rockefeller and his associates in the maze of fund raising, urban renewal negotiations, and planning operations [for] the $75 million Lincoln Center, heart of the $205 million Lincoln Square redevelopment project. ...Improvements to the area [include] street widenings, parks, and the construction of a municipal garage under Lincoln Center.

The accompanying photograph shows John D. III ensconced at the Century Club consulting with members of his "building committee." The

gathering included Rockefeller family architect Wallace K. Harrison, two insurance company executives, and, perhaps purely by coincidence, a vice president of Time Inc., the publisher of *Architectural Forum.*

Although "catalytic bigness" brought accrued benefits to the clearances for Lincoln Center, a far more urgent task for the Rockefellers lay in the support of their long-term investment in New York's historic financial core. Thus it fell to David, the family banker, to renew the district that Warren Linquist, his most trusted aide, described as "the heart pump of the capital blood that sustains the free world."

In 1962, a year after the completion of Gordon Bunshaft's gleaming sixty-story Chase Plaza, Linquist carried David's renewal message onto the pages of the *New York Times*—then, as now, a potent force in the crafting of public perceptions. The heart of Lower Manhattan, Linquist wrote, needed yet another great pumping chamber—a World Trade Center—for "this great project constitutes the most important single source of continued vitality and progress for New York City and the entire bi-state port area."

THE FAILING HEART

In one respect, David Rockefeller and the DLMA were undoubtedly right. Lower Manhattan was not on a par with midtown. Property values downtown had never bounced back to their peak in the glory days of the pre-Crash 1920s. But was a real estate slump adjacent to the financial district really a threat to the city as a whole? It all depended on whose city you were talking about.

In their 1962 book *Anatomy of a Metropolis,* two Harvard-trained urbanists, Edgar M. Hoover and Raymond Vernon, concluded that as a center of employment, the city was not faring badly at all. They estimated that into the late 1950s Manhattan was generating over 400 times more jobs per acre than anyplace else in the region.

Hoover and Vernon's study quantified the effects of what would later be inelegantly termed "agglomeration": economies that thrive where markets are uncertain, where production is nonstandardized, and where quality design and craft production are decisive factors in the success of a business. New York's industrial quarters had historically provided a fertile seedbed for innovations in steam power, terra cotta, cast iron, electric elevators, refrigeration, and sound recording for movies.

Technical advances in radio, television, consumer audio, and military electronics were hatched, then spread outward from the city's industrial agglomeration. Here, a multiplicity of small and midsize firms were able to survive, and frequently flourish, through cooperation—by sharing space, workers, capital facilities, and a variety of other resources. Producers worked in small establishments with low fixed costs, relying upon the advantages still to be found on some of the less-prestigious blocks in Manhattan's central business district.

One might assume that the city government would have taken measures to preserve and support the conditions favoring such agglomeration, particularly given its capacity to absorb immigrant workers into the job market and stabilize low- and middle-income neighborhoods. But quite the opposite was true. In *Industrial Location,* a 1956 study published by City College of the City University of New York, John I. Griffin found that industrial job loss was directly tied to city policy. Local manufacturers felt that municipal officials were unresponsive to their concerns and seemed not to care that they were being forced out. Despite public declarations to the contrary, city policy set a low priority on relocating displaced manufacturers. In advancing a strategy for retaining jobs, Griffin made the bold suggestion that Title I urban renewal legislation be invoked to earmark rundown areas for new industrial development. But the city's municipal leadership, along with its developers and planners, shared a vastly different notion of what the land and resources of Lower Manhattan should be used for.

NO LITTLE PLAN

David Rockefeller's initial DLMA plan, as drawn up by the renowned architectural firm of Skidmore, Owings, and Merrill, proposed to take two large bites, a total of twenty square blocks, out of the east side of Lower Manhattan south of Canal Street. The plan made its public debut in the October 15, 1958, issue of the *New York Times,* on the front page, replete with a map indicating proposed zoning changes and an aerial photograph showing the Lower Manhattan renewal area dramatically outlined in white.

As would so many *Times* articles to come, the initial description of the plan vibrated with the barely contained euphoria of a DLMA press release.

A billion-dollar redevelopment scheme for lower Manhattan was presented in broad outline yesterday at City Hall. The proposals for public and private improvements would cause radical changes in the 564-acre district, where the tall towers of banking, shipping and insurance offices are fringed and outnumbered by low brick buildings more than 100 years old. The plan calls for the following improvements over a number of years:

- Razing most of the outmoded structures to permit expansion of the financial district and other types of development.
- Closing many of the narrow streets and crooked alleys through the assembling of housing and other industrial sites.
- Widening other streets to create an interior traffic loop.
- Replacing some East River piers with a heliport and small boat marina.

A few historic buildings would be preserved. The plan calls for the relocation of the Fulton Fish Market and the sprawling West Side wholesale produce market.

The city hall meeting had been convened by Manhattan Borough President Hulan E. Jack. Besides Mayor Wagner, other city officials who had been "consulted previously about matters that would require action or approval by their departments" were also in attendance. These officials, no doubt struck by its self-evident virtues, appeared to be "in accord with the general plan." The city government's top ranks were complemented by several of the "business and financial leaders . . . expected to finance some of the private development."

In presenting his plan, David Rockefeller acknowledged that "publication of the proposals was certain to create much interest and some concern among property owners, business men and residents of the area." Adopting the plural pronoun associated with royal proclamations, the banker struck a tone of reassurance toward those who stood to be inconvenienced by the inevitable march of progress: "We realize that all changes bring some hardship. . . . We want to work with you in minimizing any hardship."

But whatever discomfort the billion-dollar plan might cause, the *Times* was prepared to offer it what amounted to a front-page endorsement, noting that "in the present hodge-podge, properties across the street from one another may vary in assessed valuation from $17 to $115 a square foot. Slum tenements, auto-body works, warehouses and

tiny industrial plants are jumbled in the shadows of skyscrapers." Here the *Times* eerily echoed the language invoked by the Regional Plan Association a generation before:

> Some of the poorest people live in conveniently located slums on high-priced land. On patrician Fifth Avenue, Tiffany and Woolworth, cheek by jowl, offer jewels and gimcracks from substantially identical sites. . . . A stone's throw from the stock exchange, the air is filled with the aroma of roasting coffee; a few hundred feet from Times Square, with the stench of slaughter houses. . . . Such a situation outrages one's sense of order. Everything seems misplaced. One yearns to re-arrange the hodge-podge and put things where they belong.

SKIRMISH ON FULTON STREET

Light-headed from the vapors of a billion-dollar redevelopment proposal carrying with it an anticipated deluge of political goodwill, the city's municipal officials wasted little time on bureaucratic trifling and passed the DLMA plan down the line to the Board of Estimate in January 1959. "We recommend," the mayor's committee report read, "that the city government cooperate with the Downtown–Lower Manhattan Association in furtherance of the objectives of their report." Among the committee's members were future Mayor Abraham D. Beame, City Planning Commissioner James Felt, and City Construction Coordinator Robert Moses. The Board of Estimate took two days to give the plan its endorsement.

But virtually blanket support from the city's political leadership and the building industry did not guarantee that the Rockefeller touch would prove any more popular downtown than it had been in Morningside Heights or Lincoln Square, where community groups had battled in the streets and fought with delaying tactics in the courts. In a prefiguration of the protracted struggle that would later take place over the displacement of Radio Row, the first phase of the DLMA's initial plan—widening Fulton Street—ran into an unexpected wall of local merchant solidarity. Mobilizing under the banner of the Fulton Street Association, and publicly supported by Jane Jacobs, several hundred merchants and property owners confronted Borough President Jack at a City Planning Commission session, angrily demanding to know if David Rockefeller would like to have *his* building wrecked. "I am sure," the association's attorney argued, "that if we were to propose

that Pine Street be widened and that a highway be constructed through the heart of the Chase Manhattan Bank . . . members of the Down-town–Lower Manhattan Association would be gravely concerned."

Faced with a barrage of negative publicity, Jack was forced to with-draw the Fulton Street provision of the plan. By successfully resisting, the Fulton Street merchants catalyzed community opposition to another provision of the DLMA master plan: the arterial highway that would have leveled much of SoHo, Chinatown, and Little Italy and resulted in an expressway and slab high-rises from river to river.

But for David Rockefeller and the DLMA, far too much was at stake to abandon the field to a rabble of tradesmen and shopkeepers. Conceding his "enlightened self-interest" in the Fulton Street debacle, Rockefeller took a step back and repositioned the billion-dollar plan. The "superblocks of low business buildings, above the roofs of which would rise tall office towers"—plans that had been so hazily sketched in the initial architectural designs—needed to be refined, sharpened in focus, and invested with an overarching public purpose. Fortunately, David's brother ran an agency that could validate the public purpose of just about anything—even the World Trade Center.

STATEHOUSE, CITY HALL, UNION HALL

When the *New York Times* profiled Julius Caius Caesar Edelstein in 1964, it called him the "Man Behind the Mayor"—the mayor being in-dependent Democrat Robert F. Wagner. Prior to joining the city admin-istration, Edelstein, the son of a Russian revolutionary, had made an eclectic, behind-the-scenes political career that seemed drawn from the plot of a Graham Greene novel. Under Wagner, he served first as executive assistant on poverty and joblessness and later as coordinator of policy planning, a job that placed him literally at Wagner's right hand. According to Edelstein, it was a 1960 municipal report, one that came as a "shock to the city," that prompted the mayor's support for the World Trade Center. Based on new U.S. Labor Department statistics, the best estimate was that New York had lost 200,000 jobs, most of them industrial, in the previous decade.

For the mayor, then, a Lower Manhattan renewal plan, with the trade center as its cornerstone, represented an opportunity to attract jobs to the city and stimulate the sluggish construction industry. But it was the "dawning awareness among political and business leaders of the beginning of a service economy" that gave the trade center an even

more compelling raison d'être. Its emergence on the skyline would broadcast the news that New York had—like Münchhausen yanking himself out of the swamp by his own pigtail—wrenched itself free of the murky industrial past. As they had from the turn of the century into the 1930s, the towers of Lower Manhattan would once again serve as symbols of the financial center's manifest destiny and would secure the city's position as the vital hub of the coming postindustrial world.

In Edelstein's view, the human factor moving the trade center forward was the mutual admiration between these two political anomalies: an "independent" mayor and a "liberal" Republican governor—a bond forged during their negotiations over Lincoln Center. The amity between Wagner and Rockefeller was particularly unusual given that the governor controlled much of the city's cash flow. When open hostility erupted between Nelson and Wagner's successor, independent Republican John V. Lindsay, the customary balance of antipathy was restored. But in the gestation phase of the World Trade Center moment, the Wagner-Rockefeller dyad was augmented by a mutual friend and political bedfellow of both men: Harry Van Arsdale, head of the Central Labor Council. As overlord of a consortium of building trade unions, Van Arsdale could claim, without exaggeration, to control single-handedly the costs and timetables of every major construction project in metropolitan New York.

The support of the mayor and the city's top union boss was doubtless instrumental to the realization of the trade center. But their alliance in and of itself could not have built the World Trade Center. The spectacular towers were leveraged from their foundation in the dynastic power of three generations of Rockefellers—a power based on the bedrock of Standard Oil, the first great industrial-age monopoly. Among their many other layers of signification, the twin towers reflect the fraternal relationship between banker David and politician Nelson, and ultimately between the realms of private and public capital.

Standing side by side—not quite separate yet never merging into one—the WTC buildings divide their singular name in two. Each tower might be the clone of the other. But architecture is as slippery as any other language. It would be a mistake to read the World Trade Center's parallel lines as a sign of equality.

ROCKEFELLER FAMILY VALUES

David Rockefeller professed a lifelong indifference to electoral politics. His intimates, among them the Shah of Iran and Henry Kissinger,

tended not to be men who required a popular mandate for the exercise of their power. When Bill Moyers followed David to Europe in 1979 for a television documentary on the "Chairman of the Establishment," the banker, using the Vatican as a backdrop, spoke of "one world, governed by the logical motive for profit," and "a universal church of money with its own curia." Unlike Nelson, David had never deemed it his mission to wield political power directly; rather, his role was to act as a "banker-statesman"—a consensus builder within the international financial community, facilitating pursuit of its collective strategic goals.

"David's always got an Emperor or a Shah or some other damn person over here, and is always giving him lunches," said Sidney J. Weinberg, former head of Goldman Sachs. "If I went to all the lunches he gives for people like that, I'd never get any work done."

Thus David, though nominally the director of a major New York–based "money center" bank, found his true community of peers among the membership of the Trilateral Commission, the Council on Foreign Relations and the Bilderberg, the World Bank and the IMF— organizations known to view governments primarily as regulatory mechanisms for the flow of capital.

However global their respective economic and political agendas, David and Nelson remained enmeshed in the political life of New York City and the state. And whatever field of operations lay before them, their game plan called for clearly defined roles within the family and the forging of long-term strategic alliances with powerful outside partners.

Both David and Harry Van Arsdale served on the board of Nelson's Urban Development Corporation (UDC), the public agency the governor had created as an alternative strategy in 1968 after voters rejected his slum clearance bond proposals for the fifth time. New oil in the creaky old urban renewal machine, the UDC made mortgages primarily to residential developers and raised cash in the short-term money market, a policy that precipitated its collapse in 1975, shortly after Nelson left office. Called back from Washington to testify before the commission probing the UDC's collapse, Nelson countered accusations of his fiscal incompetence by taking the investigators to task for their crass materialism. "Let's not talk as if we are running a bank," he admonished. "We are running a social institution to meet the people's needs."

Nelson often professed a distaste for banking, an antipathy grounded in personal experience. In the early 1930s he had worked

part-time at Chase while also managing Rockefeller Center. Gore Vidal drew on the insights of one himself to the manor born when he made this trenchant analysis of the division of labor in the Rockefeller family: "Politics was for the ones who weren't very good at business, and the family was terrified to make them president of the company. Nelson Rockefeller took it a little too far, and the family got quite upset because the Governor of New York and the President of the United States, these are people that you hire, that you pay for, and then they do what you want them to do."

Brother David, however, *was* charged with keeping the family fortune—a role that went with being cochairman of Chase, which had long held huge Rockefeller deposits. The extended Rockefeller family owned $70 million of Chase stock, and David was the bank's largest single shareholder. In addition, Chase administered almost all of the family's numerous trusts.

David was born in 1915, the year after his father, John D. Jr., ordered company guards to break the strike at the family's Ludlow, Colorado, mining operation. In multiple armed assaults, dozens of miners and their wives and children were killed or wounded. Popular outrage over the "Ludlow Massacre" prompted the family to pioneer strategies for perception management that have since become standard corporate policy. Beginning with the ubiquitous image of the top-hatted John D. Sr. pressing dimes into the ink-stained palms of impoverished newsboys, Ivy Lee, one of the first great masters of public relations, tirelessly sought to focus media attention on the family's philanthropic largesse.

To a great extent, Lee's strategy worked. If one could not hope to efface entirely the horrific images of children's corpses piled in the trenches at Ludlow, it was nonetheless possible to project a positive counterimage, however contrived. Just as then, today we welcome any sign of hope that the world is not so brutal a place as it seems, and few if any business entities have used charitable giving as a public relations strategy with anything approaching the effectiveness of the Rockefeller family. Among the highly visible institutions the family founded are the University of Chicago, the Rockefeller Institute, Rockefeller University, and the Museum of Modern Art, and their largesse has endowed and helped shape numerous others. In the 1950s alone, under Dean Rusk's tenure, the Rockefeller Foundation spent $250 million burnishing the family image, including its contribution to Lincoln Center.

David's road rules for personal image-shaping were simple and un-varying: Remain an eminence; avoid becoming a celebrity. Seek expo-sure only when it furthers a strategic purpose. Speak for the record only with journalists who consider it a privilege to be in your presence. A comparison of David's and Nelson's biographies speaks volumes— and the lack of them. More than a dozen books have been written about Nelson, ranging along a continuum from excoriating to sycophantic. Only one has been written about his brother, and it hardly reflects the veneration of a loyal scribe. Rather, *David,* William Hoffman's unau-thorized 1971 biography, may be read as a literary prefiguration of Michael Moore's 1987 film *Roger and Me,* since its narrative is orga-nized around the absence of its subject and the author's dogged quest for a dialogue with a shadow figure.

But David was no recluse. He simply insisted on choosing his mo-ments to go public. And on picking his friends, from whom he elicited an extraordinary level of trust and loyalty, manifest in nearly universal and apparently sincere praise. On a frigid winter's day in late 1959, David convinced his friend André Meyer, founder and head of Lazard Frères, to don a hard hat and ride with him to the top of the still-skele-tal Chase Plaza in an open-air construction elevator. For Meyer, the perilous trip to the summit and the "splendid view of New York harbor" from sixty stories up gave him an insight into what made his fellow banker run. "Many people do things because they can't avoid it," Meyer said. "David does them out of sincerity."

Interviewed for a 1965 *New Yorker* article, which appeared just months before the Port Authority demolished the first building on the site of the World Trade Center, Meyer affirmed his devotion. "There's nothing on earth I wouldn't do for David. It's not because he's a Rock-efeller, but because he's the kind of human being you want to do some-thing for. I've never seen him mean. I've always seen him acting with poise and class, and greatness. In this financial jungle, you have all kinds of animals. He's the best." And a competing Wall Street banker echoed Meyer's encomium: "All the Rockefellers have been brought up to love humanity. David just likes people."

And David may indeed have liked Guy Tozzoli. Certainly he would have smiled indulgently in thinking Tozzoli an unvarnished reflection of himself. Though they came from widely divergent backgrounds, the two men shared a similar metapolitical ideal. Tozzoli had learned, in an altogether different school than had the Chase banker-statesman, the value of thinking globally and acting locally. What moved Tozzoli was

the vision of an all-embracing network of trade linking cities globally in a great fraternal chain that would turn the wheels of commerce for the benefit of all.

Born to a working-class family in New Jersey in the 1930s, Tozzoli took a job with the Port Authority in the mid-1950s where he rose through the ranks of Austin Tobin's tough-love meritocracy to head the World Trade Center Department during the clearance of Radio Row and the trade towers' construction. After retiring from the PA in the late 1970s, Tozzoli founded and became president of the World Trade Centers Association. The WTCA is a membership organization of some three hundred real estate developments in seventy-five countries woven into a kind of information-age Hanseatic League. Tozzoli's abiding faith in the beneficent power of global, borderless trade is distilled in this extract from an unedited 1993 promotional video.

> We're like one world. We cut all those borders out. We have no people representing a country. Each Trade Center represents its local city . . . so Taipei sits next to Shanghai and Beijing, and Tel Aviv sits next to Cairo. . . .
>
> When the walls came down in the Eastern bloc countries, people came and said "makes no difference anymore, we don't have to worry about our politics—what we were or what we're going to be—all we want to do is business." We want to create one world with no political boundaries, with people working together to help one another through fair international business . . . to create jobs and work together to keep people living together in harmony.

All in all, not a far cry from David's "one world, governed by the logical motive for profit."

INTERNATIONAL ROCKEFELLER TIME

In 1928, the hoary savants of the New York real estate establishment laughed in their sleeves when John D. Jr. signed what was generally considered a bad lease for the Columbia University–owned land on which he was to build Rockefeller Center. And for a generation and more, the Center bearing the family's name was widely assumed to constitute a chronic drain on its fortunes. But Junior's children persevered and hung onto their interest through all kinds of changing

market weather. In 1988, a year after Wall Street's Black Monday, as midtown values peaked, the family flipped the landmark complex to Mitsubishi Properties for an estimated $3 billion. The Rockefeller Center deal may or may not have been the largest single real estate transaction in New York City history, but it was certainly a masterfully laid trap. When the market hit bottom and languished there for years, the then-bankrupt Center hemorrhaged millions. In 1996, David led a consortium that paid Mitsubishi's creditors pennies on the dollar and again brought Rockefeller Center back into the family sphere.

However questionable the ethical basis of Rockefeller wealth, one overarching characteristic of the family has, from the early years of John D. Sr. and the Standard Oil monopoly, remained essentially beyond dispute. The Rockefellers have demonstrated a highly developed capacity for coordinating complex political and economic maneuvers over long periods of time. Thus the strategies invoked by David and Nelson in their protracted battle for Lower Manhattan existed at a fundamentally different level from that of their adversaries. Their clan had staked its claim in the financial district a generation before most of the Radio Row merchants had, either literally or metaphorically, gotten off the boat.

By comparison with the Rockefellers, Oscar Nadel, the intelligent and charismatic leader of Radio Row, possessed a much more immediate and localized game plan—and an entirely different notion of what business in America was about. In Nadel's scenario, you rented a store in a good location for the kind of trade you wanted to do. You stocked it with merchandise you knew something about how to service. If you thought the window display down the street at East Radio had some style to it, you hired the same guy to do your windows too. Over the years, you sold reputable products for a reasonable profit margin to customers you expected to sell to again. You advertised seasonal sales, upgraded next year's catalog, gradually expanded your product line. You saved to send your kids to college, and if things worked out well, you bought a house in the outer boroughs or suburbs.

Rockefeller power was, by contrast, strategic power. Its model was not the everyday give-and-take of the merchants' new world shtetl but rather the imperial military campaign. It worked by projecting a set of long-term objectives into a wide range of scenarios. On such an abstract field of operation, mobilized wealth and political

connections could be deployed to maximum advantage. The tactical elements of any given plan could always be modified—witness the revisions of the first billion-dollar plan—while preserving wider strategies intact. Rockefeller time, like that of the medieval builders who envisioned the cathedrals they never expected to see completed, was reckoned in multiple generations. Their aggressive impulses thus tempered by enormous patience, the Rockefellers proved adept at minimizing the damage caused by short-term reversals and then moving on.

The Rockefellers' immense wealth and enmeshment in local and national politics, when coupled with such an understanding of space and time, afforded them a range of advantages beyond the reach, or perhaps even the comprehension, of the Radio Row merchants and indeed most of New York's developers and would-be master builders. In the case of the World Trade Center, it enabled the Rockefellers to turn some of their presumptive competitors into allies and to work the game of power up and down the social ladder.

Along with their shares in the family fortune, it was the value of strategic perseverance that David and Nelson inherited from their father and that he in turn had been taught by John D. Sr. In *The Robber Barons*, his classic study of American monopolists first published in 1934, Matthew Josephson described the astounding tenacity that served the brothers' paternal lineage so long and so well. "During forty years, the Standard Oil men marched from trial to trial like habitual felons, before the public was convinced that it was not dealing with the arch-criminals of the age, but with destiny."

FULL NELSON

If, over three generations, a combination of persistence and public relations had largely turned the family's mythos into a force of nature among many North Americans, the sense of Rockefeller "destiny" had not exported so successfully south of the border. When he went on a fact-finding mission to Latin America and the Caribbean in 1969 on behalf of President Nixon, Nelson—who like his brother had presumably been brought up to "love humanity"—often found his affections unreciprocated.

In truth, an extraordinary trail of insurrection attended Nelson's every movement. In the Dominican Republic, a Standard Oil refinery

was blown up. A General Motors plant in Uruguay was burned to the ground. So were nine Rockefeller-owned supermarkets in Argentina. In Honduras, Costa Rica, Paraguay, Bolivia, Colombia, Panama, and Venezuela, students and workers fought pitched street battles with police. Nelson would have met with the president of Chile had not a national strike prevented his visit. In Ecuador, news cameras captured the moment when Nelson's limousine was nearly overturned by demonstrators. But he found a more respectful reception in Brazil, where the government prudently instituted a state of siege before his arrival.

Though Nelson proved a less-than-ideal ambassador of North American goodwill, he nonetheless operated effectively in Lower Manhattan: clearing a path for, building, and subsidizing the World Trade Center. Elected governor in 1958, Nelson stacked the PA board of directors with a mix of family and party loyalists. Among his appointees was Bernard J. Lasker, former chairman of the board of governors of the New York Stock Exchange, a senior partner in Lasker, Stone, and Stern, and a major fund-raiser both for the state Republican party and the Nixon presidential campaign.

Joining Lasker was Gustave L. Levy, another former governor of the NYSE board and a senior partner in Goldman, Sachs. Also aboard was James G. Hellmuth, a seasoned Rockefeller campaigner, treasurer of the state Republican committee, and vice president of Bankers Trust Company. Alexander Halpern, head of Citizens for Rockefeller and partner in a prestigious New York law firm, completed the trade center's praetorian guard. And when the time came, Nelson played an able game of hardball with a recalcitrant New Jersey governor and legislature over the terms of the eventual trade center agreement.

As its planning evolved and, like Topsy, the WTC "just grow'd" to an astounding ten million square feet, Nelson continued to rain the beneficence of imperial governorship on the financially overextended towers. In a flat downtown real estate market, where the vacancy rate was already higher than in the Great Depression, Nelson rented, at rates well above the prevailing market standard, the entirety of Tower 2 as a New York State office building. In 1972, as an army of state functionaries prepared to occupy their warrens in a hundred-plus prairielike floors of the World Trade Center, Nelson was packing his bags—heading for Washington, D.C., and the vice presidency that would cap his political career. He would never realize his dream of occupying the Oval Office. But he had successfully brought to fruition several large-scale building projects of his own, as well as the one he had inherited from his brother a decade before.

The actual moment of torch-passing between David and Nelson occurred in January 1960, when the revised DLMA plan recommended that "the bi-state Port of New York Authority be requested to make detailed studies" for a World Trade Center. Though easing himself out of the picture, David continued to employ his own modes of public address in support of the WTC even after it was placed in the hands of brother Nelson and the PA. That July, a *New Yorker* interviewer, after drawing the banker out at length on the subject of his beloved beetle collection and affinity for modern and "primitive" art, guilelessly inquired about his most exciting current project. David responded that the World Trade Center was "the hottest thing I'm involved in at the moment" and seized the opportunity to expound the virtues of Lower Manhattan slum clearance to the magazine's urbane and influential readership: "This area is now largely occupied by commercial slums, right next to the greatest concentration of real-estate values in the city. In a way, the existence of these slums presents a great opportunity, because they pose a minimum problem of dislocation. . . . I don't know of any other area in the city where there's as good an opportunity to expand inexpensively."

The interviewer then described how David

> handed us two illustrated brochures, handsomely got up by Skidmore, Owings and Merrill, the architects, and we saw that the Center was to include a Commerce Building of sixty floors of offices surmounted by a hotel lobby and ten stories of hotel rooms, with a World Trade Club on top of them; a Central Securities exchange housing the commodity exchanges and ("We hope," Mr. Rockefeller said) the Stock Exchange; a World Trade Mart of shops and exhibit space; and, running under these, a five-ramp, fifteen-hundred-car parking garage. "We don't want to compete with existing office space," Mr. R. said. "We want to provide some new use. A World Trade Center seems logical and it seems logical to have it near the banks that service the bulk of United States foreign trade. . . . The whole Trade Center area covers thirteen and a half acres, of which four acres will come out of street beds. The project has been well received by city and state officials. We've asked the Port Authority to undertake it and decide what major tenants will go in. If this thing continues to catch hold as it has so far, I think that by 1964—when the World's Fair opens—it will be at least in the leasing stage."

David's rosy predictions proved somewhat premature, for despite the enormous momentum driving the trade center plan, the entire project was about to stumble, badly, over an obstacle that its boosters, for all their erudition and political savvy, had somehow overlooked. In the early spring of 1961, David and Nelson and Austin Tobin convened the interested parties for the purpose of gazing, presumably in rapturous accord, upon the new, improved World Trade Center. Entering the room, Governor Richard B. Meyner of New Jersey looked first with intense interest at the renderings of the ideal Lower Manhattan to come and next at the scale model of Gordon Bunshaft's magnificent superblock design for the World Trade Center—the heart of the billion-dollar plan. Then he reportedly shrugged his shoulders, turned to Nelson, and asked, "What's in it for me?" In the ensuing silence, raised eyebrows and darting glances gave way to harrumphs of embarrassment as the collective realization dawned on those gathered that the interests of a sovereignty crucial to the plan's approval had been utterly ignored.

Without Meyner's support and the New Jersey legislature's approval, the plan could not go forward under the Port Authority. Given the stakes—Chase Plaza was to open in a mere two months—it is not difficult to imagine the intensity of the scramble to once again reconfigure the plan, this time presenting Meyner with something he could sell to his legislators and their constituents. Operating with extraordinary speed, the Rockefellers and Tobin repackaged the deal, and in December 1961, Nelson prevailed upon Meyner's successor, Richard J. Hughes, to endorse a plan that the bistate legislatures would enact early the following year.

In the course of reworking the billion-dollar plan, the Rockefeller brothers had neatly divided the Lower Manhattan turf. In gangster-movie parlance, this meant that David got the east side and Nelson the west. Most notably, the WTC had been extracted from the east-side renewal scheme and plunked down a mile across town where it would sit on top of Radio Row. And after decades of shunning railroads as a "bottomless pit," Austin Tobin and the Port Authority had finally bought in. The new World Trade Center was born legislatively joined at the hip to the Hudson Tubes, New Jersey's bankrupt commuter lifeline to thousands of Manhattan jobs. But for Tobin, the prospect of building the trade center justified the almost certain losses he would absorb on the Tubes. As part of the package for New Jersey, the PA would build a transportation center and office complex at the Tubes' terminal in Jersey City. But implicit in the deal, though this could

never be publicly acknowledged, was that New Jersey got what remained of the Port of New York.

Long delayed in their arrival, key aspects of Henry Dreyfuss's "Democracity," Bruno Taut's *Stadtkrone*, and the real estate imperatives of the RPA plan were suddenly moving toward a dynamic convergence atop a single vast Corbusian superblock at the southern tip of Manhattan.

PART II

F I V E

THE COMING THING

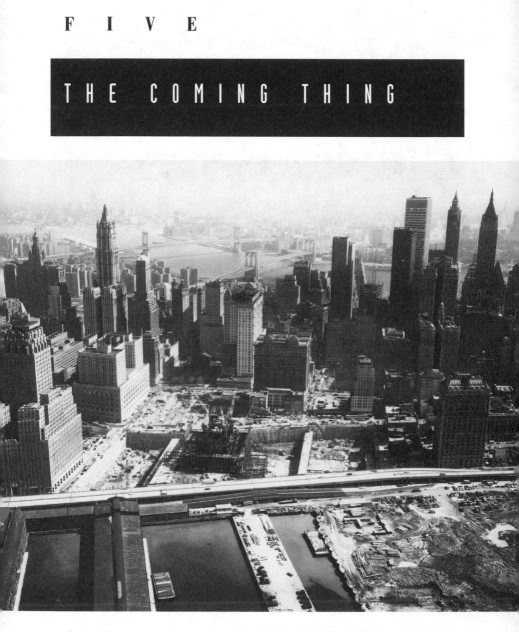

On site: Kangaroo cranes begin to jump above the rim of the bathtub while the giant lily pad serves as a platform for construction materials, c. 1968. Note at center the remaining, soon-to-be-demolished Hudson Terminal twin.

As you were in the middle of writing about "the heart pump of the capital blood that sustains the free world," your laptop computer's hard drive suddenly failed. When something like this happens, the best thing to do is walk over to David Lerner's Tek-Serve, "the old reliable Macintosh service shop," the local clinic famous for its miracle cures, solid workmanship, and fair prices. TekServe occupies a whole floor of an industrial building in the West 20s—the "valley" between the high-rise clusters of the midtown and Lower Manhattan CBDs—traditionally New York City's home to offset-printing shops, garment manufacturers, and the wholesale flower district. As the elevator door opens on TekServe's floor, it triggers an electronic fanfare that announces your entrance: the familiar but highly amplified chord of a booting-up Mac.

David's workshop is a repository—a curio cabinet, really—of contemporary and obsolete technological artifacts: Victrolas, ancient Burroughs adding machines, and oscilloscopes that look like submarine hardware. Waiting clients can dispel their anxiety by dropping dimes into a venerable Coke dispenser loaded with freezing-cold, six-ounce green glass bottles, then sitting down to rock on the porch swing bolted into the ceiling beams. David knows every one of his artifact machines inside out—his first business was designing and manufacturing audio electronic equipment. But the company he was producing for took its production offshore, and today his business thrives on curing the ills of interactive computing gear: from big fruit-candy-colored iMacs to older, gray PowerBooks—the kind that resemble laptop stealth bombers.

David started his business in the early 1990s with a skeleton staff and in a much smaller loft. But TekServe grew apace with the publishing, advertising, and other media industries "agglomerating" in this eclectic mix of buildings—since transformed by the magic language of brokerese into the Flatiron District. Taking its name from Burnham's landmark triangular Flatiron Building on Twenty-third Street at the convergence of Broadway and Fifth Avenue, this area now forms the northern end of Sili-

con Alley, a corridor of information-age enterprises that wends about the spine of Broadway, southward into the heart of the old financial district. Today, as you look around David's loft, about forty young technicians work at long industrial benches, probing the mysteries of good silicon gone bad.

You watch over David's shoulder as he labors to restore some coherence to the scrambled digits frozen inside your computer's memory. Bringing data back from the dead can take time, and time and proximity can lead to conversation. In the intervals between his deftly fielding calls from Mac users in varying stages of meltdown and engaging in dryly humorous shoptalk with his employees, the two of you cover a lot of ground.

"So what's your book about?" he asked, a moment before the "happy Mac" chord sounds and your screen flickers back to life. Stunned to see your vanished text miraculously resuscitated, you pause before responding, but when you speak, David registers a classic double take—one that swiftly modulates his benign expression into an almost accusatory stare. "Are you writing anything about Cortlandt Street before the Trade Center?"

"You mean Radio Row?"

"Yeah. I practically lived down there. Got all my parts out of barrels there when I was a kid." He gestures to a magnetic tuning fork oscillator now used as a paperweight at the corner of his desk. "I bought this at Leeds Radio. It was just south of Cortlandt Street, so the World Trade Center missed it by a block." David is older than he looks.

ILLUMINATION, RADIO ROW

As it turns out, you, David Lerner, and B. J. Jaffe are all roughly the same age. B. J. is a fine-art photographer and photography teacher, and again, your laptop triggered the conversation. You and B. J. used to frequent the same café every morning and nearly always sat at neighboring tables. After exchanging a friendly greeting, she would disappear behind the *New York Times*. Besides "hello," you had little more to say to each other, until one day came the sound of a newspaper being folded up and then, "What are you writing?"

That's how you came to be sitting in B. J.'s apartment talking with her mother Ethel about Radio Row. Ethel's husband Irving, B. J.'s father, had run East Radio, on the corner of Cortlandt and Washington Streets, from 1933 until it folded in 1965. East Radio was small com-

pared with some of the district's better-known enterprises—Heinz and Bollet, Leonard's, and Cantor the Cabinet King—but it was always busy enough to keep Irving and two salesclerks on their toes. And though it stocked mainly radios, tubes, and TV sets—incorporating a watch and jewelry concession—East Radio's catalogue offered a wide range of appliances, from vacuum cleaners to refrigerators and lawn-mowers, that could be ordered from dozens of domestic manufacturers.

Ethel did double duty as East Radio's bookkeeper and holiday salesclerk, and she remembers shoppers coming to the store from all over the tristate area. Thirty-five years after East Radio closed its doors, she still exchanges Christmas cards with some of Irving's old customers.

The way she remembers it, Radio Row was more than a business district. It was an "interchange," a place where competition among merchants was combined with a sense of interdependency, where "if you needed a part or something, you could just go down the street to another store and get it." Prior to the scarcity of consumer appliances brought on by World War II, East Radio, like other stores on the Row, was open six days a week until nine or ten at night.

Besides its electronics and furniture stores, Radio Row was home to florists, fruit and vegetable shops, and restaurants, many supplied by the nearby Washington wholesale market. Irving knew and was on friendly terms with scores of local merchants, from Oscar Nadel and Barry Ray to Seymour Merns, whose discount clothing store—later known by the contraction Syms—moved a few blocks out of the path of destruction and survives today, still affirming its time-honored slogan: "The educated consumer is our best customer."

Ethel attributes East Radio's success to Irving's ability to establish an immediate rapport with anyone who walked through the door. She remembers Irving once talking to a man at length and wondering to herself why she couldn't place him. When the man left after buying a new radio, she asked Irving who his friend was. "Just met him," he replied.

It was Irving who gave Manny Bosky his first job in the window display business. After Radio Row's dispersal, Bosky continued to work for many of the city's electronics and appliance dealers, keeping them up-to-date on the shifting fortunes of their former neighbors. Later, he corresponded with Ethel until his death in 1992, two years after Irving's.

What happened to East Radio? As Ethel tells it, Irving actively joined in the resistance to the trade center. But once the Port Authority's condemnation order was upheld in the courts, he simply went out

of business, as did many of the local merchants. "It would have cost more than we could afford," she says, and Irving felt too old and too rooted in the neighborhood to pick up and reestablish the store elsewhere.

As stores around them closed, Radio Row's businesses thinned, and nocturnal fires and break-ins plagued the area, including several at East Radio. Irving reported the incidents to the police, but the perpetrators were never caught. Ethel is certain that the PA was behind a campaign to harass the holdouts into leaving rapidly. "In the end," she says, "we were pushed out by the goons." Because he chose not to relocate, Irving received no compensation from the Port Authority when East Radio closed its doors.

For several more years, until his retirement, Irving worked as a salesman in an electronics store in midtown. His wife and his daughter watched as, by degrees, he fell into a protracted depression. B. J. recalls that her father's despondency was tempered by his relief that he had been able to put her through college.

Ethel remembers Oscar Nadel, of Oscar's Radio, as an energetic leader, an eloquent spokesman for the merchants and "a fighter against the PA." She credits him with galvanizing local resistance to clearances for the trade center. Then she sighs and shrugs her shoulders. "But how could we fight them?"

ILLUMINATION, WORLD TRADE CENTER LOBBY

May 1993, three months after the bombing. Morning light streams diagonally into Tower 1's plaza-level lobby and across the carpet toward the exhibit celebrating the World Trade Center's grand reopening. Surrounded by a display of large photographic panels depicting the area before and after the coming of the twin towers stands a video kiosk. The talking head on the monitor is Guy Tozzoli, the former chief of the Port Authority's World Trade Center Department, now CEO of the World Trade Centers Association, narrating his tale in monologue, as though responding to an interlocutor whose presence has been edited out.

Listening to Tozzoli's gravelly voice you recall the story his assistant told you about the day that smoke from three hundred incinerated cars filled the stairwell of this tower, and how Tozzoli had led the WTCA staff down seventy-seven floors to safety. Midway through the

seemingly interminable descent, Tozzoli had sensed the wave of panic welling behind him and turned to face them in the darkness. "I built these towers," he said. "I know they won't fall down."

And they didn't. Onscreen, Tozzoli talks about the genesis of his newly reborn towers, about the utopian and speculative drives that pushed them toward the sky, that turned a sixteen-square-block crater in Lower Manhattan into the nexus of an international association of trade centers spanning seventy-five countries. "We were aiming toward one world with free trade. . . . That was our premise twenty years ago," he replies. Then, a short pause as though in response to an unasked question and he averts his eyes for an instant before continuing.

"We were not very happy at displacing people, but to build a project of this size, it had to displace someone. . . . We agreed to give the Radio Row people new business places, so we helped relocate them. It's true we were breaking down a neighborhood of businesses—of old businesses—but those that relocated were more successful than while they were here because more people came to Lower Manhattan." And then, looking directly at the camera, "David really wanted to create an economic development entity in Lower Manhattan that would also be a symbol of international business."

GO WEST, YOUNG PLAN

Before the twin towers emerged from their immense concrete "bathtub" at the shore of the Hudson River, the World Trade Center existed as a shifting vision—a plastic concept that took four years to coalesce into the form we recognize today. It was during this protracted gestation period that the trade center mutated from a superblock speculation specifically mandated for port and international trade functions into a superblock speculation having almost nothing to do with either.

Although the earliest 1958 version of the DLMA plan had called for the removal of the Washington Market from the area north of what is now the trade center, as well as the demolition of the district's "obsolete" structures, it still reserved substantial portions of the west side for manufacturing and other existing uses. It was only later, in 1961, when the deal was struck to link the trade center with the PA's acquisition of the bankrupt Hudson Tubes, that the planning imperative shifted westward and opened up the prospect of eliminating Lower Manhattan manufacturing and the port altogether.

Prior to that, though it had already been placed in the hands of the Port Authority, the WTC remained a creature of the east side. Summarizing its evaluation of the trade center for Governors Rockefeller and Meyner and Mayor Wagner, the PA declared itself "honored to have had the opportunity to make this Study, which, if implemented, can be of enormous significance to the citizens of the States of New Jersey and New York and particularly to the millions of people who depend upon the continued prosperity of the Port of New York for their livelihood."

Operating under the premise that it was "of overwhelming importance to the metropolitan area . . . to its economy and its population, to do everything possible to maintain the pre-eminence of the Port of New York, to insure that increasing amounts of cargo in foreign trade continue to move through the Port, and to make every effort to preserve and enhance the Port's competitive position as a focal point for United States foreign trade," the PA presented the WTC's proposed east-side location—much of which has since become the South Street Seaport Historic District—as particularly advantageous.

The low-rise blocks northeast of the financial core had been "identified by the Association [DLMA] as being appropriate for redevelopment and as presently representing a 'drain upon' the economic health of the area." Furthermore, "the condition of the area is such that, assuming urban renewal assistance, it should be available at reasonable cost." When built, the gleaming new trade center "would command a panoramic view of the great bi-state harbor with its thousands of overseas vessels which annually carry almost every conceivable commodity between the Port of New York and every country on earth."

The PA then argued the necessity of its own role, asserting that

The marginal financial return anticipated from the proposed World Trade Center . . . suggests that [its] successful activation . . . could be undertaken only by a public agency. The very nature of the World Trade Center and its importance to the general community requires that its operation be motivated not by the development of maximum economic return, but by the improvement of the competitive position of the Port to assure its continued prosperity.

As then envisaged, the WTC would serve as a trade facilitation complex par excellence, containing "substantial quantities of space suitable for permanent exhibits" along the lines of an updated European trade fair. Moreover, the trade center would unite under one roof a grand ensemble of integrated commercial activities vital to a thriving

port city: import-export firms, customs brokers, freight forwarders, commodity exchanges, international banks, and a newly transplanted Stock Exchange.

But in the latter half of 1961, when the trade center was linked to the Hudson Tubes and began rolling west, Austin Tobin's public statements began to backpedal on the specifics, compensating with a blizzard of superlatives for the vagueness of the plan itself. However fuzzy it was on details, the PA reiterated that the WTC's objective remained to "centralize at one location a vast number of critically important services and functions relating to the foreign trade of the New York/New Jersey port."

For his part, David Rockefeller lent a timely endorsement to the westward slide. "To me, personally, the new plan seems to offer a number of attractive advantages," he told the *New York Times*. One advantage, pointed out by brother Nelson in the same article, was that on the west side, farther from the financial core, "land would be cheaper." And the new site made sense, given the shotgun wedding between the trade center and the bankrupt New York–New Jersey commuter rail line. Legally melded to the Hudson Tubes—now renamed PATH (Port Authority Trans-Hudson)—the trade center took on an enhanced "public purpose," one that would be used to justify the PA's condemnation of Radio Row.

RUDE AWAKENINGS

Bringing the project under the aegis of the Port Authority had a consequence less visible than the twin towers themselves but equally enduring: The World Trade Center ceased to be a creature of New York City and became instead a ward of the two states. The city lost nearly all financial and legal leverage over an immense real estate development taking shape within its own confines. Though it took some months for Mayor Wagner to fully appreciate the extent to which he had been flimflammed by his friends at Chase Manhattan—and the New York statehouse—he ultimately gave public voice to his dismay.

In February 1962, Wagner complained to the *Times* that enabling legislation for the trade center and PATH would "exempt [its] property, buildings and facilities from New York City taxation" and instead "would authorize payments *in lieu of taxes* subject to negotiation between the Port Authority and New York City"—a potential loss of many millions in yearly revenue. Worse, "the city is not even in a position to turn the proposition down [and] must take it whether it wants it or not.

We want the World Trade project to succeed, but we must be in on the take-off as well as in any crash landings." Wagner might protest, but concretely there was no longer much he could do. However urgently phrased, his demands had no political teeth.

Despite its powerful head of steam and the futility of standing in its way, the coming of the WTC did not go entirely unchallenged by public officials, including eight Democrats in the New York State legislature. In one of the rare statements of opposition that the *Times* saw fit to print, state senator Frank J. Pino of Brooklyn called the enabling legislation the "surrender of sixteen square blocks of the most valuable land in the world" and warned that the trade center would amount to "nothing more than an ordinary office building operation that could be done privately."

Although correct in his first assertion, the senator erred in the latter. The World Trade Center could not have been built privately. No lending institution, not even David's mortgage-crazy Chase, would have risked hundreds of millions on one highly leveraged speculation—that sort of banking would have to wait until the 1980s. Rather, it was the planning agenda of the DLMA, combined with the powers and prerogatives vested in the Port Authority and the political maneuvers of Nelson Rockefeller, that sent the WTC hurtling into the sky.

TOBIN'S MOBILIZATION

In early 1962, over Wagner's belated protestations and the opposition of a handful of state senators and representatives, the New York and New Jersey legislatures passed identical enabling bills and ratified covenants indemnifying bondholders against possible PATH losses. Now legally in the driver's seat, the Port Authority mobilized its enormous institutional machinery toward vanquishing the New York port and raising a Maginot Line of towering commercial real estate on the rubble of its historical core.

Never one to be deterred by community opposition or legal challenges, Austin Tobin, Olympian bureaucrat, had long made a habit— and a strategy—of brushing away lawsuits as though they were so many gnats. In 1960, undaunted by a contempt citation, he had stonewalled a federal congressional committee's request for access to PA financial records. Now, with the trade center officially settled in on the west side and the PA itching to commence demolitions, Tobin earned a sharp re-

buke from New York State Supreme Court Justice Peter A. Quinn. Quinn accused Tobin of having opportunistically interpreted the court's go-ahead to condemn the old Hudson and Manhattan buildings as a green light to exercise eminent domain over the entire trade center site, including many still-disputed properties. Tobin responded as he generally did when faced with any attempt to constrain the PA or render it accountable. He simply ignored it.

Lawsuits seeking to block the WTC were making their way through the courts, but Tobin proceeded as though by divine right: issuing contracts for test borings, promoting Guy Tozzoli to head the World Trade Center Department, and signing on "gothic modernist" Minoru Yamasaki as chief architect, with the firm of Emery Roth and Sons acting as chief engineers and associate architects.

As the trade towers' form unfolded behind the closed doors of the PA, Tobin worked out his strategy for the conflicts to come. Opponents of the trade center ranged along a continuum from the outright rejectionists of Radio Row to politicians (like the mayor) who were angling for a better deal. Given the improbability of his adversaries making common cause—fragmented as they were along economic and cultural lines—Tobin saw, correctly, that they could best be neutralized piecemeal. Thus if the trade center antagonists could not quite be described as fish in a barrel, they could hardly match his fire power.

In addition, Tobin began his campaign in possession of crucial strategic advantages: the backing of powerful financial and political interest groups, ratified by a bistate license to build. Nor did he have to concern himself with facing the electorate's displeasure at the ballot box. Nevertheless, it was important to keep the project as tightly wrapped as possible until it was ready to be unveiled. This meant making sure the PA's line dominated the public discourse—keeping the trade center's detractors permanently on the defensive and scrambling to hold their ever-diminishing ground.

Tobin had not become a public authority titan by avoiding conflicts—he had achieved his power by winning them. And the strategies he now invoked had been learned over decades: in his battles with federal investigators, in authority turf-wars with Robert Moses, and in numerous struggles over displacements for the PA's bridges and its bus terminals in midtown and Washington Heights. To the fight over the World Trade Center, he brought his considerable rhetorical and oratorical skills and a set of strategies so powerful that John D. Rockefeller Senior would have been proud to claim him as a spiritual grandson.

First and foremost, choose your battleground. Confront your adversaries individually—never collectively. Play them off against one another, denying them any material they might use to forge a united front. Make separate peaces. Co-opt some enemies, annihilate others. Exploit the confusion this causes so that eventually those who question your authority come to turn that doubt upon themselves. Lead them inexorably toward the abject condition in which their defeat appears to flow naturally from their own weakness. At every stage in the battle, no matter how indefensible your position, project your will as the workings out of a natural force—your acts as "manifest destiny."

DE-PORTATION

As late as 1965, Tobin was still publicly claiming that "no tenants other than those who are engaged in overseas trade and commerce, and the services which support that commerce, are eligible for occupancy of the Trade Center." But while continually positioning the twin towers as the vertical salvation of New York's maritime commerce, he was simultaneously planning the port's removal to Newark-Elizabeth. Tobin opened what can rightly be called his "de-portation" campaign by leveling his heavy artillery at a sitting duck.

Their legendary corruption and thuggishness cemented firmly in the popular imagination with Marlon Brando's Oscar-winning 1954 performance in *On the Waterfront*, the New York locals of the International Longshoremen's Association had now lost the protection of Tammany Hall and lay wide open to attack. Tobin seized his opportunity to create a smoke screen by blaming labor's intractability for the decline of the Manhattan piers, citing "a tremendous cost burden here at New York" due to the "swollen size of our longshore work gangs, restrictive I.L.A. customs and practices and lack of flexibility in manpower assignments in the Port." Tobin's rhetoric aimed at displacing the PA's culpability for the port's decline onto a deservedly unloved scapegoat while prejustifying the coming surrogate port.

Though Tobin and Mayor Wagner's successor, John V. Lindsay, would soon lock horns over the WTC's paltry compensation for devouring sixteen blocks of the city's tax base, they found a unanimity of interest in concurring that Manhattan had better things to do with its waterfront than support maritime trade or the livelihoods that its ancillary enterprises generated. Elected as an independent Republican,

Lindsay was a banker, and though hardly of the same specific gravity as David Rockefeller, he brought—for the first time since the reform era—an erudite, worldly sensibility to city hall. Like other exponents of the notion that what was good for the real estate market was good for the city, he was disinclined to sentimentalize the decaying piers.

"The Manhattan waterfront is a priceless asset. Instead of being wasted on obsolete functions, it should be opened up to new uses. In addition to passenger shipping, we believe it has great potentials for recreation, commerce and housing." Lindsay's views, as promulgated in the 1969 City Planning Commission's *Plan for New York City*, lent a refreshing, youthful gloss to the hoary patrician values of the 1930s RPA. But beneath the *Plan*'s chic presentation—its pop-architectural language, oversized photo spreads, and stylish multicolored maps—lay an ideology that spoke with less polish but more honesty, as evidenced in this excerpt from an unpublished draft:

> In the long run, New York does not want to retain the low skill, low wage segment of its industrial mix. . . . The displacement of manufacturing activity in the CBD is the complement to the expansion of office construction which results in more intensive land use, higher investments and more jobs than the manufacturing activities they replaced.

Given the directness of his planners' language, it is clear that Lindsay had no intrinsic quarrel with the aims and intentions behind the World Trade Center. What he objected to was getting stuck with the political fallout from the bad deal Wagner had cut on "payments in lieu of taxes" (PILOTs) to the city. From where Lindsay sat, Wagner had folded when he should have bluffed, because the city still retained one significant bargaining chip—a vestige of its long-vanished urban sovereignty. Though the PA had the power to condemn property for a public purpose, the city still held title to its own streets. Without the approval of the City Council and Board of Estimate, the PA could not assemble a superblock upon which to pedestal a gargantuan WTC.

Lindsay's opening gambit in his ante-raising face-off with Tobin took the form of a two-pronged attack. He prevailed upon the City Council to hold public hearings and requested that the City Planning Commission make an independent study of the trade center project. For an official possessed of any less bureaucratic sangfroid than Austin Tobin, the prospect of defending the trade center before the City Council would have been daunting indeed.

The "public" in public authority has come to refer to the amorphous, undifferentiated masses in whose interest the agency purportedly operates. When taken in this abstract sense, the word becomes a substitute for democratic practice. Over the course of its history, the father-knows-best brand of political absolutism to which the PA adhered had generally operated quite invisibly and well insulated from the risky carnival of public debate. But now, as on the other rare occasions that Tobin was forced to appear outside of his self-created Star Chamber, he turned to the task with an almost voracious enthusiasm. In the City Council hot seat, he would be quite visibly confronted by some of New York's most powerful landlords and developers, a contingent of furious Radio Row merchants, and a host of politicians—opportunistic and sincere—all hoping to take him down a peg, if not topple him outright.

In spring 1966, just prior to the first City Council hearing, Tobin began his offensive by voluntarily upping the PA's PILOTs to the city from $1.7 million to 4.0 million. By appearing flexible, even munificent, Tobin blunted the city's strongest argument against the project. Tough negotiations with Lindsay over the final amount of compensation still lay ahead, but the city's dominant political players had been at least temporarily mollified.

Having bought a truce with the municipality, Tobin could now concentrate his fire on the one group of adversaries to which every state or city politician was beholden: the big, established real estate players organized by Lawrence Wein and Harry Helmsley under the banner of the Committee for a Reasonable World Trade Center. The committee also included a few holdout retailers from Radio Row. Though their legal appeals had been nearly exhausted, some merchants still clung to the rapidly evaporating hope of stopping the WTC outright or, alternatively, striking some sort of eleventh-hour deal with a chastened PA.

Despite its bluster, the committee's strategy accepted the reality of some version of a world trade center in Lower Manhattan, and the thrust of its campaign aimed at making the trade towers "reasonable" rather than blocking them outright. For Wein and Helmsley, the key objective lay in protecting their own world-class monolith, the Empire State Building, from economic or symbolic displacement by an over-reaching downtown interloper. As the world's then-tallest building, the Empire State had traditionally served as a projective watermark for the rental aspirations of the entire midtown CBD. The commanding height of King Kong's cinematic Waterloo was of more than symbolic value,

though, since lucrative revenues flowed from its spire's now-threatened monopoly on metropolitan-area television transmission.

But the issue that united Wein and Helmsley with a significant number of New York's entrenched and parvenu real estate barons was the ten million square feet of new Class A office space that the PA was proposing to dump on the downtown market—a move they feared would be followed by the nearly audible gurgle of their midtown tenants draining southward. With its deep pockets, the committee began mounting a campaign of full-page *New York Times* ads accusing Tobin and Rockefeller of doing exactly what they were doing: using a public agency for the purposes of real estate speculation. But the World Trade Center the PA *wasn't* building had consequences as well.

THE A-TRAIN NOT TAKEN

Eight miles north of the council chambers where Tobin would soon testify lived people less concerned with shoring up their midtown rent bases or angling for a larger slice of the PILOTs pie than with the economics of their everyday lives. Among those New Yorkers in whose ears the sound of the coming WTC struck a distinctly dissonant chord were many residents of Harlem, the historic and symbolically charged center of twentieth-century African American life. In 1966, battered by two decades of urban renewal, Harlem's great jazz-age renaissance was rapidly receding into the realm of myth. And like many other racially marginalized communities, a broad swath of Manhattan north of Ninety-sixth Street remained cut off from the benefits of the nation's booming Vietnam-era economy.

Facing a reality on the ground that a presumptive "trickle-up" of downtown wealth would do little to ameliorate, several African American political and community leaders joined forces in a bid to relocate the World Trade Center to 125th Street. In conjunction with several Harlem-based civic and commercial organizations, David N. Dinkins (who subsequently served as mayor from 1988 to 1992) and Percy Sutton proposed to Nelson Rockefeller that he move the trade center uptown, where it might serve, as Urban League chairman Whitney Young Jr. put it, as "an architectural beacon of faith." Supporting their bid, another assemblyman noted angrily that the only public works project planned for Harlem was a sewage treatment plant on the Hudson River.

Not surprisingly, the as-yet-unbuilt twin towers remained moored in the symbolic bedrock of Lower Manhattan. But the Harlem coalition did

succeed in casting in high relief the political ironies inherent in the financial district's billion-dollar shot in the arm. Eventually, as a result of Albany deal-making, 125th Street got the Adam Clayton Powell Jr. State Office Building—for which Nelson claimed extensive public credit—*and* the sewage treatment plant. Later still, a park and playground were built atop the waste facility, complete with a carousel whose fantastical leaping mounts were designed by Harlem schoolchildren. Today, the same lightness of spirit imbues the waterfront esplanade and green lawns of Battery Park City, built on the landfill from the WTC excavations that buried the piers. But before there was a trade center site to excavate, the workings of power, immured behind wealth, legal mandate, and rhetoric, emerged—however fleetingly—into the light of public scrutiny.

TESTIFYING: TOBIN'S EPISTLE TO THE PHILISTINES

History has Mayor John V. Lindsay—operating through the powers of the City Council—to thank for flushing Austin Tobin out of the Port Authority boardroom and into the only public forum to be held on the WTC. Having tirelessly articulated his philosophy of the public good in scores of speeches and position papers over the course of three decades, Tobin now had to make the stultified rabble overflowing the City Council chambers understand in absolutely unambiguous terms the sovereign power of his PA that, even as he spoke, was implacably raising a great vertical port at the Hudson's edge.

Lacking televised gavel-to-gavel coverage, we can only imagine the scene that unfolded on May Day 1966 as Tobin mounted the stand to deliver his opening salvo against his antagonists. But we do have a written record that eloquently conveys the tenor of the moment. The *New York Times* described the Columbia-trained real estate lawyer "gesturing with a clenched fist" as he "icily denied that the Port Authority was a 'super government' that acted independently of state and city officials."

Then, without skipping a beat, Tobin launched into an attack against a pending resolution to halt work on the WTC, turning his testimony into a prospectus for his vision of the future.

> It is clear to us. . . that others have provided you with misleading and
> distorted information. Here are the facts. For more than three centuries,
> foreign trade has been the lifeblood of the Port of New York. The port
> has been the magnet which has attracted the many other businesses
> and industries which made this metropolis the world's largest and made

it prosper as a center of finance, publishing, communications, and the arts.

Today our position as the world's greatest trading center is threatened as never before by competition from other rapidly-developing American ports. If we lose our supremacy as a port, New York's welfare and prosperity in other fields will inevitably be undermined. This situation creates the need for the World Trade Center, one of the most significant port projects which this or any other port has ever seen, an opportunity without parallel to expand the trade horizons of this entire region.

The commerce that moves through this Port is the means of livelihood, directly or indirectly, for one out of every four of the more than twelve million residents of the Port District, and it gives jobs directly to over 400,000 people.

Certainly no one would question the need to continue to promote and strengthen the facilities and institutions of the Port of New York. *This is the sole purpose of the Trade Center,* although it will not be its only benefit. We all recall how Rockefeller Center turned a stagnant Sixth Avenue into the gleaming skyscraper city that it is today. We all recall how the United Nations turned the old gas house district along the East river into a soaring symbol of man's hopes for peace. In the same way, the Trade Center will dramatically revitalize a drab and decaying area of lower Manhattan, and transform it into a magnificent international marketplace for people from all over the world. [Italics mine.]

Tobin then quantified in detail the decline of the Port of New York's share of oceanborne trade and the need, in view of the trade centers springing up in other U.S. ports, to maintain New York's competitive edge. And he firmly rebutted any imputation that the PA bore responsibility for allowing the port to fall into decay.

Lacking the trade center, though, the outlook would be bleak indeed, for

like a securities market without a stock exchange, [port] procedures have been staggering under a load of inefficiency, waste and lost time. The merchandising, financing, insuring and government clearing of our foreign commerce is scattered all over Manhattan. We need an army of foot-slogging messengers to carry documents from the freight forwarders to banks, to insurers, to the consulate, to the Customs House, and back again. Communication by old-fashioned telephone and messenger is primitive compared with the modern communications and data systems and resources that can be made available today.

Further, these resources would be integral to a WTC possessing "the most advanced communications system ever designed for commercial use, matched only by the scope and sophistication of the systems currently operated by the military." This description of the integrative function of the trade center turned out, of course, to be pure hyperbole, or, as the psychoanalysts term it, *pseudologica fantastica*. It is at this point, as Tobin's chronicle so far parted company with reality, that one is left to wonder whether his testimony was genuinely self-delusory or consciously intended to deceive.

> In 1960, the business and shipping interests and the insurance and real estate men who comprise the extensive membership of the Downtown–Lower Manhattan Association revived the idea of a World Trade Center to promote the commerce of the Port of New York. They reported to Governor Rockefeller, Governor Meyner and Mayor Wagner that such a Trade Center would "assist immensely in servicing the constantly increasing volume of international commerce," and that it would benefit not only labor and business in the Port, but also manufacturers, large and small throughout the Port Districts whose products were or could be sold abroad.
> In July 1962, the Corporation Counsel of the City of New York joined the Port Authority counsel in defense of the action instituted by Mr. Oscar Nadel and a group of his fellow merchants on the site to have the enabling legislation declared unconstitutional. Judge Adrian Burke wrote the decision of the Court of Appeals upholding the statute in every respect. In declaring the Trade Center's purpose of "the gathering together of all business relating to world trade" to be a public purpose, Judge Burke noted that "the history of western civilization demonstrates the cause and effect relationship between a great port and a great city."

One can only wonder if Tobin was remotely aware of how soon his own language would come back to haunt him.

TESTIFYING: JUST SAY YES

Tobin had thus far succeeded in transforming a potentially disastrous City Council hearing into a live, marathon infomercial for the World Trade Center. Now, prior to taking on his real estate and merchant adversaries, he invoked a brief interlude of feel-good rhetoric by remind-

ing the council that the PA's plan for clearing the WTC site had won the approval of Herman Badillo, then the city's relocation commissioner.

Claiming "overwhelming public support of the Trade Center," Tobin proceeded to recite editorial endorsements from virtually every regional daily newspaper. *The Journal-American,* which was to fold in less than a month, offered an encomium that rang with the cadences of a Port Authority press release: "Architects, engineers and PA planners have surpassed themselves in designing the proposed WTC. They have achieved a thing of beauty, laid the groundwork for vast new profits and jobs for New Yorkers, and insured our City its dominant role as the capital of world trade."

Behind the phalanx of Fourth Estaters, Tobin had mustered a mighty host of political eminences to the cause, among them the late John F. Kennedy Jr., Secretary of State Dean Rusk, Secretaries of the Treasury Douglas Dillon and Henry H. Fowler, and the secretaries of commerce. By the time the session was over, the council had heard testimony from representatives of virtually every chamber of commerce and business association in the bistate port district, including former Undersecretary of Commerce Franklin D. Roosevelt Jr.

But the ranks of trade center boosters were not composed exclusively of scribes, politicians, businessmen, and bluebloods. Tobin's host incorporated two powerful union bosses, Harry Van Arsdale and Peter J. Brennan, the latter head of the Building Trades Council. After the testimony of these labor stalwarts, it would have been a cynic indeed who doubted that building the WTC constituted the single greatest boon to the working man since the Wagner Act.

TESTIFYING: ROCKY'S WORKERS

While Brennan was testifying inside the council chambers, several hundred of his hard hats massed outside in City Hall Park, waving American flags, roughing up long-haired passersby, and loudly demanding that construction of the trade center begin immediately.

Brennan—who routinely contended that the virtual absence of blacks from his locals was a naturally occurring phenomenon—later threatened strikes and construction slowdowns throughout the city if Lindsay kept stalling on the WTC. During the mid-1960s construction slump, if any members of his constituency fell idle, Brennan kept up their morale by inciting them to assault anti–Vietnam War protesters.

Three years later, as construction activity on the trade center peaked, five thousand members of his labor council would be working at the site.

The other star labor witness on behalf of the trade center was Nelson Rockefeller's crony and personal working-class hero Harry Van Arsdale, whose electricians would soon be up to their ears in time-and-a-half installing the trade center's twenty-seven miles of high-voltage underground cable and hundreds of thousands of miles of superstructure wiring.

Besides Mohawk Indians, who since the 1930s had been workers of choice for high-steel gangs, the few hard hats of color who would help build the WTC owed their jobs to James Haughton, an African American protégé of A. Philip Randolph. As the trade towers moved from the drawing board into steel and concrete, Haughton tirelessly agitated for jobs for black and Latino workers with the PA as well as with the scores of trade center contractors whose employees were almost exclusively white.

"This is a retail operation," said Haughton in 1969 of his negotiations with individual companies. "No other way Black brother's going to get the job. All the executive orders from City Hall, all the compliance officers sitting in their posh offices won't do anything unless you push and push, day after day. But we've got to do a lot better, especially when public tax dollars are being spent. I'm totally dissatisfied . . . with the response of the Port Authority so far."

Under political pressure, the PA eventually awarded two contracts worth a total of $1.25 million to a black-owned electrical firm, nearly half of whose workers were white. In December 1971, as trade center construction wound down, hundreds of white steamfitters staged a wildcat walkout in an attempt to force a contractor to lay off black and Puerto Rican workers. And though the Vietnam War disproportionately consumed Americans of color, only one black foreman would witness the traditional hoisting of the Stars and Stripes to the summit the day the World Trade Center's steelwork "topped out."

TESTIFYING: THE TROUBLE WITH HARRY AND LARRY

But exactly at what floor would the twin towers top out? A lot fewer than 110 if the real estate coalition led by Harry Helmsley and his partner Lawrence Wein had its way. Bolstered by the political establishment, the press, and organized labor, Tobin unleashed a blistering attack on

the pending resolution to halt work based on "misinformation supplied by opponents of the World Trade Center." These opponents were

> guilty of a contemptible imposition on the trust and confidence ex-
> tended to them by members of the Council for the "whereases" reflect
> a multitude of misrepresentations, mis-statements and gross exaggera-
> tions. . . . [They allege] that the WTC "may be a tax exempt real es-
> tate venture by a public authority, which could greatly affect the
> economic life of the City of New York." [This] is disposed of by Judge
> Breitel's opinion in the Appellate Division, an opinion which was af-
> firmed by a vote of six-to-one in the Court of Appeals. Judge Breitel
> said:
> "Such a center is not a private purpose, but a public purpose, so long
> as it is reasonably considered *essential to the life of the port.* It is no
> more a 'real estate project,' as appellants would characterize it, than is
> a State fair or a municipal public market." [Italics mine.]

In Tobin's view, Wein and Helmsley were not just legally in the wrong. They were self-serving opportunists as well, biting the hand of the PA that would soon be feeding them a rich diet of escalating rents.

> It is interesting to note that among the real estate operators and develop-
> ers who have been active in buying and developing downtown office
> buildings in the neighborhood of the Trade Center have been Mr.
> Lawrence Wein and his associate, Mr. Harry B. Helmsley. In fact, the
> brochure issued by Mr. Helmsley and his associates offering space in
> their new building at 140 Broadway features the fact that they will be only
> one block from the new Trade Center.

To demonstrate the aberrance of the Wein-Helmsley position as well as to point out their political isolation, Tobin announced that Robert Tishman (the WTC's future chief builder), Lewis Rudin, and several other large builder-developers would offer testimony that "the Trade Center will be a great and positive factor in the future stability and continued development of Manhattan's office space and the continued commercial pre-eminence of Lower Manhattan."

Tobin had already definitively succeeded in turning a potentially volatile public forum into an opportunity to tighten his grip on the hearts and minds of the city's power players. He had sought to drive home in unambiguous terms—and with a kind of prophetic inten-sity—that the World Trade Center was not a hubristic Babel-on-

Hudson but something on the order of "destiny" manifesting itself in ten million square feet of vertical office space.

But when he called the nakedly self-interested Rudin and Tishman to arms against the equally venal Harry and Larry, he exposed what contemporary Maoists termed a "two-line struggle" dividing the ranks of New York's real estate titans. And despite Tobin's efforts, the speculative underpinnings of the WTC were beginning to narrate themselves in unmediated language on the public record. Unprotected by the scrutiny-proof walls of the PA boardroom, the World Trade Center was, by degrees, revealing its hidden anatomy. Maneuvers begun discreetly in the dark were rapidly culminating as the twentieth century's most spectacular act of full-frontal real estate. Only the fig leaf remained to drop.

TESTIFYING: MOMENT OF TRUTH

As Tobin summed up his case before the City Council—and by extension, the court of public opinion—he moderated the invective he had unleashed against the real estate committee. When it came to dealing with the Radio Row merchants, he adopted the paternalistic tone of one who has exhausted his patience reasoning with obdurate children.

> On May 1, 1962, we established a tenant information office in the center of the site to keep tenants informed and to provide advice and assistance to them in their problems. The Borough President of Manhattan, the City's Relocation Commissioner, its Commerce Commissioner, and members of the Mayor's own staff met personally with the merchants group and with its counsel. All of us were ready and more than willing to help them work out their relocation problems. Among other possibilities, it was suggested to them that they accept the offer of City officials to explore for them the possibility of relocation as a group to the adjacent Washington Street Market area which was already in the process of urban renewal. The City's Commissioner of Commerce and Industrial Development offered to assist them in obtaining advice and financial help from the Federal Small Business Administration. Unfortunately, at that time the merchants were too dedicated to their course of litigating to thwart the World Trade Center project to be receptive to help from either the City or the Port Authority.

Prior to the council hearings, Tobin and other PA officials had steered clear of publicly commenting on their legal conflict with the merchants and confined their statements on the displacement of Radio Row to extolling the virtues of their relocation program. The previous year, Tobin had claimed that "the personalized relocation program will be similar to those successfully carried out by the Port Authority in connection with construction projects at its midtown Bus Terminal. . . . In our relocation for the World Trade Center, the staff of our Relocation Office . . . will maintain constant contact with each occupant to provide him with listings of available space in other areas of the city and assist him with problems which he may have in connection with his relocation." This would presumably result in "a program tailored to the individual needs and circumstances [to be] carried out in time to meet construction schedules."

Seven months after the council hearings, as wrecking crews leveled the trade center site, Tobin would claim that the PA had "relocated more than half of the 310 tenants who occupied the dilapidated buildings in the area." This was, of course, vintage Tobin spin, given that a recently issued City Planning Commission report had estimated that 800 firms and retail businesses occupied the site prior to the WTC's westward slide in 1962. The CPC report noted that "many of the large commercial firms in the more substantial buildings did not wait until title was taken, but moved away as soon as they could make convenient arrangements elsewhere," yet allowed that this was "not an unusual phenomenon in areas scheduled for redevelopment." As of February 1966, less than three months prior to the council hearings, 530 retail, office, and commercial firms still held out on the site where the trade center was soon to rise.

Nonetheless, Tobin brought before the council the glad, if fictitious, tidings that "many of these merchants are already establishing 'radio row' around the Avenue of the Americas, north of 42nd Street," and declared himself "happy to add that discount radio and electronics stores will not lose their neighborhood identity."

Finally, Tobin summarized his case in a series of bulleted points whose logic even the most skeptical council member would find very difficult to resist.

- the Trade Center will dramatically revitalize a drab and decaying section of Lower Manhattan and stimulate the development of the entire area

- in the immediate future, the construction of the Trade Center will provide much needed jobs for construction workers, involving some $200 million in wages with as many as 7,000 to 8,000 workers on site at one time
- the completed WTC will be a place of employment for 50,000 people

And last, but certainly not least,

- the City will receive greatly increased revenues not only from the WTC itself, but *by virtue of the increased values of real estate and the new construction which will result from the Trade Center's transformation of the downtown area.* [Italics mine.]

Thus Tobin had finally done what no one else could have contemplated: He openly spoke the World Trade Center's secret name. In so doing, the head of the agency charged with protecting the region's maritime commerce went on public record endorsing a speculative real estate venture as the highest form of public good.

Tobin, well versed in the law, was no doubt familiar with the doctrine *res ipsa loquitur:* the thing speaks for itself. Succinctly defined, *res ipsa* creates a presumption of negligence when a substantial injury has been caused by an agency or instrumentality under exclusive control or management of the defendant—an injury that in the ordinary course of things would not have happened had reasonable care been used. Would a desperate gambit like the World Trade Center have been deemed necessary, or desirable, if the Port Authority had taken reasonable care of the port?

On May Day 1996, though, what counted was that Tobin had effectively countered the Wein-Helmsley campaign against the trade center and set the agenda for future negotiations with the city. Since the passage of the bistate enabling legislation in 1962, there had been little doubt that a world trade center would, in some form, eventually be built. But now, any lingering questions about the inevitability of the twin towers as they were then conceived had been dispatched outright.

After a half year of bitter wrangling with the Port Authority, Lindsay, pressed on all sides, settled for just over $6 million in PILOTs—$2 million more than Tobin's offer and approximately one quarter of what the city would have gotten from a private developer. And the mu-

nicipality approved the fusing of an area the size of Peter Minuit's entire Nieuw Amsterdam colony into a single vast superblock.

Even as the wrecking balls and sledgehammers took Radio Row apart piece by piece, and the PA excavated with archaeological precision around the century-old cast-iron tunnels of the Hudson Tubes, the merchant organization and the Wein-Helmsley coalition persisted in their legal efforts to close the door on what was now a definitively vacant barn. A hundred yards west, the Lower Manhattan piers disappeared beneath millions of tons of rubble. When the digging was over and the concrete walls were poured five stories down, Moby Dick could have swum laps in the World Trade Center's "bathtub."

THE THING ITSELF

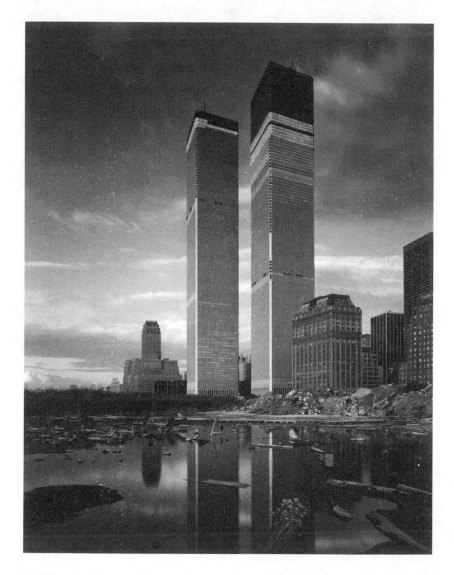

Todd Watts, World Trade Center 3, *1972. From a series commissioned by Minoru Yamasaki documenting his masterwork-in-progress.*

ILLUMINATION, THE OTHER SIDE OF THE WORLD

As you walked up the steps of the U.S. Army Induction Center on Whitehall Street off Bowling Green, you turned and noticed that one tower of the World Trade Center had topped out and the other was taller by a third than the last time you looked. At that moment, with the midmorning sun warming your back and flashing off the first fifty stories of aluminum skin, the trade center resembled a host of other New York towers on the rise, different only in scale.

In those days, if you thought about harbors, they were West Coast ports. If you thought of ships, they were freighters and troop carriers steaming out of the Presidio, bound for Subic Bay. If you dreamed of boats, they were low-draft and plying the Mekong river maze. Some were powered by poles pushed to the river bottom. Others trolled through the reeds, Gatling guns mounted fore and aft. Attuned only to the struggle unfolding thousands of miles away, you never counted tugs at the Battery anymore and only dimly remembered cycling there through the Washington Market and Radio Row. Given the world you were living in that morning, the trade towers might as well have been rising on the moon. But still, you remember asking yourself, *Who built those things?*

TOBIN'S CHOICE

What manner of man was it that Tobin chose to design the World Trade Center? What sort of architectural mind embraced the problem of building a ten-million-square-foot vertical "port"? What kind of imagination articulated the structure tagged as a "revolutionary dinosaur" in *New York Times Magazine* even before it was officially dedicated? Because the subject of this book is the trade center itself, rather than any individual who gave it form, only a sketch of the architect's presence is offered here. But if a tragic history of incommensurable architecture is ever attempted, Minoru Yamasaki will deserve a volume all his own—and not on the strength of his twin towers alone.

By drafting Yama, as he was familiarly known, to be chief architect of the World Trade Cen-

ter, Tobin consolidated his hold over the project and gave it the definitive stamp of Port Authority planning. His choice of Yamasaki constituted a flanking maneuver that bypassed the entire pantheon of enshrined architectural modernists, many of them members of David Rockefeller's "genius committee" for Lower Manhattan renewal: Richard Adler, Gordon Bunshaft, Wallace K. Harrison, and Edward Durell Stone. Tobin also rejected World Trade Center proposals by Walter Gropius, Philip Johnson, I. M. Pei, and Louis Kahn.

To appreciate what his choice of Yamasaki signified, consider briefly the field of talent that Tobin dismissed. Bunshaft was a partner in Skidmore, Owings, and Merrill, and in addition to the previously mentioned see-through bank and One Chase Plaza, he had designed Lever House and, with Wallace K. Harrison, consulted with the PA on Idlewild Airport. Harrison is generally considered to have been the Rockefeller family's house architect. A member of the Rockefeller Center team, he went on to direct international planning for the United Nations, design the Metropolitan Opera House at Lincoln Center, and much of Nelson Rockefeller's Albany Mall. He had also created, earlier in his career, the Trylon and Perisphere buildings (the latter housed Dreyfuss's Democracity) whose futuristic geometry served as the ubiquitous symbol of the 1939 New York World's Fair. Stone, who later designed the Kennedy Center in Washington, D.C., also had longtime ties to the Rockefellers, having collaborated on the Museum of Modern Art. Walter Gropius's Pan Am building (now Met Life) towers over the former New York Central building (now Helmsley Building), which in turn looms above Grand Central Station, curtaining off the vistas of Park Avenue looking both north and south. Gropius had served a favored apprenticeship, along with Le Corbusier and Mies van der Rohe, in Peter Behrens's legendary Bauhaus atelier.

In the end, Tobin delivered the World Trade Center into the hands of a kindred spirit: an ambitious climber with the soul of an engineer. Though Yamasaki claimed that "one can't fit the people who use the building into it in any fashion the architect desires just to suit the exterior appearance," he demonstrated exactly this reverse engineering when the functional demands of the trade towers made it unavoidable. From Yamasaki's drawing boards emerged a heroic, disastrous attempt to reconcile the real estate imperatives of his client, Austin Tobin, with the sculptural aesthetics of his guiding spirit, Mies van der Rohe.

It was a Mies project, and one Yamasaki considered among the "four masterpieces of modern architecture," that he adapted and took to monstrous extremes in his design of the World Trade Center. In *Space, Time, and Architecture,* his "bible" of the modernist ethos, Sigfried Giedion observed that "none of Mies van der Rohe's buildings has had such an immediate influence upon American contemporaries as his two largest and most radical apartment houses at 860 Shore Drive, Chicago." Here, double high-rise residential slabs were "placed in a reciprocal relation such as Mies often repeated later." Giedion noted that since Shore Drive's construction in 1951, "'twin buildings' have become fashionable in the United States—even to the point of distortion (for instance Yamasaki's International [*sic*] Trade Center in New York)."

However much Yamasaki admired Mies for his formal elegance or wished, as he stated in his biography, to emulate Frank Lloyd Wright's serene embrace of nature, his own history belied the myths commonly associated with the patrician architects he idealized. The son of Japanese immigrants—his father worked as a maintenance man in a Seattle shoe factory—Yamasaki was born in 1912, the year before Morgan's bank and the Woolworth Building were completed. In his 1979 memoir, *A Life in Architecture,* Yamasaki described his boyhood in the hostile, racist culture of the northwest coast, where he grew up imbued with a sense of foreignness and targeted as a sissy by his classmates because his mother persistently sent him off to school wearing flamboyant bow ties.

He recalled being barred from a public swimming pool and relegated to balcony seats in movie theaters. When, in the depths of the Depression, Yamasaki entered the University of Washington, his autocratic father demanded that the aspiring architect forgo the seductive diversions of popular culture and put an end to his relationship with his girlfriend—the better to concentrate on his studies. With local jobs impossible to obtain, Yamasaki paid for his schooling by working hundred-hour weeks in Alaska's fish canneries during the summer.

After graduating, Yamasaki moved to New York to take his master's degree at New York University. There he found work in the offices of Shreve, Lamb, and Harmon, the architectural firm most famous for its astonishing time efficiencies in constructing the Empire State Building. Later, he served a protracted apprenticeship at the firm of one of

his idols, Wallace K. Harrison, and a short, unhappy stint in the atelier of industrial designer Raymond Loewy before moving west again for a job with a well-respected Detroit firm. Carefully navigating the domestic minefield of virulent anti-Japanese sentiment during World War II, Yamasaki eventually launched his own partnership. And adhering to his youthful habit of unflagging diligence, he prospered.

By 1962, when the PA approached Minoru Yamasaki and Associates for a World Trade Center proposal, he was presiding over a firm of fifty employees that had recently outgrown its Troy, Michigan, offices. The partnership had also become flush enough to relocate to the swank Detroit suburb of Birmingham where, fifteen years earlier, a bigoted real estate agent had refused to sell a house to Minoru and his wife. But Yamasaki's extraordinary professional rise, and his outsider's drive to assert his presence within the elite ranks of American architecture, exacted a tremendous physical and psychic toll. His marriage verged close to disintegration, and he was plagued with illnesses, including a life-threatening bout with bleeding ulcers. The early 1960s found him struggling to shake off, with characteristic iron self-discipline, a morphine addiction he had acquired over the course of several hospitalizations.

No setback slowed Yamasaki down for long, though, and with dozens of workmanlike, solidly engineered—and increasingly vertical—projects under his belt, he had, through sheer force of will, attained a position where he could successfully compete against the forty other architects who submitted proposals to design the WTC. For Tobin, two decisive factors recommended Yama to the task. First, he was no modernist prima donna. His track record showed that he was capable of putting his client's needs ahead of his ego. More important, he was an engineer with a reputation for diligence above and beyond the call. In addition, Yama's hunger for grand achievement, bubbling beneath his self-effacing manner, harmonized well with the PA's internal myth of a band of incorruptible professionals sublimating their talents in the cause of public service.

For Tobin, artful, high-modernist aesthetics could be no more appropriately applied to the World Trade Center than to the design of the PA's bridges, bus terminals, or freight facilities. The great vertical port was not being built to impress its beholders as either an artistic statement or an act of vanity. Through their visual drama, the trade towers were to serve as an emblem of the PA's time-honored institutional culture—a monument to a half century's worth of projects diligently planned and effectively engineered.

But in its unprecedented scale, as much as in its speculative nature, lay the seeds of the trade center's hubris. In the split center Yamasaki designed, the architect's goal of creating a zone of "rational" serenity clashed sharply with the draconian specifications laid down by the PA. Further, Yamasaki's own contradictions revealed themselves every time he resorted to spoken or written language. When he first visited the trade center site, he thought it "very fortunate that there was not a single building worth saving" among its "tiny, irregular blocks," filled as they were with "radio and electronic shops in old structures, clothing stores, bars and many other businesses that could be relocated without much anguish." In a letter to Tobin written shortly after he was hired, Yamasaki envisioned

a beautiful solution to form and silhouette which fits well into Lower Manhattan and gives the World Trade Center the symbolic importance which it deserves and must have. In my opinion, this should not be an over-all form which melts into the multi-towered landscape of Lower Manhattan, but it should be unique, have excitement of its own, and yet be respectful to the general area. The great scope of your project demands a way to scale it to the human being so that, rather than be an overpowering group of buildings, it will be inviting, friendly and humane.

YAMA, ARCHITECT OF TERROR

The World Trade Center was Yamasaki's most prestigious, highly visible commission. Its would-be levelers were, presumably, a band of terrorists who packed a van with explosives and detonated it in the basement garage. Their intention was to blow out the supporting columns along one wall of Tower 2, causing it to keel over and topple against its twin. Yamasaki had engineered his towers to withstand the force of a 747 shearing into them—the nightmare scenario of an earlier, more "innocent" era—and though shaken by the February 1993 blast, his squared-off tubes remained standing. Six people died, but scores of thousands might have if the columns had failed. Though the terrorists had used sufficient explosives to do the job, according to Eugene Faso, the Port Authority's chief engineer, they had built "the wrong kind of bomb."

Twenty years before, on July 15, 1972, another Yamasaki project—the one that had made his reputation as an architect—*was* successfully

blown up. At a signal from the mayor of St. Louis, demolition experts imploded the massive Pruitt-Igoe public housing project. The spectacular demise of the buildings the mayor had called "a complete and colossal failure" was cheered by thousands who had experienced the project's terrors firsthand. Since then, hundreds of buildings based on the Pruitt-Igoe model have been destroyed by municipal officials in cities across the country, in a continuing wave of public housing demolition, now proceeding under the auspices of a federal program ironically billed as Hope VI.

When the project was built in 1955, Pruitt-Igoe's experimental high-rises earned Yamasaki several prestigious awards and a laudatory article in *Architectural Forum.* By the time it was dynamited seventeen years later, the project had become an internationally recognized synonym for catastrophic urban design. Yamasaki himself confessed that the project was "one of the sorriest mistakes I have made in this business." But the architect disclaimed responsibility for the shortcomings of his design, since "social ills can't be cured by nice buildings."

Pruitt-Igoe's short and troubled life has been the subject of much scrutiny by urban planners and those concerned with the wider cultural function of architecture. In his book *Defensible Space: Crime Prevention and Urban Design,* planning critic Oscar Newman concluded that Yamasaki's fatal design error lay in his concern with "each building as a complete, separate and formal entity, exclusive of any consideration of the functional use of grounds or the relationship of a building to the ground area it might share with other buildings. It is almost as if the architect assumed the role of a sculptor and saw the grounds of the project as nothing more than a surface on which he was endeavoring to arrange a whole series of vertical elements into a compositionally pleasing whole."

Of course, the implosion of Pruitt-Igoe has made Newman's allegations untestable, but you need only stand for a moment in Austin Tobin Plaza to become immediately and keenly aware of how Yamasaki's abstract sculptural ethos achieved a kind of chilling perfection in his World Trade Center design. Here you find yourself in the presence of two monumental structures whose formal relationship gives no indication of their purpose or intent. You know they are office buildings, yet their design makes it nearly impossible to imagine that they are full of *people.* It is at this point that—even without invoking the optical trick of standing at a tower's corner and looking upward—you realize the trade towers disappear as sites of human habitation and reassert their power at the level of an aesthetic relationship. And it is through recog-

nizing this process that you may become uncomfortably aware of a kindred spirit linking the apparently polar realms of skyscraper terrorist and skyscraper builder.

This analogy between those who seek to destroy the structures the latter thought it rational and desirable to build becomes possible by shifting focus momentarily to the shared, underlying predicate of their acts. To attempt creation or destruction on such an immense scale requires both bombers and master builders to view living processes in general, and social life in particular, with a high degree of abstraction. Both must undertake a radical distancing of themselves from the flesh-and-blood experience of mundane existence "on the ground." Gaston Bachelard observed in *The Poetics of Space* that attaining such a state requires one to manufacture a "daydream": a reverie in which one observes others as they "move about irrationally 'like ants.'" Separated from "the restless world" of the here and now, the daydream world offers up the "impression of domination at little cost."

For Bachelard, the design of the tall building demands, as the price of its extreme verticality, the sacrifice of a "dream cellar." The skyscraper fails to make room for the volatile urges that raised it so that they may be explored, acknowledged, and integrated. Such structures remain, in Bachelard's term, "oneirically incomplete"—robbed of space for the language of the unconscious. Thus our city of towers stands condemned to communicate only one side of the dialogue—it transmits messages of a "purely *exterior*" value alone.

Through building and inhabiting our towers, we push ourselves toward a break in connection with the stuff of our own humanness. For Bachelard, the skyscrapers' elevators "do away with the heroism of stair climbing. . . . Everything about [them] is mechanical and, on every side, intimate living flees." For the terrorist and the skyscraper builder alike, day-to-day existence shrinks to insignificance—reality distills itself to the instrumental use of physical forces in service of an abstract goal. Engulfed by their daydream, they are "no longer aware of the outside universe."

In February 1993, the World Trade Center's vulnerable basement garage became host to a superheated rush of fast-moving air that blew a crater five stories deep, burying its subterranean control systems under thousands of tons of rubble and flooding its ventilation systems and elevator shafts with the toxic vapors of several hundred burning cars. A traumatic event of this magnitude, with its horrific loss of life, opens up disquieting questions of how we have come to build and live in structures we are powerless to defend.

How might Yamasaki have created a "defensible" World Trade Center? According to Newman, he would have had to adopt "building forms and idioms which avoid the stigma of peculiarity that allows others to perceive the vulnerability and isolation of the inhabitants." This approach, however, would hardly have resulted in the sort of building Tobin had in mind when, via PA design chief Malcolm Levy, he ordered Yamasaki to make the World Trade Center "a project that would be noticed." But prior to and after the World Trade Center, Yamasaki designed numerous buildings that bore the stamp of his internal contradictions writ large.

Besides Pruitt-Igoe, Yamasaki's other early high-profile commissions included air terminals in Dhahran and St. Louis (he won an American Institute of Architecture award for the latter) and student centers for Wayne State University in Detroit and Pahlavi University in Tehran. By the early 1960s, Yamasaki was gravitating deeper into the realm of corporate patronage and cutting his teeth in the heady world of high-rise office engineering. And he was articulating, as discrete projects, the columnar towers and blocky low-rise companion structures that he would bring together in the WTC.

"A Temple of Insurance" is how the article in *Architectural Forum* described Yamasaki's 1964 headquarters for Northwest National Life in Minneapolis. A massive, horizontally oriented, Lincoln Center–style structure faced with Gothic arches, Northwest National prefigured the design of the low-rise buildings that occupy the eastern corners of the WTC site. For the trade towers themselves, Yamasaki elongated the square column he designed for Consolidated Gas in Detroit. The Consolidated tower was cited by critic Charles Jencks as a prime example of "high camp" because its squared-off top was surmounted by an immense stylized crown of blue flame. In his reliance on a single spectacular detail, Yamasaki anticipated Philip Johnson's "Chippendale" AT&T headquarters by fifteen years. For Jencks, Yamasaki's "attempt to transform urban realities into a nostalgic dream of a classical past" resulted in " 'failed seriousness' at its best—most horrible."

With the Consolidated tower, Yamasaki's trajectory began moving steadily skyward, and *Architectural Record* quoted the architect's own interpretation of his project, titling its article "Yamasaki's Expression of 'Aspiring Verticality.' " It was not long before Yamasaki found himself fulfilling his most vertical aspirations. But in commissioning him to design the World Trade Center, Tobin was not granting Yamasaki a license to fail at seriousness. The towers he designed to represent the

Port Authority are kitsch-free, and if they can be read as an architectural joke, they are the city's grimmest and most unwitting.

After completing the WTC, Yamasaki took his penchant for high-rise engineering home to Seattle. Returning in the early 1970s as a local hero, Yamasaki accepted a commission to design new headquarters for the Rainier Bank. If the World Trade Center stands as his distorted interpretation of Mies van der Rohe, the Rainier Bank tower took to new extremes the injunction of his other hero, Frank Lloyd Wright, to "destroy the box." In Seattle, Yamasaki stood a conventional skyscraper on its head. The bank tower's forty-story squared-off bulk rises above a base that tapers in width by more than half as it meets the ground.

Approached from any angle, the Rainier Bank imparts the frightful impression that it is about to tip over. So threatening was Yamasaki's darkly hilarious inversion of architectural order that *New York Times* critic Paul Goldberger titled his 1975 review "Seattle's Balance of Terror" and observed, eighteen years before the trade center blast, that the building resembled a "giant inflatable form that has just blown out from beneath the earth's surface." In the Rainier Bank, Yamasaki had designed a mad bomber's dream tower—a soaring skyscraper with no visible means of support.

The World Trade Center stands at a chronological midpoint in Yamasaki's career—between the imploded Pruitt-Igoe and the perennially terrifying "balance" of the Rainier Bank. Yamasaki's multifarious projects offer a body of work too refracted to be encompassed by the word *vision*. Yet in his public statements he continually struggled to articulate a unified philosophy of design, normalize his architectural contradictions, and assert the utopian sentiments animating his work.

While still in the process of designing Pruitt-Igoe, Yamasaki told an interviewer from the American Institute of Architects journal that humane, low-rise architecture "within the framework of our present cities is impossible to achieve. WHY? Because we must recognize social and economic limitations and requirements." Yet despite these constraints, "man needs a serene architectural background to save his sanity in today's world," and "an architecture to implement our way of life and reflect it must recognize those human characteristics we cherish most: love, gentility, joy, serenity, beauty and hope, and the dignity and individuality of man. This idea in its essence is the philosophy of humanism in architecture."

And what to make of Yamasaki's credo, espoused in *Architectural Forum* in 1958—the same year David Rockefeller's soon-to-be-dwarfed Chase Manhattan slab topped out?

> I learned that good architecture makes you want to touch it. The Taj Mahal
> made me want to touch it, Corbu's Chandigarh [temple complex] didn't.
> And I learned that behind beauty there has to be a cultural concept. Now
> the Taj Mahal is so wonderful that it makes your hair curl, even when you
> know that the walls have to be 12 feet thick to hold it up; *there's a cultural
> concept supporting it.* What I decided to do, the only thing I would get fun
> out of doing, was the beautiful thing; *beauty through structure and technol-
> ogy, because that's* _our_ *culture.* [Italics and emphasis in original.]

Was Yamasaki correct? Had "our culture" become an exercise in "beauty through structure and technology"? If so, Tobin and Yamasaki were preparing to deliver up one of its most uncompromising icons.

THE SERENE REPUBLIC OF LOWER MANHATTAN

However much Tobin and his subordinates desired that the World Trade Center be "noticed," they had remarkably little to say about its architectural content. Many of Tobin's public statements treated the towers less as actual structures than as futuristic harbingers of the coming millennial cityscape of "hundred-story skyscrapers on sites of two or more combined blocks, mostly in lower Manhattan and in the midtown area." Thus the "first buildings of the 21st Century" emerged from Tobin's rhetoric swathed in an abstruse fog of "grace and beauty" that served to deflect attention from their cyclopean scale.

> From the beginning of our work on the Trade Center, we had determined
> that, despite our tremendous space requirements, the Center should be a
> thing of grace and beauty that would enrich the lives of all who lived in it
> and visited it, and of which we could all be proud. These criteria were
> given to Mr. Yamasaki and the Roths in our first conversations with them.
> And when Yamasaki began to design the wide plazas and then, to meet
> our space requirements, to throw his towers toward the sky, we knew that
> our objective of a beautiful, as well as functional complex of Trade Center
> buildings, was going to be accomplished.

Though many PA statements followed a predictable pattern, re-ferring to the towers in vague, grandiose technospeak, a parallel

strain of nostalgia revealed itself in the agency's emphasis on the trade center's most visible ground-level element. Tobin lavished much descriptive attention on the plaza that would eventually bear his name—even when preaching to such unabashed advocates of the super-skyscraper as the membership of the Building Trades Employers' Association: "The two great towers of the Center are 1,350 feet high and 209 feet square. They will rise from a very large open plaza about five acres in extent—that's about as large as the Piazza San Marco in Venice. And like that lovely plaza in Venice, it will also be surrounded by a great square of low-rise plaza buildings, beautifully designed."

Tobin made reference to the much-beloved spatial qualities of Venice's market square on numerous occasions, perhaps in an effort to domesticate a project that defied all previous notions of scale. The trade center's plaza, for example, is actually *three times* larger than Piazza San Marco. Ironically, Tobin's language served to tie the WTC to a maritime culture and bustling street-level commerce that more resembled the Lower Manhattan he was plowing under than the one he was building. In architectural form, Yamasaki's towers referred more pointedly to the looming fortified towers of San Gimignano than the cityscape of the Serene Republic.

Initially, before the Vista Hotel abruptly curtained off the view, the WTC plaza did provide one genuine public amenity: a wide swath of harbor offering an unobstructed view of the Statue of Liberty, framed by the twin towers. This feature was perhaps the World Trade Center's closest link with Venice, for Yamasaki's elongated square pillars recalled, even in their absurd distortion, the fabled columns of the Molo—which for centuries had acted as a symbolic portal onto the lagoon and, beyond it, the life- and commerce-giving sea.

Whatever motives underlay the Port Authority's Venetian romance, it was the PA's dictate of extreme functionality that in the end determined the trade center's form. In 1964, soon after the design was made public, *Architectural Forum* noted that "the plaza was central to Yamasaki's thinking from the first," since it was upon this tabula rasa that "the hundred-odd schemes he developed with models before settling on the tall twin towers" would be raised. Among the scores of alternative ideas Yamasaki discarded were a series of lower towers that he thought "looked too much like a housing project" and a single, huge, 150-story shaft that was "simply too big."

In the end, adept as he was at papering over the most insupportable contradictions, Yamasaki solved, if only in his own mind, the riddle of how to render ten million square feet of vertical office space on

a "human scale." The same logic of disarticulation that had allowed Yamasaki to sever the formal relationship of architectural elements from lived experience at Pruitt-Igoe held true when—after months of struggling to fit a form around the gargantuan footage demanded by the PA—the architect arrived at the conclusion that "what really matters in Manhattan is the scale near the ground—it doesn't matter . . . how high you go. So I concentrated on providing human scale—a broad plaza, arcades, restaurants and fountains."

COUNTING TO ONE HUNDRED AND TEN

After arriving at last at a design that resolved—at least on paper—the World Trade Center's formal demands, the Port Authority proceeded to execute a stunning feat of engineering that awestruck commentators and PA press releases frequently described as a "miracle." That this presumptively divine manifestation had mortal origins of a sweatier, bloodier, dustier, noisier, and more dangerous nature made it no less astonishing. First, an army of workers reinforced by heavy machinery flattened the preexisting structures, and the ruins of Radio Row were carted a few hundred feet westward and dumped into the Hudson River.

Next, employing an experimental technique adapted from the construction of the Milan subway system, PA structural engineers supervised the pouring of a three-foot-thick concrete wall, seventy feet deep and tied to bedrock with steel cables, around the WTC's five-hundred-by one-thousand-foot perimeter. With river water and surrounding earth now held at bay, excavators began removing material from the giant "bathtub," unearthing in the process several eighteenth-century ship hulls, the remains of a pottery factory, and abundant detritus of day-to-day colonial life.

A critical aspect in the foundation work was the shoring up of the Hudson Tubes. So painstaking was the PA's excavation around the ancient cast-iron tunnels that for the duration of construction, while work went on all around and above them, passengers in the Tubes did not experience a single significant disruption in service. All the while, thousands of tons of debris were accumulating in a new landfill "beach" that from the air resembled a gargantuan square lily pad floating by the riverbank. With excavation completed, the heavy steel plates underlying the tower columns were bolted into the bedrock and the basement floor slabs installed.

Then the spectacle of high-steel engineering emerged from underground. Huge, specially designed hydraulic "jumping kangaroo" cranes cantilevered the towers' steelwork floor by floor. By the end of each week, Old Glory had edged a notch further toward the stratosphere, charting in H-beams the progress of the towers' massed columns. Initiated as a Florida developer's fantasy of a modern medieval trade fair, the World Trade Center had been successively shaped by David and Nelson Rockefeller, Austin Tobin, and Minoru Yamasaki. Now the process belonged to structural engineers and four thousand construction workers—among them a man who, like the trade center itself, exemplified the city's shifting fortunes, its contradictions, and its powers of self-reinvention.

Operating out of a construction shed tagged with "Nixon's the One" and "Bomb Hanoi" graffiti, Carl Furillo, a former right fielder for the Brooklyn Dodgers and master of the 300-foot throw to Roy Campanella at home plate, spent three years shuttling from the trade center's basement to its ever-rising summit, installing two thousand Otis Elevator doors. Fired by the Dodgers after a leg injury in 1960, Furillo sued to collect the $21,000 the ball club owed him on his contract. For his temerity Dodgers management branded him a "Bolshevik" in the press, and Furillo, then recovered from his injury, found himself blacklisted from professional baseball.

Just as the Dodgers were cementing their new identity as a Los Angeles team, the twin towers began their ascent on the New York skyline. For Furillo, in his new career, the coming of the trade center meant steady, well-paid work. But after the job was over, Furillo had no intention of continuing to live in the city of towers he had helped build. Already he had moved his family to rural Pennsylvania. Furillo planned to retire there, near where he had grown up, and spend his days hunting and fishing.

Furillo's dream of an Arcadian future is not difficult to imagine, given the harsh conditions he worked in. The day Roger Kahn interviewed Furillo for *The Boys of Summer*, his 1972 homage to baseball's charismatic individualists, wind was "slamming across the Hudson, blowing bits of debris from unfinished floors. . . . And the sprawling site had acquired the scarred desolation that comes with construction or with aerial bombardment. The sun gleamed chilly silver. It was 11 degrees and getting colder."

This buffeting by natural forces was paralleled by an onslaught of social energies at their most violent and extreme. Dozens of mysterious fires broke out around the site. Several bombs—including one that

blew a Tishman company trailer to smithereens—were set off, apparently by disgruntled subcontractors. Over the course of construction, the WTC racked up several times its expected quotient of injury, death, sabotage, and corruption.

But besides acting as a lightning rod for destructive forces, the trade towers also evoked attempts to locate some sense of the "human" within—and in relationship to—their overawing presence. As construction activity peaked, a *New York Times* story offered a breezy account of two attractive, unmarried PA nurses seeking potential mates in this "husband-hunting paradise." Once the towers were built, their mass and austerity repelled any such facile attempts at domestication. Instead, they inspired heroic, and at times lunatic, efforts to reaffirm Yamasaki's ruptured covenant with human scale. To some, the trade center's immensity beckoned as an invitation to play out a dangerous, exhilarating game.

Among those rising to the implicit challenge was George Willig, a toy maker and urban mountaineer. Willig saw no percentage in riding Carl Furillo's elevators to the top of the World Trade Center. Instead, he contrived a less expedient but more dramatic means of making his ascent. For hours a rapt crowd watched from the plaza as this "human fly" used homemade climbing equipment to inch his way up Tower 1's facade to the summit. In 1972, a daredevil skydiver made a bull's-eye landing atop Tower 2, and an unemployed construction worker, protesting the plight of the world's poor, parachuted off the other, landing safely in Austin Tobin Plaza. And in August 1974, the legendary aerialist Philippe Petite accomplished what no one else could have: He brought the towers together—at least in the mind—braving fierce gusts of wind to walk a narrow wire across the chasm between them and into the arms of waiting Port Authority police.

But before the WTC was visited by these spectacular acts of heroism or folly—or came to house a small city of office workers—a vast tide of money had coursed around and through the trade center's worksite, perfusing every square inch of concrete and steel and seeking, as always, its own version of human scale. While the PA awarded hundreds of millions of dollars in contracts to Borg Warner, Pacific Car and Foundry, and Otis Elevator, one enterprising electrician—subsequently convicted of graft—pocketed $76,000 in overtime.

At last, after seven years of building, the irresistible force of a billion dollars had leveraged millions of hours' worth of human labor into the world's tallest buildings, sheathed in glass and aluminum—and waiting to be touched.

Alongside the flesh-and-blood steel and concrete towers grew a parallel structure: the World Trade Center as a narrative for public consumption. The pile drivers at the Hudson's shore now shared a formal relationship to a rising WTC of language. Atop the foundation laid down by David and Nelson Rockefeller, Austin Tobin, and Minoru Yamasaki, this narrative trade center was constructed by numerous authors in dozens of newspapers and periodicals. Though initially much of this parallel trade center emanated from architecture journals, the role of general-interest reporting, particularly the coverage provided by the *New York Times*, was sufficiently important to be taken up shortly in its own right.

Initially, the unveiling of Yamasaki's grand design seems to have induced in several influential critics a mood bordering on euphoria. Early commentators frequently echoed some version of Tobin's spin, breathlessly extolling the trade center's linkage of futuristic engineering to the venerable traditions of San Marco Square. The generally sober chief critic for the *New York Times*, Ada Louise Huxtable, called the twin towers a "breakthrough in terms of New York's architectural trademark—skyscraper design," though she would later substantially revise her opinions. At first, though, Huxtable went so far as to proclaim the WTC the bellwether of a "second great period of the skyscraper because the two factors that have limited the height of the tall building until now—construction cost and elevator space—have been solved." Ann Holmes, fine-arts editor for the *Houston Chronicle*, described the proposed trade center as "a stunning creation," whose "soaring metallic structures will be clean but not sterile: its plaza at the base . . . surrounded by buildings and galleries, reminiscent again of Italy."

But the towers' design by no means elicited universal enthusiasm. *Los Angeles Times* critic Wolf von Eckardt sourly predicted that New York's skyline "will be rudely disrupted by Yamasaki's double intruders which are straight and stark and simply sawed off at the top. They'll stick out like that unspeakable perpetual slab in the middle of Boston [the Prudential Center] which dominates everything in a 30 mile radius." And Russell Baker dryly observed that the towers "seem to go on and on and on endlessly in the upward dimension, as though being constructed by battalions of exuberantly unstoppable madmen determined to keep building until the architect decides what kind of top he wants."

A handful of dissenting WTC critics used the towers to condemn what they saw as a coercive, antidemocratic social trajectory that had now found its most vivid architectural expression. To Charles Jencks, the trade center exemplified a pernicious form of "late Capitalist extreme repetition," redolent with crypto-fascist "persuasive power."

> The effect of extreme repetition may be monotony or a hypnotic trance: positively it can elicit feelings of the sublime and the inevitable because it so incessantly returns to the same theme. A musical figure, repeated at length, such as that in *Bolero,* acts not just as a form of mental torture but as a pacifier. Repetitive architecture can put you to sleep. Both Mussolini and Hitler used it as a form of thought control knowing that before people can be coerced they first have to be hypnotized and then bored.

Lewis Mumford drew an acerbic parallel between the WTC's "purposeless gigantism and technological exhibitionism" and the "magatechnic chaos" of Jean Tinguely's *Homage to New York.* Described by the sculptor as "a self-constructing and self-destroying work of art," *Homage* elicited delighted applause when it blew itself to pieces in a "happening" at the Museum of Modern Art's sculpture garden in 1960.

While critics of all stripes contributed their interpretive material, the PA and Tishman continued building. In the same month that Pruitt-Igoe was being blown into the history of planning catastrophes, the English journal *Architectural Review* ran a full-page photograph of the nearly completed WTC looming above the restrained Georgian proportions of St. Paul's Chapel, rendered minuscule below. This graphic depiction of high-rise corporatism dwarfing the communitarian values of the meetinghouse lent credence to the magazine's assertion that "New York provides us with a dire warning" heralding "the latest and most terrifying stage in that relentless process, which in American cities seems to know no bounds, of putting more and more accommodation on less and less land." Yamasaki's towers proved that "the ultimate sterility toward which monumental redevelopment is heading is of no concern to the developers. They are gamblers on a giant scale, whose only interest is in the next fall of the dice." Interestingly, these British critics apparently lumped the Port Authority and private speculators together in the same catchall category.

Whatever the motive force behind "monumental redevelopment," the WTC towers embodied, in their particular monstrosity, essential messages concerning the social dynamics that gave them form—mes-

sages that have become clearer over time and that would have been difficult for even the most incisive contemporary critic to decode. When we consider the towers today—particularly in light of the attempt to obliterate them—they may communicate more directly than when, in their newness and novelty, it was difficult to know what to make of them. Missing in the critical interpretation surrounding the WTC's ascent—and hence from the story told about it—was the conscious awareness that the gravity-defiant verticalized mass and concentration of the skyscraper had finally been pushed beyond the sustainable "envelope" to new and transformative extremes.

With the World Trade Center, the skyscraper mutated into a creature of a fundamentally different species from Bradford Gilbert's heroically "idiotic" Tower Building, or Cass Gilbert's five-and-dime cathedral, or even Gordon Bunshaft's Chase Plaza slab. The trade center's scale and form had exploded the structure beyond any relationship to its surroundings. Its proportions simply gave people nothing in which they could recognize a human referent. It required the respective climbs of "human fly" George Willig and the cinematically enhanced King Kong to make clear that Yamasaki had accomplished an unwitting Claes Oldenberg parody of the modern skyscraper.

But in achieving the PA's goals, Yamasaki broke the traditional skyscraper covenant that, in exchange for precipitous heights, guaranteed breathtaking vistas. From inside the WTC, its closely spaced columns produce odd vertical window forms that feel prisonlike and chop the expected panorama into dissociative strips—hardly a fitting reward for making the labyrinthine trek from the elevator core to the perimeter. From outside, under most conditions, it is hard to tell whether, above plaza level, the towers have windows at all.

Though these anomalies are fearful enough, another source of the WTC's terror—hinted at but not developed by Jencks—was that a skyscraper had succeeded in cloning itself. Beyond the stultified patterns of extreme repetition, the WTC's split image does not permit it to be reconciled within a unified field of vision. To gaze upon it—or is it them?—is to encounter in architectural language the threat of insane multiplication: the workings of a productive apparatus generating copies of itself exponentially and at will—no longer responsive to our commands. The World Trade Center arrived on Lower Manhattan's shore at precisely the moment when industrialized culture began to realize the nightmare fable of the sorcerer's apprentice—crossing the digital and genetic frontiers into the wonderland of infinite identical reproductions.

What the trade center's design prefigured has since become an operative mode: an all-consuming global market, polarizing wealth and resources and fragmenting cultural life into a thousand unpredictable mutations. When this myriad of seemingly random energies, multiplying autonomously, shows its destructive face, we experience it as terrorism.

On some level, then, the critics who lined up behind Tobin in affirming the trade towers as "the first buildings of the twenty-first century" were correct. The problem was that they couldn't know what the twenty-first century was going to be about. But Yama had previsualized its dawning. In articulating the split center, he went beyond undermining the traditional narrative of the skyscraper. He coined an architectural language that was compulsively self-referential and relied on increasingly unreliable, incommensurable signs to support its hyperinflated values. Yama left behind an iconic testament to the refraction of his soul: an architecture on the verge of a nervous breakdown.

TELLING IT TO THE JUDGE

Since 1920, Oscar's Radio had occupied a storefront on Greenwich and Cortlandt Streets, in the middle of the site that in 1966 was to become the WTC's "footprint." When he learned that the trade center was sliding westward toward Radio Row, Nadel immediately began organizing local resistance by founding the Downtown West Businessmen's Association (DWBA) as an institutional counterforce to the PA and David Rockefeller's DLMA. But Nadel realized that something more than solidarity would be needed if the political efforts of the new organization were to prevail. Since the newspapers were lapping up every tall tale told by the Rockefellers and Austin Tobin, the merchants of Radio Row would have to tell a better story. And what story could be better than the truth?

"We intend to fight," he told the *New York Times* in April 1962. "This is a worldwide center for electronics for the home and now they are going to destroy it so that the real estate interests can take over." As accurate as Nadel was in his analysis, his next assertion was so blindingly naïve that it might have been spoken by one of Frank Capra's morally outraged "everyman" heroes: "This is not some foreign country where the government can come in and just take a man's business."

Nadel's language reflected not only an appeal to the court of public opinion but also his faith that the legal system, once presented with

the facts, would recognize the Port Authority's lies and judge in favor of his truth. Thus the DWBA took on the PA's legal department blow for blow in a series of cases that culminated with the merchants' attempt to tell their version of the story to the U.S. Supreme Court in late 1963.

Arguing on behalf of Radio Row was Stanley Geller, a liberal Greenwich Village attorney and preservation activist. He contended that the PA's condemnation of the merchants' properties was unconstitutional. The PA could not prove a public purpose, since no government agencies had committed to relocating to the WTC. The Court had agreed to hear the DWBA's petition to halt work on the WTC on December 21, but Sidney Goldstein, the PA's counsel in Washington, requested that the date be moved up to December 13. All litigation concerning the trade center had to be resolved by December 31, Goldstein argued, because that was the Port Authority's due date for payment of $16 million to the Hudson and Manhattan Railroad as partial reimbursement for its properties. John Marshall Harlan, then the most liberal justice on the Court, apparently found Goldstein's argument compelling and moved the merchants' petition date eight days forward to spare the PA from being "unfairly penalized" by the delay.

On the newsprint front, the *New York Times* reported that Austin Tobin "scoffed at a suggestion by Geller that the possible failure of Federal Agencies to use the trade center would eliminate its public status." Tobin insisted that the trade center would be a "100 percent public facility" with "every tenant . . . engaged in a public activity." On December 17, 1963, the Court upheld the lower courts' decisions that the PA condemnations were constitutional. The issue, the justices wrote, "did not represent a substantial federal question."

Lower court appeals by the DWBA continued, even after the bulldozers were rumbling over the former Radio Row properties, largely because the merchants continued to assert that they had rights superseding those of the PA, and because they were convinced that the agency's "public purpose" arguments would eventually be exposed as a sham. But when the DWBA's evidence was set against sworn statements by PA officials, the courts consistently dismissed the merchants' allegations as delaying tactics. To do otherwise would have been to acknowledge that the nation's most powerful public agency was deliberately misstating the facts in order to engage in real estate speculation. In November 1965, the Appellate Division of the New York State Supreme Court upheld the original finding that "the primary public

purpose [of the WTC] still remains." Any other story was one that the courts were simply not prepared to credit.

"WHAT ARE YOU DOING TO MY DADDY?"

Out on the street, however, the DWBA merchants found ears more sympathetic to their story. Led by Nadel, the merchants staged numerous protest rallies, developing a street theater vocabulary that, as their legal standing eroded, became increasingly trenchant, and effective in amplifying their voice through media. Demonstrations in the form of mock funeral processions—featuring the black-shrouded coffin of "Mr. Small Businessman" and the ritual display of the hangman's noose that the "Kremlin PA" had used to execute him—dogged Nelson Rockefeller throughout his 1964 presidential campaign bid.

Radio Row families greeted the governor at scores of photo opportunities and whistle-stops, their toddlers holding placards reading "Rockefeller, What Are You Doing to My Daddy?" News photos showed the Radio Row merchants, their wives, children, and supporters turning toward the camera holding their picket signs aloft: "Rockefeller, 120,000 People Demand You Stop Land Grab"; "Rocky Hates the Working Man"; "Rocky Sponsors Port Authority Dictatorship"; "Rockefeller Signed Our Death Warrant: He Made the World Trade Center Land Grab Legal"; "Rockefeller, 30,000 People Will Lose Jobs"; "Sign Up and Save Radio Row."

In January 1964, at the height of the protests, the *New York Times*—whose rare coverage of the merchants had generally been tinged with dismissive paternalism—quoted their leader at length. Though it was half-buried on page thirty-three, the *Times* at last allowed a statement by Nadel to run nearly the length of Rockefellerian soliloquy:

> The government is using taxpayers' dollars to bail out the Port Authority. There is no need for the World Trade Center and there are no tenants. Governor Rockefeller has to find tenants so he is moving the state agencies into a so-called World Trade Center so the project suggested by David Rockefeller and the Downtown Lower Manhattan Association can come into some sort of beginning. This property was condemned in the courts for a World Trade Center and not for state office buildings. We plan to continue our legal and political fight against this monstrous land grab.

Four days later, the *Times* paired a photo of Nelson Rockefeller inspecting a just-unveiled model of Yamasaki's towers at a Hilton Hotel reception with one captioned "Families of members of the Downtown West Businessmen's Association march on picket line outside." Rockefeller is shot close up in an interior space. He appears at ease within the confines of this protected sanctuary of wealth and power. The Radio Row protesters, their signs barely legible, are seen in long-shot, on a wintry street, their faces merging into an undifferentiated mass. These two disparate images—brought within hailing distance of one another on a single sheet of newsprint—eloquently articulated the gulf separating the merchants and the master builders. Standing parallel with Nelson Rockefeller and his trade center model yet dwarfed in comparison—this was as close to either political or narrative parity as Radio Row would get.

"ALL THE NEWS THAT'S FIT TO PRINT"

The World Trade Center drama inspired a host of interpretations, but the arc of its planning and construction was encompassed by a single master storyteller: the *New York Times*. In an era when print journalism played a proportionately greater role in shaping opinion than it does today, the *Times* performed double duty as the nation's "paper of record" and the New York metropolitan area's most powerful mass medium. Beginning with the adumbrations of the WTC in David Rockefeller's 1958 billion-dollar plan, to the trade tower's opening ceremonies fifteen years later, the disparate voices speaking for and against the trade center found their way onto the pages of the *Times*.

But some news is more fit to print than other news, and with unerring consistency, the *Times* gave pride of place to the statements by the Rockefeller brothers and Austin Tobin. Often a tone of open advocacy breached the margins of the editorial page and flowed into the news columns themselves. Thus the DLMA's opening gambits in the downtown renewal game were hailed in front-page headlines: "Big Gain Seen for City" and "Downtown Enters a New Era: In its blighted areas, adjoining the famed citadels of finance, stir dreams of dramatic change." As the trade center began to take shape, the headlines announced "World Mart Plan Widely Endorsed" and "New Trade Area Viewed as a Magnet."

Many of the stories reporting directly on DLMA plans or carrying quotes by David Rockefeller began on page one, while coverage by municipal officials, such as City Planning Commissioner James Felt, generally appeared further into the body of the paper. Pro–DLMA plan stories during this period took up hundreds of column inches. By contrast, a May 1960 item titled "Razing Questioned in Downtown Area," reporting local opposition to the east-side plan, was the only story of its kind to appear until demonstrations and legal actions by the merchants began to embarrass Nelson Rockefeller on the campaign trail more than three years later. Amid front-page stories of downtown renewal in full cry, "Razing Questioned" took up all of four inches at the end of the news section.

Over the years, the *Times* had generally accorded favorable coverage to both Tobin and the Port Authority. But with the advent of the WTC, the paper outdid its own precedents. In early 1960, a congressional committee under Emanuel Cellar launched an investigation into corruption at the Port Authority charging Tobin and two other officials with contempt of Congress. The *Times* shied away from the common practice of running related stories in close proximity, and the PA scandal, while reported, was kept at a safe remove from items on the WTC. *Times* stories on the inquiry and contempt proceedings made no mention of the trade center whatsoever, at a moment when the entire organizational mandate of the PA was being called into question by the U.S. government. What readers encountered was a PR practitioner's dream: two Port Authorities neatly separated by an editorial firewall—one butting heads with legislators in Washington, while the other catapulted Lower Manhattan into the twenty-first century.

The tone of future reporting by the *Times* was set in a January 1960 editorial titled "Downtown's Big Future," just as the trade center was emerging as the cornerstone of the billion-dollar plan.

> They are thinking large in downtown Manhattan. The World Trade Center, with a construction cost of perhaps a quarter of a billion dollars, proposed by the Downtown–Lower Manhattan Association, Inc., is the most important project for the economic future of the Port of New York launched for many a year. As "a headquarters to assure the expanding role of our country in international trade," it has meaning that goes beyond dollars and goods, the encouragement of that friendly if competitive exchange of business with peoples throughout the world that makes for better understanding.

We now begin to get the specifics of the billion dollar redevelopment program first presented to Mayor Wagner in the fall of 1958 by the association led by David Rockefeller and John D. Butt. The clouds of uncertainty about the future of downtown or waterfront areas has already been lifted.

Despite the avalanche of favorable press coverage for the trade center in the *Times* and other local newspapers, David Rockefeller—following a time-honored family tradition—sought more direct influence over the shaping of public perception. Such a strategy was risky, though, and one of his PR initiatives backfired spectacularly with the April 1964 broadcast of "Another Day Downtown," a purported documentary aired on the New York City educational television station WNDT. The program, which previewed the coming of the WTC to Lower Manhattan, had been underwritten by a DLMA grant of $10,000.

David Rockefeller appeared on "Another Day Downtown" laying down his standard line, unchallenged by Nadel or any other trade center opponent. When the Radio Row merchants protested, demanding equal time to air their viewpoint, the station's vice president turned them down, insisting that the program had been fair. But amid furious opposition from the DWBA, the planned second broadcast of "Another Day" was canceled. Though it reported the squabble between the merchants and WNDT, the *Times* did not treat Rockefeller's embarrassment as hard news but ran it as an "entertainment" story next to an ad for an NBC special on the opening of the New York World's Fair.

That June, the views of the Radio Row merchants made another of their infrequent appearances in the *Times*. Buoyed by the news that the U.S. Customs Service might back out of its commitment to the PA and legally undercut the trade center's public-purpose rationale, Oscar Nadel affirmed that the merchants were "much more sophisticated than we were when we started this fight two years ago. . . . I think we can kill this thing." Nadel's statement ran on page thirty-four, next to a review of a movie called *Circus World* starring John Wayne.

SPIN AND SMOKE SIGNALS

Nadel's ultimate prediction was wrong, but four years into their fight with the PA, the Radio Row merchants were indeed functioning with

increasing sophistication and tactical effectiveness. The Customs Service's balking had come to light via the efforts of Fern Fass, the DWBA's resourceful women's director, as a result of her correspondence with the General Services Administration's head of space management. They were also learning the art of public relations.

When in June 1964 the merchants learned of a PA plan to encourage foreign firms to rent space in the trade center, the DWBA fired off letters to eleven European heads of state. Signed by Barry Ray, the proprietor of the Courtesy Sandwich Shop in his role as "chairman, foreign relations committee, the Downtown West Businessmen's Association," the letter warned of "a scheme which is shortly to be perpetrated upon you, your government, and your people under the thinly veiled lie of a 'World Trade Center.' You will shortly be swarmed upon by an extremely energetic group of salesmen. They will submit beautiful brochures filled with deliberate lies as well as half truths. This is sponsored by financiers who have no honest interest in world trade, but who believe they have found a way to create the issuance of almost a billion dollars of tax-free bonds which they are in a favorable position to exploit." Ray concluded by stating that he spoke for a thousand businessmen who "serve millions of Americans annually with products imported from 60 countries, including your own."

When it came to public relations mastery, though, David Rockefeller had seized the initiative and, despite the "Another Day Downtown" misstep, he maintained it throughout. The *Downtown Manhattan Courier,* a local tabloid intelligencer, began publishing in September 1959. This lively, unassuming, eight-page monthly was, in fact, a publicity vehicle for the DLMA. With the WTC slated for the east side, the *Courier's* front page boosted Radio Row to the status of "Electronic City"—a thriving commercial hub. When two years later the west side became the site for the WTC, Austin Tobin dismissed the electronics center as "a drab and decaying area of Lower Manhattan."

Not surprisingly, the *Courier* devoted much of its editorial space to the activities of David Rockefeller in his role as "Chief Spearhead of Downtown Redevelopment" and pulled out the journalistic stops in imbuing the modern office tower with the aura of venerable tradition.

After an absence of some 300 years, Indian smoke signals appeared on
the Manhattan landscape. . . . In this day of modern technology, and
from the heart of the world's most mechanized city, Caughnawaga Indians, a branch of the Mohawks, used one of mankind's oldest forms of

communication to bring together fellow tribesmen working on the construction of two major office buildings in the Wall Street area.

Three puffs of smoke—meaning "assemble"—followed by two puffs, signifying "party" or "pow wow" were sent by Indian workmen laying the final 40th floor of structural steel. . . . The party signified the completion of steel work at . . . an office skyscraper being erected by Samuel Rudin from plans by Emery Roth & Sons, architects. The celebration also highlights the close working relationship between 80 Pine and the Chase Manhattan Building, one block west of the Rudin structure.

This article was illustrated by a photograph of two Mohawk steelworkers wearing feathered headdresses, dancing amid a cloud of ritual smoke. Six years later, Emery Roth & Sons would be teamed with Minoru Yamasaki as associate architects-engineers of the World Trade Center.

The *Courier*'s inaugural issue also pushed David Rockefeller's agenda of transforming Lower Manhattan into a residential community by bringing—as the *Times* had put it—"round-the-clock activity to the district around some of New York's most expensive real estate." Serving as the *Courier*'s paradigm of Wall Street domesticity were the Griegs, a young married couple living in a "spacious, airy, well-appointed, four room 'penthouse.'" Their apartment, furnished "in French and English provincial style," was perched atop a twenty-five-story office building on Maiden Lane where Mr. Grieg worked as the building's engineer, and Mrs. Grieg, a painter, reveled in the abundant natural light.

Thirty years would pass before residential pioneers like the Griegs were joined in any significant numbers. What precipitated a round-the-clock community downtown was not pioneering spirit but the real estate crash of the late 1980s when city and state planning officials rezoned the area to encourage residential conversions. No longer viable as commercial space, the upper floors of aging, nearly empty skyscrapers still possessed one competitive marketing draw: their world-class harbor views.

STRANGE BEDFELLOWS, ODD COUPLE

The only group with anything approaching the deep pockets and publicity savvy of David Rockefeller and the DLMA was the Committee for

a Reasonable World Trade Center. The committee represented a late-blooming alliance of midtown real estate interests with remnants of the bloody but unbowed Radio Row merchants association—both parties sharing, if little else, the hope that Gargantua could somehow be fore-shortened. For the merchants, any reduction in the scale of the towers offered the tantalizing prospect that some part of Radio Row might survive. Formed in the wake of the unveiling of Yamasaki's plan in mid-1964 and led by Lawrence Wein, Harry Helmsley's partner in the Empire State Building, the committee also unsuccessfully sued the Port Authority on the basis of the trade center's projected broadcast interference.

Because its objections to the trade towers did not, seemingly, qualify as news, the committee launched a series of full-page ads in the *Times* and other dailies in the fall of 1966—a half year after the first twenty-six Radio Row buildings were demolished—accusing Nelson Rockefeller and Austin Tobin of lying to the public about the trade center's cost and purposes. Unlike the vanquished merchant association, whose members had been fighting for their livelihoods, the committee's major objective—beyond retaining the lucrative transmission privileges accorded to the Empire State Building—was to cushion the impact of ten million square feet of office space landing on top of an already overbuilt market.

But neither Helmsley nor Wein was possessed of David Rockefeller's Kiplingesque "common touch," nor had they learned the art of operating effectively from behind a front organization. Thus their campaign, though it accurately targeted Tobin's and Nelson Rockefeller's vulnerabilities, failed to turn popular sentiment significantly because the self-interest of their claims was so conspicuously transparent. It was this weakness that Tobin used to savage them in the City Council chambers.

Of all the narrative strategies employed in the ongoing struggle to manipulate public perception around the WTC, the most richly ironic emanated from Austin Tobin himself. In 1968, even as he buried the piers, Tobin wooed and then commissioned the well-known travel writer James (later Jan) Morris to write a book, mentioned earlier, *The Great Port*. This is how Morris described his first encounter with the legendary PA titan:

> At first, my attention was on my lamb chop, but as he talked, I began to feel obscurely excited by his company. . . . He talked about turmoil, experiment, bitter rivalry, tragedy. He told me of glorious bridges and

colossal tunnels and desperately expanding airports. He said they were at that moment erecting the two tallest buildings on earth. . . . "Would it interest you to write a book about it all?" Mr. Tobin mildly inquired. "We would be delighted to give you any help you might need—our official resources are considerable. You might care to survey the harbor from one of our helicopters.". . .

"I could write what I liked?"

"Of course."

"I could see what I wanted?"

"Naturally. From my own office I can look directly out to the harbor. During the war I used to see your two great *Queen* liners, painted gray, sailing out towards the Narrow and the open sea. . . . It was a fine sight, those great ships sailing out. We never knew whether we would see them back in New York again. . . . I was often much moved myself. Many of us within the Authority have a great pride in our port and what it stands for. It had great romance and historical meaning, you see. It is very beautiful, too."

Dedicated to Tobin, *The Great Port* reads as a charming, picturesque, bemused ramble—full of fascinating journalistic details—a full-scale literary Canaletto of the Port Authority's realm and dominion. One chapter, its style verging on the turgid, describes the habits of the exotic, savage, and soon-to-be-extinct tribe known as the New York longshoremen.

SUNDAY TIMES

By 1971, most of James Morris's longshoremen had moved on to other occupations, major construction on the trade towers had been completed, and tenants were moving in. Although its official dedication would come two years later, the WTC experienced a kind of media christening when its advertising supplement appeared in the February 28 issue of the Sunday *New York Times*. Set in the paper's signature typefaces and containing a mix of articles and ads laid out to resemble the magazine section, the supplement might have been mistaken by casual readers for a special news report. One illustration in particular conjured up an odd warping of space and time that made one look once, twice, and then again. The photograph showed a Yamasaki model of the trade center in context with its surrounding area. The twin towers and nearby buildings were all accurately depicted, but instead of

the massive landfill, a row of sleekly rendered finger piers still lined the Hudson, all the way down to the Battery. Five years after they had been buried, the Lower Manhattan piers still registered their ghostly presence.

Full-page advertisements for the trade center's contractors made up the bulk of the supplement's content. Borg-Warner shared a spread with Con Edison—an appropriate placement given the symbiotic relationship among motors, air conditioning, and electric power. As thanks for not building its own generators beneath the WTC, the PA had been awarded a "bulk rate" by the utility—hence the ad's headline "Con Edison Salutes the World Trade Center. More Power to It!" This last play on words was grounded in some truth, since the twin towers, built before energy conservation became a concern to architects and developers, consumed wattage for a city of a hundred thousand.

Not to be outdone by the other major contractors represented in the supplement, Tishman Realty and Construction Company, the WTC's chief builder, headlined its full-page ad "Making America's Cities Look Up." Fortunately for Tishman, the twin towers had made the company's balance sheets look up. The PA contract had, in fact, saved the builder from financial ruin. In 1970, Tishman had been left holding the bag on a half-completed skyscraper it was constructing for General Telegraph and Electronics at 1166 Sixth Avenue in Rockefeller Center's backyard.

GTE left New York for a Corbusian high-rise in a landscaped plaza in Stamford, Connecticut. The defense contractor cited the difficulties of doing business in the city, coupled with Fairfield County's "ease of access by automobile and public transportation . . . availability of housing, and [low] construction and land cost," as reasons for its move. GTE officials vehemently denied that the 1969 bombing of their offices, along with those of Mobil Oil and IBM—in protest over their role in the Vietnam War—had factored into their decision to relocate. Expressing the city's dismay at being jilted by yet another corporate giant, the *Times* sniped: "GTE Lost!"

Though the World Trade Center had stopped growing at 110 floors, U.S. involvement in Vietnam continued to escalate. Increasingly, bombings shook the foundations of the headquarters of companies viewed as war profiteers. Accordingly, the *Times* published an article headlined "Bombings on Rise Over the Nation." Interviewed for his reaction to the bombings, Nelson Rockefeller "indicated surprise."

"This is a new concept," the governor mused, "blowing up buildings in protest." By way of explanation, a "psychiatric specialist in the

study of violence" offered a personality profile of the type of person who would plant a bomb. "[They] have an uncanny tendency to seek out people of their own make . . . and there you get conspiracies. They want to annihilate a symbol of what they hate, and they want to show that they have power over people."

MONDAY-MORNING SOCIOLOGY

In March 1966, just after the Appellate Division of the New York State Supreme Court upheld the legality of the PA's condemnation order, the City Planning Commission issued its report on the WTC. The mayor had requested the report in February, and because of the tight time constraints, commission officials were able to spend only one day at the trade center site. Nonetheless, they managed to interview 221 of the remaining Radio Row merchants. The commission determined that "more than half of the shopkeepers who are in the area now have been located there in excess of 15 years. About a third of them had been in the area more than 25 years. Of the 157 shopkeepers who responded to this question, 112 claimed they had no relocation plans, 34 stated that they were going out of business, and 11 reported that they had definite relocation plans."

The city planners then summarized the mood of the remaining merchants:

> The large majority of storekeepers appeared hopeless, immobilized and powerless in the face of the forthcoming changes. It is apparently the combination of change with no perceived satisfactory accommodations and the sense of loss of control over personal destiny that has brought forth the angry counter attack by the shopkeepers in their efforts to stop the project. It should be noted that the primary energies of the shopkeepers have been directed toward legal efforts to halt the project rather than toward negotiating for the best possible relocation arrangements.

The commission went on to recommend that the mayor urge the Port Authority to facilitate nearby relocations for the merchants, extend relocation deadlines, and bring their liquidation and small business relocation benefits up to parity with those normally provided in federal Title I urban renewal projects. The report concluded by lending its official, and by now superfluous, endorsement to the trade center juggernaut already in momentum.

Fascinated by the scale of the demolition, photographer Danny Lyon began documenting the leveling of Radio Row. In his book *The Destruction of Lower Manhattan,* Lyon's images were accompanied by diary entries such as this one for June 18, 1966.

I've begun to work on the west side, and in Washington Market I have somewhat of a jump on the demo men. The Trade Center site is practically impossible to work in. PATH has the ruins guarded quite seriously, and the wrecking is going so fast that buildings disappear overnight. As I see it now I might weave a kind of song of destruction. The base of it would be a documentary record of demolition work. There will be portraits of housewreckers, and anyone left in the neighborhood. In a way the whole project is sad; except for the demolition men and their work.

A SENSE OF OCCASION

It is seven years later, and Carl Furillo's elevators now whisk passengers up 110 stories to survey the Port Authority's sovereign domain: Outerbridge Crossing to the southwest, Kennedy Airport to the east, and from the Pine Barrens and the container mountains of Newark-Elizabeth, up north past the George Washington Bridge into the foothills of the Shwangunks.

In offices on the upper stories of the twin towers, closet doors occasionally open and close by themselves, and pens roll off tables. No action of ghosts at work here, just the swaying of the towers at this height. Some people working here find it helpful to wear magnetic pulse bracelets for the first few weeks to prevent seasickness at 1,350 feet above Austin Tobin Plaza.

Tobin himself does not attend the official dedication of the World Trade Center on April 4, 1973. He uses the day's heavy rainfall as an excuse, but the real reason for his absence is bitterness over his resignation under fire, a year before, in a dispute with New Jersey's Governor William T. Cahill. Attending the ceremony are Governors Rockefeller and Cahill. A message from President Nixon hailing the WTC as "a major factor for the expansion of the nation's international trade" was to be read by Labor Secretary Peter J. Brennan, but the former New York construction boss refused to cross a picket line of striking PATH carmen, and the speech is delivered instead by James C. Kellog III, chairman of the Port Authority; senior partner of Spear,

Leeds, and Kellogg; director of Mutual Benefit Life Insurance and the East River Savings Bank; and former chair of the New York Stock Exchange's Board of Governors.

After the ceremony, Cahill and Rockefeller trade good-natured gibes over the apportionment of the PA's favors between their neighboring states. Cahill implies that New Jersey's commuter rail needs have taken second place to the trade center, and Rockefeller, still grinning, points toward the Jersey shore. "You can see those magnificent container ports," he says, "that took all those jobs away from New York."

With the arrival of the World Trade Center as an actuality, all the voices telling all the stories about its coming momentarily fall silent. But the force of narrative is not long in picking up the thread. Soon new stories will weave the towers into the fabric of the city in which it stands.

S E V E N

BEING THERE

Inside out: looking northeast toward the Empire State Building and the midtown central business district. At upper right, the skyscraper hops across the East River and into Queens as Citicorp disperses its back-office operations from the central city.

ILLUMINATION, NATURE CALLING

This is the day you are going to finish your document research at the Port Authority library on the fifty-fifth floor of Tower 1. Midway into the morning you take a break to visit the bathroom, where about a half inch of water covers the floor—perhaps three-quarters of an inch toward the west side. Maybe the buildings have a pitch after all—certainly the floor does. You didn't need to punch in the usual combination code to get into the bathroom because the lock was broken and someone had thoughtfully jammed the bolt with a crumpled paper towel. Here, adjacent to the elevator shafts, the wind sounds great, slow-crescendo roars.

You think about the last document you were looking at: "Wind Program Interim Report, Supplement #2," prepared for the Port Authority back in 1964 by Worthington, Skilling, Helle, and Jackson, consulting civil and structural engineers. "The square cylinder," the engineers wrote, "is a shape which is known to be subject to the excitation of the Karman vortex street type and is known to be subject to 'galloping' instability if the mechanical damping of the system is low."

You haven't the slightest idea what any of this means, but it sounds ominous. Ever prey to anthropomorphic projections, you imagine you are lodged within the body of a wheezing but easily excited giant that at any moment might take off down Karman Vortex Street. A security man enters while you are washing up. He systematically flushes all the toilets and urinals and shines his flashlight under the sink, checking for leaks. Nothing amiss. The two of you exchange shrugs and he hoists his walkie talkie: "Maintenance—mop-job—men's west fifty-five." That afternoon as you head for the elevator to leave, you notice that the door is still ajar and the pool of water remains.

UNDERGROUND STREETS

Even viewed from a great distance, on any reasonably clear day, the twin pylons of the World Trade Center indisputably dominate the skyline of metropolitan New York. Driving toward Manhattan along one of its radial arteries—say, the New Jersey

Turnpike, or Robert Moses's Long Island Expressway—one can be visited by the strange sensation that the Centeron Tower at the heart of Democracity has cracked out of its shell, split in two, and grown to Brobdingnagian proportions. Or perhaps it is we who have developed double vision and shrunk to fit inside the model.

In the classical Corbusian planning fantasy, the highway leads directly to the tower in the park. We experience our destination along a continuous path from distant image to close-up reality before making a seamless transition between automobile and skyscraper. But given the conditions of New York City, we generally leave our car at some remove, reaching our final destination via underground public transportation. And it remains one of the ironies of the World Trade Center that after our glimpse from afar, our next experience of this most highly visible, supremely external of structures will probably be from within. Most likely we will not register the image of the towers again until they are framed in our rearview mirror.

Whether we have come as visitors to the trade center or are among the more than 40,000 people who work here, chances are we arrived via PATH train from New Jersey or on one of several subway lines that converge in Lower Manhattan. Though it is possible to enter the trade towers by walking across the raised plateau of Austin Tobin Plaza, this requires a deliberate detour because the design of primary access routes works against street-level approach. It is far more likely that we have navigated a warren of corridors, staircases, and escalators and entered the complex via the vast enclosed WTC Mall submerged beneath the plaza. Thus our journey from horizontal subway tunnel toward vertical elevator shaft takes place within a completely internal world—unexposed to natural light, open air, or the play of the elements.

Here, where shop-lined passageways connect rapid transit stations to the elevator lobbies of the twin towers and peripheral buildings, the tortured spatiality of the WTC can first be viscerally felt. Though brightly lit, this labyrinth, its ceilings hung with jumbled airport-style signage, feels distinctly subterranean—a world apart from the life of the city. Although we are walking only a few feet below grade, it is not difficult to imagine that the old streets of Lower Manhattan have been sunk deep into the earth, narrowed to corridors, and paved over at the height of the first floor. It is as though Yamasaki and the Port Authority, shrinking from Le Corbusier's exhortation to kill the street, had settled for burying it alive.

But they did provide the maze of passageways beneath the trade center with a focal point, and this is PATH Square, where a massive, vertiginous escalator bank funnels people to and from what used to be

the Hudson Tubes. Here, by invoking the concept of a public square, we encounter yet another retrospective gesture toward the urban forms obliterated by the superblock.

Originally called the Concourse and renamed when "mall" took on its present connotation, the commercial space beneath the trade center has, in recent years, undergone nearly constant renovation as the PA pursued a strategy of replacing small shops with larger national and regional chain stores. But efforts toward a qualitative transformation remain blunted at the level of spatial actuality, and despite measures to upscale it, the mall retains a more proletarian feel than the spacious, marble shopping arcades of the World Financial Center, built on the trade center's landfill a few hundred yards across the highway to the west.

Because of its built-in limitations as a commercial environment and new sources of competition—expanded services in Battery Park City and the immense Newport City mall one PATH stop across the river in New Jersey—the trade center mall today reprises, in troglodyte form, the uncertain pastiche of urban and suburban cultures that much of aboveground New York has become. High-profile retail outlets like The Gap, along with a large "discount" drugstore and several commercial bank branches, anchor a host of smaller entities, among them an optician, a photo finisher, a jeweler, a shoe repair shop, a florist, several newsstands, and numerous fast-food counters. At lunchtime a cluster of men stand transfixed before the electronic tickerboard display at the Charles Schwab brokerage office, as the tide of movement swirls around them.

But those who pause for any reason are a rarity here. Pedestrian traffic during working hours is dense, purposeful, and, at times, frenetic—and little in the aspect of the place invites our lingering here. There are no public benches to sit on, or tranquil sidelines from which to observe the passing scene. These qualities combine to yield, par excellence, a transitional space: a space to be hurried through and forgotten as quickly as possible. Rapidly, then, we make for the proverbial light at the end of the tunnel, the point where the ceiling abruptly rises, the corridors widen, and natural illumination, pouring down from above, signals our arrival at one of the twin tower elevator lobbies.

Despite our palpable relief upon leaving it, the trade center mall is not, it seems, a universally inhospitable environment, and at least one creature has called it home. In the early 1980s, a raccoon took up residence in the ceiling among a tangle of wires, conduits, and pipes. "Yesterday he was seen munching something up over the Manhattan Savings Bank, [and] today he was up over the Market Restaurant," said

a PA police sergeant summoned to one sighting only to find that his elusive subject had fled the scene. Legend has it that after eluding capture for several years, the raccoon was eventually bagged and relocated to the woods of Long Island.

We, however, are bound upward, to the top of Tower 2 from which, on a clear day, the deep green of the raccoon's new suburban home spills into visibility over the horizon. Passing through the revolving doors that separate the mall from the tower lobbies, we find ourselves in a bright, open, marble-walled well a floor beneath plaza level. In the aftermath of the bombing, entry to the towers is preceded by a process of security clearance that ranges from perfunctory to elaborate. Employees of trade center tenants flash identity cards to guards as they enter the elevator. People who have appointments at tenants' offices queue up for admission at the visitors desk, which resembles an airport check-in counter.

Waiting time is generally about three minutes. A uniformed expediter waves visitors toward clerks who request photo identification cards and call tenants to confirm appointments. Once a visitor's legitimacy is confirmed, a computer printer issues a pressure-sensitive lapel pass, its daily color code randomly selected, bearing the name of the visitor, the date, and the suite number of the person's destination. The pass is examined by guards stationed at the entrances of the elevator bays, but this process is ultimately of more psychological than actual deterrent value. Indeed, given the high volume of people entering the WTC during peak hours, scrutiny diminishes to the point that a person bearing a reasonably accurate facsimile stands a good chance of gaining entrance unchallenged.

If we were to halt our journey upward on the thirtieth floor—the height of an average New York office building—we might take in the compelling play of light and shadow on the cityscape before us. But such a view would never be dramatic enough to justify our journey to the WTC. It is only by ascending for a full half mile, to where our view will extend for forty-five miles, that we may rip ourselves free of the city's immediacy and imagine—however fleetingly—the ease with which we might remake the jumbled and disordered world below.

"WELCOME TO THE WORLLD"

"It's hard to be down when you're up," ran the PA's 1975 television and radio jingles for the Tower 2's observation deck, trading on the assumption that spectacular views might ameliorate the morbid effects of

the city's fiscal near-death experience. And it is certainly true that a trip to the summit of the World Trade Center provides, whatever the psychological conditions on the ground, a highly leveraged flight from the mundane, to a place where one neither hears nor smells anything of the exquisitely visible city and its surroundings. But the elements can play tricks here, as they did on July 4, 1981, when a layer of clouds interposed itself between hundreds of invited dignitaries and the celebratory fireworks bursting unseen below.

On gusty days, the closer one gets to the 110th floor, the more palpable the sensation of swaying may become. The towers have so much give that when wind velocity is high, the outer elevators can knock against their shafts; once, during a particularly violent storm, they seized up altogether. Under high-wind conditions, only the elevators closest to the core operate, and these run at half speed. When the wind hits the towers from certain angles, a remarkable range of pitches emanates from what have become, in effect, a set of immense panpipes.

On calm days, however, the ride to the 107th floor observation deck takes less than a minute via a special elevator car in which, when the PA still managed the attraction, the word "welcome" was posted in eighteen languages. Now an entertainment company runs the deck, and the motif is suitably "Broadway." Arriving at the deck, one is struck by the proximity of the adjacent twin, topped by its huge microwave transmitter spire. Next comes the realization that our anticipation of a sweeping, unimpeded view of the city and the terrain beyond cannot be sustained, for we are caught in a contradiction between a panoramic ideal and a structural actuality.

To create completely columnless floors, Yamasaki and Roth designed the exterior walls to bear the building's weight load. Thus we find eighteen inches of structural steel alternating with every twenty-two inches of glass. With panes set back twelve inches to provide a modicum of shade, a succession of vertical bars fractures our attempt to construct an unbroken vista. The eye simply cannot make sense of this repetitive alternation between fields of focus: opaque and transparent, foreground and background, surface and depth. The promise of limitless observation from a supreme height is canceled in the foreclosure of visual coherence.

For all the deliberate "Gothic" references of Yamasaki's detailing, the World Trade Center takes a step backward from the structural achievements of the medieval cathedral builders. Where arches and flying buttresses converted the masonry wall into a latticework, the steel curtain wall must, of necessity, constrict the passage of light and

eliminate natural circulation of air. Yet, as we press close to a window, our shoulders nearly touching the columns to the left and right and our breath clouding the glass, we nonetheless enter a world of miniatures—observed from an altitude that lends itself to intoxicating levels of abstraction.

This cannot be a living city we are looking down on—it is much easier to see it as a highly detailed diorama of animated souvenirs. South of Ellis Island and the minuscule Statue of Liberty, red tugboats nudge bright orange and green container ships through the Kill Van Kull toward Newark-Elizabeth. Recently, the PA spent more than $300 million dynamiting the Kill to a depth of forty feet. But freighters of the latest generation—the ones that now unload in Norfolk and Baltimore—require another ten feet of draft. There is depth to spare in South Brooklyn, which is also two hours closer to the sea, but it no longer has much of a port—just a few rotting piers that the PA hoped to sell to private developers.

Beyond the Kill, on Staten Island, amid clusters of suburban-style homes, the Teleport spreads itself like a mutant Corbusian golf course, its white satellite dishes and office complexes dotting the greensward. Guy Tozzoli, former overseer of the twin towers, conceived the Teleport as a world trade center for the information age—and the Port Authority was its initial primary backer. Like its tall, vertical cousins, Teleport is fundamentally a real estate speculation, providing "off–Wall Street" commercial space to financial services firms. But given Tozzoli's lengthy career at the PA, it is not surprising that Teleport's development was carefully couched in the language of regional planning.

Teleport's stated purpose is to anchor the FIRE industries (finance, insurance, real estate) in the New York region by linking Wall Street firms by fiber-optic lines to the world's largest and most robust assemblage of satellite antennae. Applying an information-age gloss to vintage Tobin-era jargon, PA chairman Alan Sagner said in 1993 that whereas "water, rail, road and aircraft movements were once vital factors in maintaining the Port District's national preeminence, in the coming century, the ease of information movement using telecommunications will be a major factor in revitalizing and nurturing our region's health." But if Teleport was, as the *Times* put it, "envisioned as [the] city's link to a bright future," it is also in business as a local telephone service provider, beating out Nynex in 1993 for a $6.3 million contract to install new payphones in PA facilities, including the trade center and its airports and bus terminals.

As we shift our gaze eastward from the Teleport and follow the graceful curve of the Verrazano Narrows Bridge—Othmar Ammann's

"enormous object drawn as faintly as possible"—we see the gentle rise of Sunset Park, New York City's highest natural point. Here in South Brooklyn, at the shore of the bay, standing out among the ranks of tremendous warehouses, Cass Gilbert's even more immense Army Terminal building stretches along the shore. With its multiple railroad sidings, overhead cranes, soaring glass atria, truck-sized elevators, and great reinforced concrete columns shaped like Ellsworth Kelly sculptures, a two-million-square-foot cathedral of heavy industry seems toy-like at this remove.

If we face east, we can see the Woolworth Building close beneath us—Gilbert's highly ornamented vertical masterpiece, now shrunk to the stature of the trade towers' pygmy grandfather. Nearby, Roebling's Brooklyn Bridge spans the East River toward Metrotech, downtown Brooklyn's sleek new central business district. Metrotech is where Chase took its five thousand back-office workers in 1988, agreeing to keep the jobs in New York State in exchange for a record $235 million in tax breaks and energy subsidies. By night, Chase's blue "beveled bagel" logo, affixed to the top of a Metrotech tower, hovers over Brooklyn like a luminescent UFO.

Just across Vesey Street, immediately to the north of the twin towers' superblock, stands 7WTC, the complex's forty-seven-story trapezoidal glass and red granite newcomer in which Mayor Rudolph Giuliani has, to much ridicule, installed a bomb- and nerve gas–proof command and control bunker from which he will run the city in case of armageddon. Built in 1987 on Port Authority land by speculator Larry Silverstein— also a major Teleport investor—7WTC was to have served as the new headquarters for the investment firm Drexel Burnham Lambert. Drexel canceled its $3 billion deal with Silverstein only months before the bottom fell out of junk bonds—collapsing scores of the S&Ls that had bought them. Drexel dissolved three years later, amid an avalanche of criminal prosecutions and civil lawsuits. But Drexel, like Chase, had been treated generously by the city it was threatening to leave. Shortly before its implosion, the firm had received an incentives package worth $85 million to keep its five thousand employees in New York.

Looking west toward the Hudson River, we see sleek cruise ships bound for the remaining mid-Manhattan piers sliding past tug-drawn barges heaped with gravel from upstate. Beyond, in New Jersey, stretch the vast marshlands, and to the southwest, a sprawl of oil refineries and the Newark-Elizabeth container port. Closer to the shore, a Leviathan-sized cup poured out decades worth of neon coffee "good to the last drop," until Maxwell House moved away. And directly across the river in Jersey City, Sam LeFrak's massive Newport City challenges Battery

Park City—built on the trade center landfill just below us—to play real estate one-on-one.

Separated from the trade center superblock by the West Side Highway, Battery Park City's luxury apartments and offices spread out on the hundred-acre "square lily pad." From our observation post, we can look directly down on Cesar Peli's World Financial Center—its conical roof vents steaming like nuclear reactors. Built by Olympia and York, the since-dismembered Canadian real estate giant that once racked up $5 billion in debt for its office holdings, Peli's towers—and thus the Battery Park City Authority's bond obligations—were based on a foundation even less stable than landfill: the shifting fortunes of the futures market.

That the Port Authority is itself undergoing a massive restructuring is evidenced by changing circumstances of the observation deck on which we stand. Under political pressure to privatize many of its holdings, the PA spent $6 million renovating this asset before leasing it to an entertainment company in 1995. One new attraction here is a "virtual" helicopter ride—actually an out-of-focus movie made vertiginous by the banking and diving of hydraulic bleachers—over a Manhattan sonorously invoked as a "place of poets and planners, dreamers and schemers." The intention, according to the company's senior vice president, is to offer the deck's nearly two million yearly visitors more bang for their bucks. Without it, he says, there is really "nothing to do when they get up there but look out the window."

When weather permits, one can take an escalator to the roof of the building. Here in the open air and buffeted by exhilarating gusts of wind, visitors find the view indeed panoramic and expansive. But the sense of immediacy is blunted in another way, since for security reasons, the viewing platform is separated from the edge of the building by a distance of some thirty feet and an electrified fence.

Across the chasm, seemingly within reach, stands Tower 1. From here the twin feels even more present than it does three floors below. If only one had a cable, an anchor, and a balance bar, one might risk everything to bridge the gap, complete the circuit, and see what the world looks like from the space between.

VISTAS AND WINDOWS

Traversing the paving stones of Austin Tobin Plaza presents us with a much different view from the one we experienced only a few moments ago from a half mile above. Now when we face toward the harbor, we see

the back end of the Vista Hotel, also known as 5WTC. Hilton International opened the twenty-three-story, 825-room hotel in 1981. Designed by Skidmore, Owings, and Merrill, the Vista cost $70 million to build and was intended to support the "twenty-four-hour community" scenario that harked back to the initial DLMA plan. For guests facing southwest, the Vista lived up to its name. But from plaza level, it curtained off the harbor view that the towers had initially framed. More than a view was lost, however. The placement of the hotel also foreclosed a profound psychological experience that the twin towers carried forward from ancient times: the passage across a symbolic threshold framed by two massive columns. Walking through such a liminal space signified a transformation of the spirit. Almost instinctively, then, we head toward the space between the towers, but stepping over the threshold only brings us into the lobby of a flashy, overdecorated hotel.

The PA purchased the Vista for $78 million in 1989 and began a $28.5 million renovation program in 1992. The "incident," as the hotel's manager describes the explosion beneath the hotel, caused a nearly two-year shutdown and loss of $80 million in revenues. The final component of the original WTC complex to be built, and the PA's last major real estate acquisition, the Vista was also the first property to be unloaded as the agency began to sell off or lease its holdings—a process that has now put the trade center itself on the block. To help pay the immense costs of postbombing renovation—underwritten by bond debt—the Vista was sold to Marriott for $141.5 million in January 1996.

Dismantling of the PA empire is proceeding from the top down as well. In addition to the observation deck, the restaurant Windows on the World is now privately managed. Twenty-one months after the bombing, Windows was reopened by Restaurant Associates, Inc., headed by the late Joseph Baum, who had run the original restaurant under Hilton management. But like virtually every other encounter with the World Trade Center, Windows defies expectations and offers up a host of disjunctive images. Arriving in the winter of 1997 at the 107th floor of Tower 1, diners were greeted by a stuffed deer posed beside a rustic fence amid simulated snow-covered pine trees. This display was presumably intended to set a tone of "Americana" and perhaps whet the palate for grilled venison chops to come. But at this altitude, with the lights of the greater metropolis glittering beyond, the sylvan effect added a pinch of unwitting but not altogether appetizing surrealism to the dining experience.

Back when the trade center was being built, the Port Authority had intended to make Windows a gustatory aerie for private use by its top

brass and the DLMA crowd. But when the news got out that World Trade Center chief Guy Tozzoli was spending $6 million of public money to feather his crow's nest for the elite—$3,500 of it on four chairs alone—it triggered a storm of protest that eventually forced a compromise: Windows would remain a private club during lunch, but those members of the general public who could pay the freight were welcome to come up for dinner.

What they found in 1976, according to Mimi Sheraton's review in the *Times*, was a "Stylish Menu Full of Promise That Isn't Yet Fully Realized." While the city below reeled from its bout with near default, Windows diners sampled "quail eggs in a tarragon aspic . . . much too stiffly set, so that the result looked like a glass paperweight." Though the rack of spring lamb was "ordered pink," it came "almost raw," while the "overly dark fried zucchini and a bitingly salty grilled eggplant with soy and ginger was disastrous." And for dessert, an order of strawberries "half rotten, half unripe—that should never have left the kitchen."

In these early days of the trade center, pans of its dining experience were the least of the Port Authority's worries. The trade towers were nearly half vacant and losing double-digit millions annually, despite Nelson Rockefeller's provision of a rent base in the form of 25,000 state workers. Concurrent with its entry into the high-rolling world of real estate speculation, the PA's hermetic culture of Wilsonian "professionalism" had begun to leak corruption at the seams. No longer under the iron control of Austin Tobin, the PA faced a series of interlocking scandals that culminated in the late 1970s with a state comptroller's audit and criminal investigations into its lavish perks, including around-the-world junkets for its top executives and their families. Authority officials were accused of retroactively altering expense vouchers, "massive abuse" of the agency's fleet of nearly six hundred vehicles, and insider bidding deals on purportedly competitive service contracts.

Eventually the PA admitted aiding Hilton International in its $26 million bid to run the WTC's restaurants but denied any impropriety. What might appear to be irregularity to outsiders, PA officials contended, was sensible and efficient management. Public affairs officer John Tillman and design chief Malcolm Levy were indicted on grand larceny charges for expense-account padding and falsifying records. Both plea-bargained, paid fines, and continued to work for the PA. But the agency's protective shield failed to save Alexander Leslie, the PA treasurer who stood accused of colluding with thirty-three of his fellow executives in faking their expense reports. Leslie leaped to his death from the window of his upper East Side apartment in January 1978 while still under investigation by the district attorney.

From the late 1970s through the mid-1990s—though the skyline changed dramatically with a new crop of midtown and financial district skyscrapers built in the booming 1980s—no architectural intervention of anything like the WTC's magnitude appeared on the scene. The port that had vanished from New York now shrank in New Jersey. The municipality recovered, after a fashion, from its brush with bankruptcy and resuscitated its collapsed bond rating. But corporations continued their flight to the suburbs or negotiated tax breaks using their workers' jobs as bargaining chips. Successive mayors invoked even more elaborate and generous subsidy schemes as gifts to the developers to whom they were beholden. And the city's aboveground economy continued its transition to a monoculture based on the finance, insurance, and real estate industries, signified by the expansion of the financial district even farther westward, past the trade towers and onto the landfill of Battery Park City—the post-WTC development most closely approaching a Burnham-style "big plan."

In January 1996, a blizzard hit the New York area, dropping eighteen inches of snow on Lower Manhattan—temporarily transforming Wall Street's canyons into an even more fantastical cityscape, alternating incandescent brightness with deep, blue-black shadows. As 30 percent of the financial district's office space stood vacant above, building maintenance workers—members of Locals 32B and J of the Service Employees International Union, AFL-CIO—were picketing on the nearly impassable streets below, on strike against the owners and managers of New York's commercial high-rises.

At issue was management's attempt to invoke a two-tiered pay system, one that would lower starting salaries to $350 a week—a 40 percent cut. From the union's perspective, the raw economics of such a contract would provide landlords and management companies with an irresistible temptation to fire current workers and replace them with cheaper newcomers. At a time when massive layoffs in pursuit of "flexibility" and "competitiveness" had achieved the circularity of a numbing, corporate fugue, leaders in the commercial building industry seized upon the eight-year slump in the New York real estate market as a rationale for their position. The high salaries of the maintenance workers, they asserted, were contributing to the alarming vacancy rate downtown.

"If we don't keep our costs down," said Charles Mahoney of Tishman Speyer Properties, the development and management spin-off of

the company that had been the trade center's chief builder, "our tenants and potential tenants are obviously going to continue to go elsewhere in the tri-state area."

Competitive markets and high unemployment are ideal conditions for wringing concessions from organized labor, so the logic ran. The time was ripe, therefore, for New York's most subsidized industry to take on a union that, though legendary for the corruption of its leadership, had succeeded, over the years, in nudging its rank and file ever closer to the middle class.

The Monday morning after the blizzard, as they had every day for the past two weeks, members of 32B and J formed a picket line in front of the street-level entrances to the World Trade Center, the union's single largest worksite, and were handing out leaflets to passersby and stamping their feet to keep warm. Banter between the strikers and office workers was genial and familiar; after all, they were used to seeing one another, if only in passing—the former beginning work as the latter headed home. But as the days passed, tension mounted on the picket line, and the police presence continued to increase to the point that the cops outnumbered the strikers. How long would the office workers remain sympathetic? They could not have been pleased with emptying their own trash cans and running a gauntlet of piling-up garbage. Nasty scuffles occurred as some buildings brought in nonunion workers. At the trade center's northeastern entrance, splattered eggs could be seen frozen to the windowpanes of the lower floors.

A few yards from the picket line, Austin J. Tobin Plaza was completely roped off, not because of the strike but to guard against the danger of falling ice. Port Authority bulldozers rumbled between the towers, piling up huge embankments of snow, while at the base of Tower 2, snowblowers circled, attempting to excavate the trade center's most recent "amenity": an ice-skating rink, just opened by the PA at a cost of $1 million—its latest effort to stimulate Lower Manhattan tourism and impart a sense of neighborhood to the area's new residents.

ILLUMINATION, GLIDING

You are ice skating to disco music at the foot of the World Trade Center. The snow has vanished, and the members of 32B and J are back at

work, having ratified a contract that gave a lower salary to new members while providing a modicum of job security for all. The vacancy rate for Lower Manhattan office space is slowly edging downward, tracking with the rise in the financial markets. In the midmorning sun, you count twenty other skaters gliding on the ice.

Even the most familiar sights look different when you're moving so smoothly. Circling the rink, you look up at the towers first and across to St. Paul's steeple. Then you make a survey of the plaza's three large sculptures, commissioned by the PA in the early 1970s. Before the blast, you hardly noticed the artworks at all, but now each piece seems to represent some aspect of the violence written into the trade center's story. Closest is Masayuki Nagare's black granite carving, which stands mounted on a pedestal at the plaza's main entrance off Church Street. Whenever you see the sculpture now, you can't help but imagine it as a jagged fragment of rock, hurled to the surface by an underground eruption.

Over in the plaza's center, Fritz Koenig's massive bronze sphere, fifteen feet in diameter, appears somehow to have ruptured, threatening to prolapse its oxidized innards into the surrounding fountain. It is supposed to rotate every hour, but the mechanism has been broken for more than a decade. Off to the fountain's left, near the foot of Tower 1, James Rosati's *Ideogram,* a sharply angled construction of stainless steel, suggests an assemblage of beams and girders torqued to the point of collapse yet miraculously still standing. Farther to the left, nearly against the rear wall of the Vista Hotel, stands the plaza's newcomer: Ellen Zimmerman's circular granite memorial to the bombing victims, placed directly above the epicenter of the blast. You recall having heard that the PA was planning to plant a grove of evergreens around the memorial to shelter it from the plaza's winds and create a tranquil zone for meditation. Perhaps come the spring.

Skating at the foot of Tower 2 has been an extravagance, costing twice as much as it does seven miles north at Lasker Rink at the Harlem end of Central Park, and you are determined to get your money's worth. When you're finished, though, you'll walk over to one of the towers and perform the optical magic of turning it into a vertical highway to the clouds. If the Vista Hotel and the high-rise apartments of Battery Park City lying beyond could somehow be rendered transparent, then gliding across the ice in sight of the Statue of Liberty would be worth doing every winter's day. It would be like skating on the harbor itself.

There are scores of places to eat in and around the World Trade Center. But Papoo's Italian Cuisine and Bar is a proud survivor of the Radio Row era located a block south of the trade center at the northwest corner of Greenwich and Thames Streets, on one the few low-rise blocks left downtown. Harry Manolakos owned Papoo's in the 1970s. He was born in a walk-up flat just across the street on the site where Bankers Trust Plaza stands today. And he recalls skinny-dipping with his friends in the summer off the Staten Island Ferry slips.

Even then New York harbor wasn't famous for its clean water, so swimming off the tip of Manhattan was not the sort of thing you told your mother you'd been up to. But today, diving in downstream from where the pumps spew thousands of gallons of the trade center's heated effluvia into the Hudson—well, that would be lunacy.

In the early 1960s when Port Authority engineers studied the environmental impact of the trade center, they estimated that it would produce over two million gallons of sewage a day. Because of delays in the completion of a city treatment facility, this waste would be pumped directly into the Hudson River. When they learned of this, the mayors of ten towns downstream on the New Jersey shore briefly considered a lawsuit to block tenant occupancy of the WTC. But they withdrew their threat, apparently under pressure from a statehouse more concerned about potential delays on the PATH and Jersey City development than with the salubrity of the area's coastal waters.

Port Authority engineers ended up designing a dual sewerage system for the trade center based on its proximity to the river and the need to cut construction costs. Storm sewage from the west side of the complex—the Vista Hotel, Tower One, and the Customs building—drains into the Hudson, as does the trade center's air conditioning runoff. A pipeline was eventually built that channels the remainder of the waste water to the Newton Creek plant, on the border of Brooklyn and Queens. Given that most of Lower Manhattan's sewers date from the late nineteenth and early twentieth centuries, when New York was mostly a five-story town, it is impossible—particularly during periods of high rainfall—to separate storm and sanitary sewage effectively. Because it operates as a politically autonomous entity, the PA never seriously considered building a dedicated treatment plant for the minicity of 50,000 it had raised at the Hudson's shore.

Beneath the World Trade Center, below even the giant mains that carry its sewage under Battery Park City and into the river, and the intakes that pump the river water into its air conditioning system, lies harrowed ground. Three levels below the plaza, one may stand in a spot that, had geographic forces alone shaped Lower Manhattan, would still be in the Hudson. This concrete floor and the ones above and below it provide lateral support for the trade center's watertight foundation, exerting a counterforce against the pressure of the river and harbor tides. From within this "bathtub" excavation came the detritus of early European settlement, for this part of the Hudson was first used as a garbage dump and then filled in to extend the island westward. Here were discovered burned and capsized vessels and their anchors, clay pipes, hand-blown bottles, drinking glasses, empty salt-glaze pots, bottles, shoes—made as they were in those days to fit either foot—and the bones of countless animals.

Before the trade towers could rise, a vast multilevel structure took shape here, equal in volume to two Empire State Buildings built underground. Prior to the February 26, 1993, bombing, the basement housed behind its unmarked doors a diverse and recondite subterranean complex: a Secret Service ammunition depot; the New York City police commissioner's high-security "white room"; a PA police holding pen, used mostly as a temporary lockup for people caught shoplifting at the mall; a multimillion-line Nynex switching station and FAA communications link among the three metropolitan airports; the trade center's huge generator and air conditioning plant and the central computer that coordinates data from thousands of sensors and regulates its environmental systems. It was here, planted in one of the garage's two thousand cars, that the body of Louis DiBono, owner of a construction firm, was found—his murder proving to be the one rap John Gotti couldn't beat.

Forty feet above us in the mall, around noon each weekday, a line of customers forms at the counter of Au Bon Pain, the fast-food "bakery and sandwichmaker." But down here, in the WTC's B-2 level, where the van exploded, there is no visible evidence of Barry Ray's Courtesy Sandwich Shop—a fixture of Radio Row—or any vestige of the layers of New York City that lived here before. If a bomb went off right now, right here, and instead of blowing us to pieces it blew us back through the cities of the past, we might land on the wooden plank

floor of Eli Hart's great brick warehouse, surrounded by the swirling dust of a different sort of calamity: a flour riot, brought on by wheat speculation in the aftermath of the Panic of 1837.

When the Panic hit New York, it came at the culmination of a series of catastrophes for the city, following hard upon a cholera epidemic and a devastating fire that destroyed seventeen blocks—nearly seven hundred buildings—in Lower Manhattan. Only by denying fuel to the fire—demolishing rows of houses and stores with gunpowder brought by ship from the Brooklyn Navy Yard—were the flames eventually contained.

Transplanted back to this New York of the past, we find the city in the depths of a vicious three-year depression. The real estate market has collapsed, scores of banks and businesses have folded, and the normally clamorous ship-building wharves have fallen silent. One-third of the city's workers have lost their livelihoods, and thousands are being pushed to the brink of starvation. If we are among those lucky enough still to have work, we will likely be paid in "shinplasters"—an improvised currency of specious value—since coins have all but vanished. Those who have saved money rush to the bank and try to withdraw it. But there they find the doors barred by Plug Uglies—gang lords of the Five Points slum—armed to the teeth. They've been hired by the bankers to shoot down anyone who makes trouble.

Unless we are among the most fortunate, our difficulties are compounded by usurious rents. Even the city health inspector cannot help but decry the fact that "there are in our city so many mercenary landlords who only contrive in what space they can to stow the greatest number of human beings in the smallest space." Yet not everyone lacks for necessities. John Jacob Astor, ensconced in his thirteen-acre East River estate, spends his days buying up mortgages from those who will soon have no choice but to default. During the Panic he makes more in real estate foreclosures than from his China and fur trades combined. But for many, the promise of city life has turned nightmarish. In the pages of his *New Yorker*, Horace Greeley exhorts "mechanics, artisans, laborers, . . . the unemployed, you who are able to leave the cities should do so without delay. . . . Fly—scatter through the land—go to the Great West."

As the price of flour leaps from $6 to $15 a barrel, and a few merchants hoard the available stock, an army of the hungry, six thousand strong, gathers at noon in City Hall Park. A rumor buzzes through the crowd that huge grain stores are lying virtually unguarded at Hart's,

and three hundred and more of us march toward his warehouse at the dockside. We tear loose one iron door and use it to batter down the others. Throughout the afternoon we deliver the precious goods into our own hands, pushing casks from open windows into waiting blankets, scooping grain into any receptacle we can find.

"Here goes flour at eight dollars a barrel!" someone shouts, and like proper stock-jobbers, we pick up the chant. It is nightfall before we hear the clatter of horses' hooves. Two companies of national guard are approaching, their muskets cocked and ready. We disperse as best we can—some running east to assault another flour warehouse at Coentes Slip—but in the scuffle, several of us are seized and marched toward jail. Our company regroups, and we take the guard column by surprise. One woman flings herself upon the police commissioner and rips the coat from his back. The troops flee in disarray. The bell in St. Paul's chapel sounds the stroke of midnight. Our mob has prevailed.

Next morning, the national guard has fortified the warehouses, and a barrel of flour is up to $17. Within the week forty of our company— some of them children too—have been arrested, tried, and convicted and are riding a ferry up the Hudson to hard labor in Sing Sing prison.

"WINGS ON MY FEET"

Around the World Trade Center, the harrowed ground lies deeper still. Somewhere beneath Papoo's at the intersection of Thames and Greenwich Streets stood Hughson's Tavern. Hughson's fronted the water, since what was then called Greenwich Road ran along the edge of the island until the landfills of the early nineteenth century pushed Manhattan's shoreline a block west. Venturing here in 1741, we would find ourselves at the center of another violent social eruption—chairs and tables overturned as the police rip up the floorboards, searching for guns.

In the wake of several mysterious fires, rumors are circulating that tavern owner John Hughson has been hiding an arms cache for a band of rebellious slaves bent on taking over New York. The police search reveals no weapons, nor will any substantive evidence of a "slave plot" emerge. But on the basis of spurious allegations by a paid informer and the confessions of slaves made under torture, the rumors will mushroom into a juridically sanctioned race massacre. In crushing the slave plot, city authorities cause fourteen blacks to be burned alive. They

hang eighteen others, jail a hundred and fifty-four more, and deport seventy-one to the cane plantations of the West Indies. Twenty-four whites will be imprisoned, and four, including Hughson, hanged.

Of the ten thousand people living in New York City in the year of the slave plot, one in five is an African slave. If we are one of them, we are defined as physical property and presumed to lack souls. Thus we cannot be baptized, and our couples cannot receive the sacrament of marriage. When we die, we will be buried without rites in a plot a quarter mile northeast of where the trade center stands today. On Independence Day 1827, our people are officially emancipated, but by then the African Burial Ground has already been built over. For two hundred years, our bones and those of thousands of other women, men, and children will lie undisturbed as the city grows around and over us. Our remains will come to light in 1991, accidentally unearthed during excavations for a massive new Federal Building at Broadway between Duane and Reade Streets.

A chain-link fence surrounds the overgrown lot where the African bones were found. Nearby, the words of an old spiritual are incised in the granite facade of the Federal Building's entranceway:

> *I want to be free,*
> *Want to be free—*
> *Rainbow 'round my shoulder,*
> *Wings on my feet.*

CITY OF TRADE, CITY OF TOWERS

Before, during, and after the slave plot, New York City's merchants and auctioneers pursued their brisk trade in commodities at the foot of Wall Street, due east across the island from Hughson's Tavern. Though most of the human cargoes that were traded alongside corn and grain arrived as slaves, the merchandisers also auctioned off the free black crew members of a Spanish ship captured in the West Indies.

New York City officially suspended slave trafficking in 1762, but the commercial class of the city known in the nineteenth century as the Great Emporium maintained powerful economic ties with the plantation economy of the South. In 1833, the Planter's Hotel opened just across Greenwich Street from where Hughson's Tavern once stood. Until the Civil War, the hotel served as the favored accommodation for

Southern plantation owners doing business in New York—not least because of its proximity to the Perth Amboy, New Jersey, ferry, which connected to the Washington post road and rail links south. By the mid-nineteenth century, the plank commodities wharf at the foot of Wall Street and the once-informal curbside stock trading beneath legendary Buttonwood Tree had developed into powerful, formalized institutions—their fortunes pegged to Lower Manhattan's emergence as the world's financial capital.

In 1974, as the commodities exchanges combined their operations under one roof, silver and copper coins, packets of coffee and sugar, oranges, potatoes, and wads of cotton were planted beneath the cornerstone of their new headquarters at 4WTC. The Port Authority had secured the exchanges as trade center tenants by offering them a rent subsidy that allowed them to pay $3 per square foot—less than a third of what New York State's taxpayers were spending to rent four million square feet of Tower 2.

The commodities exchanges remained at 4WTC for twenty years, but by the early 1990s they were itching to move to larger, more technologically sophisticated headquarters. They began bargaining with the city for a new space, threatening to take their 5,000 jobs across the river to Jersey City. In late 1995, as part of a broad effort to stem corporate flight from Lower Manhattan, Joseph Rose, head of the City Planning Commission, closed a deal with the exchanges that kept their headquarters and their jobs from heading across the river: an incentives package worth nearly $100 million. The year before, the city and state had together put nearly $184 million toward building a new mercantile exchange headquarters in Battery Park City. To retain these venerable financial institutions, city hall and the statehouse together paid $165 million in cash. BPC for its part charges the mercantile exchange rent of $1 million per year, $16.5 million less than the market rate.

Battery Park City's development represented a vast and slow-culminating wave of development, but back in the early 1970s, the architectural and economic consequences of the WTC were just beginning to ripple outward. Immediately to the south, Bankers Trust combined a superblock between Liberty and Thames Street, filling it with a forty-story, late-modernist box. Just across Church to the east, Liberty Plaza consumed another two blocks: one for its tower, the other for its plaza. And to the west, atop the excavation from the twin towers, a satellite city on the Hudson was being mapped out: a broad new terrain on which the forces of urban development would soon contend.

RIPPLE EFFECTS

A rum and citrus river flowing through the World Financial Center causes the twin towers to lighten up and party down. A wallflower at the far right, Chase Plaza sits out the dance.

FISHING FOR BIG ONES IN DAVID'S POND

In exchange for disappearing nearly a half square mile of New York City's streets, overburdening its sewers, casting giant afternoon shadows over Lower Manhattan, and eliminating sixteen square blocks from the tax rolls, the Port Authority gave the city a magnificent gift: nearly 100 acres of new New York. Battery Park City, built on debris excavated from the "bathtub" and augmented with additional landfill, stands as the most visible and enduring consequence of the coming of the World Trade Center. But the trade towers themselves are a ripple effect of the building of Chase Plaza and the billion-dollar plan, whose reverberations, spreading in all directions, continue to be felt in the city today.

New housing had always been a consistent feature of David Rockefeller's downtown strategy, on the assumption that "a residential population would stimulate the development of shopping facilities, restaurants, places of entertainment and garage facilities." Deciphered, this meant that the right kind of housing would bolster the value of Lower Manhattan's commercial real estate. Even before the trade center, the original 1958 DLMA plan had called for "850 small residential units for middle-income occupancy" to be built on a superblock parcel on the east side adjacent to the Battery.

The plan anticipated the eventual construction of 4,000 housing units, the remainder of them south of the Brooklyn Bridge on the site of the Fulton Fish Market and what is now the South Street Seaport. Some of these units, the middle-income Southbridge Towers, were eventually built, though slightly to the west of the initial DLMA site. Thus was spared the old maritime district that has since been redeveloped as a tourist mecca. In 1959, a year after the first DLMA plan, Robert Moses shouldered into the Lower Manhattan housing game by proposing a development near Battery Park to be financed, in part, with federal and city slum clearance funds.

As originally planned for the east side, the WTC was to have encompassed an expanded New York Stock Exchange. But the Exchange had no intention of following the trade center

west and instead considered relocating to the parcel north of Battery Park designated for housing. Eventually the city rethought its downtown housing plans, and the Exchange decided that, for the moment, it was content where it was on Broad and Wall Streets—but not before several blocks northeast of Battery Park had been leveled. Among the seventy-odd buildings torn down as developers rushed to exploit what the DLMA termed an "optimum utilization of a prime part of the city's waterfront" were the eighteenth-century red brick home of the outspoken antidevelopment activist Maggie Petersen and the thirteen-story Seamen's Church Institute topped by a lighthouse memorial to the *Titanic*. Also bulldozed were three rare Georgian houses that the city had hoped to move elsewhere but acted too slowly to save. Three office towers—designated 1, 2, and 4 New York Plaza—now occupy the site, the buildings set, as one contemporary architect put it, in "the usual unnecessary plazas in the wrong places."

3 New York Plaza, standing just to the north of its numeric siblings, completes the cluster. Originally, 3 New York Plaza was the U.S. Army Building, also known by its address, 39 Whitehall Street. Within its fortresslike walls, for nearly a century, scores of thousands of prospective metropolitan-area inductees had been "injected, inspected, detected, and selected." Outside, in 1967, during "Stop the Draft Week," a protest against the Vietnam War, demonstrators, including pacifist pediatrician Dr. Benjamin Spock, were ridden down by police on horses only a quarter mile from "the heart pump of the capital blood that sustains the free world." In 1972, with the war winding down, the army abandoned the building, just in time for the downtown boom. Gutted, structurally augmented, and sheathed in green glass, 39 Whitehall was reborn six years later as the Lower Manhattan outpost of the New York Health and Racquet Club.

During the great preboom flux of the early and mid-1960s, the New York Stock Exchange continued to cast its wandering gaze over the downtown real estate scene in search of a new home. After lending its institutional gravitas to the east-side trade center and the Battery Park north redevelopment, it considered moving to a never-to-be-built landfill expansion of Battery Park. The Exchange also left William Zeckendorf holding the bag for a two-block parcel he had assembled at its request, just east of what would become the World Trade Center. The Zeckendorf property included Ernest Flagg's forty-one-story Singer Tower, which for a year and a half, from 1908 to mid-1909, had reigned as the city's tallest skyscraper. Flagg's landmark tower was torn down

and replaced in 1974 by Liberty Plaza, which was designed for but never occupied by U.S. Steel.

One of the most sinister late modernist structures ever designed, Liberty Plaza consists of a black box looming over a steeply sloping plaza. It is now managed by the restructured and considerably slimmed-down Olympia and York, the giant Toronto-based developer whose fortunes will soon be focused on in greater detail. One of Liberty Plaza's major tenants is New York Life. In a hard-fought 1996 "win" for city economic development officials, the giant insurance company agreed to move several hundred of its jobs back to the city—in exchange for $6.5 million in subsidies.

In the desperate early 1990s, it was difficult to imagine the downtown boom of the previous decade, much less the sublime 1960s when Chase Plaza and the World Trade Center led Lower Manhattan into what was generally agreed to be real estate Kingdom Come. In 1968, the Regional Plan Association ascended again for another bird's-eye view of the metropolitan area it had shaped and issued its second survey, with predictions for the postindustrial age. In the coming decades, the region as a whole stood to gain three million white-collar jobs, of which the Manhattan CBD's share might total nearly a million. To accommodate this anticipated upward "office job spiral," the amount of available commercial space would have to be doubled. Downtown, real estate logic argued that the expanded financial district lacked only one component: luxury housing.

CRASHED LANDING

Had David Rockefeller truly been possessed of Faustian powers, Battery Park City would have been joined by a twin on the shore of the East River. In 1967, the City Planning Commission proposed creating new land along the water as a bargaining chip in negotiating with Lower Manhattan developers. In 1972, David Rockefeller and Mayor Lindsay got together and repackaged the idea as Manhattan Landing. Described by the *New York Times* in David-like language as "a scheme to transform the ghost town into a 24-hour city," the $1.2 billion development was to have been built atop a platform extending out into the river and stretching a mile northward from the Staten Island ferry terminal to the Brooklyn Bridge. "We're adding more land," Lindsay quipped, "because we're not satisfied with the size of the island we bought."

Manhattan Landing was expected to receive its financial jump-start from the newly created Housing Development Corporation. The HDC would be authorized to sell $100 million in state-backed bonds toward construction of 9,500 luxury apartments, several office buildings, a hotel and indoor sports complex, a park and marina, oceanographic and seaport museums, and a home for the ever-restive Stock Exchange. Platform construction was chosen over landfill to encourage development, since a platform was considered part of a building's structure and therefore subject to tax depreciation.

Unlike the plans for Battery Park City, those for Manhattan Landing made no pretense of including low- or middle-income housing. Echoing vintage David Rockefeller phraseology, the *New York Times* editorialized that economically mixed residential development would be "suicidal on land that costs $40 a square foot to create." Despite fierce protests from progressive Democrats and housing advocates, Manhattan Landing cleared every stage in its approval process, before foundering in 1976 on the shoals of the city's fiscal crisis. Ironically, it is likely that Nelson's imploded economic policies ultimately administered the coup de grâce to David's plan. The state legislature controlled the city's exhausted borrowing power. In the dark days of near bankruptcy, it would be difficult to fund one such project, much less two. It seems that David's Manhattan Landing had to crash so that Nelson's Battery Park City might soar.

WIDE-OPEN SPACES

One would think that the sighting of nearly a hundred acres of virgin real estate just off the coast of Lower Manhattan would be regarded by New York's developers and planners as a manifestation of the divine presence, and that almost instantly, skyscrapers would sprout on the desert. Yet it took twenty years for anything resembling a "city" to rise there, and the planning process was so fraught with false starts and missteps that in retrospect it seems remarkable that the trade center's landfill was built on at all.

Initially, the auguries for development at Battery Park City (BPC) seemed propitious: Its residential and office blocks would not have to shoulder their way into a preexisting and overbuilt urban order. Rather, they could freely colonize an uninhabited urban moonscape spun off by the centrifugal force of downtown development. Thus, despite its physical connection to the island, Battery Park City has the artificial feel of

a gated community—a kind of privileged Gaza Strip. Its aura is that of a world apart—even from the most recondite Manhattan enclaves—and this sense of remove is reinforced in the real world by the twin barriers of the trade center superblock and the zooming traffic of West Street.

The process by which this strange urban hybrid moored itself to the Hudson River shore began with David Rockefeller's recommendation that apartment houses and a hotel be built on the landfill soon after the WTC plan had transited crosstown. But the chief strategic role in Battery Park City was played by brother Nelson in his dual aspects of master builder and governor. The former threw himself into the role of planner, while the latter pushed through the fiscal mechanism: yet another new public corporation, the Battery Park City Authority (BPCA).

When Nelson A. Rockefeller Park was officially dedicated at BPC in June 1996, David Rockefeller spoke at the ceremony. Although lauding his late brother as an urban visionary, he nonetheless claimed a modest share of credit for the enterprise, given his role in the development of the trade center. Nelson's words are inscribed on his monument at the water's edge: *There is nothing wrong with America that courage, commitment and love cannot conquer . . . if only we believe in ourselves.* But faith alone cannot raise buildings on a landfill, and David omitted mentioning that start-up loans to the BPCA from Chase Manhattan and J. P. Morgan were followed by a line of credit from Albany and hundreds of millions in bond issues.

The first comprehensive proposal for the use of the new land emanated from the Wagner administration in 1963 via the Department of Marine and Aviation, which saw the trade center's burial of the downtown west-side piers as a final opportunity to resurrect its port facilities and rail freight links. The department's plan bundled the landfill into a comprehensive, forty-year, $670 million development of the Hudson River waterfront from Battery Park north to Seventy-second Street. Incorporated into the proposal were a convention center and observation tower, heliports, and recreation areas. In addition, the plan called for a complete refurbishing of marine freight facilities and passenger terminals.

The Lower Manhattan module was to consist of eight office buildings, eighteen apartment houses, parks, restaurants, a yacht basin, and a forty-story cylindrical hotel at the landfill's southernmost tip. The office and residential structures would project out on platforms over freight docks and cargo areas running parallel to the shore. Stretching north along the river, additional berths and cargo-handling facilities

would adjoin a huge distribution center linked to the then-existing rail yards.

The department's plan fell afoul of both David Rockefeller's DLMA and William Ballard, chair of the City Planning Commission and a close associate of Nelson Rockefeller. Though elements of the plan: the passenger terminal, convention center, and heliport were eventually realized along the Hudson—albeit in forms that differed from the original plan—subsequent proposals for Battery Park City steered clear of any throwbacks to shipping or industrial uses. The planning wisdom of the moment regarded housing and services for financial district office workers as crucial to bolstering the values of greater Wall Street— thereby enriching the land for additional office development. So it was to this end that the trade center's landfill was ultimately dedicated.

At the close of the 1990s, Battery Park City—hailed in David's speech as "the largest and most complex single real estate development in this country"—comprised six million square feet of office space in the World Financial Center, clusters of luxury housing units, a high school and intermediate school, two marinas, an esplanade, playgrounds, and recreation areas. Building continued, "going like the hammers of hell," as BPCA chair James F. Gill put it, and plans included a multiplex cinema and two luxury hotels. Even with the addition of three new high-rise apartment towers at the northern tip, plenty of open space still lay undeveloped.

Given the fluctuations of the real estate market, the achievement of maximum density at Battery Park City may not occur in the first decade of the new century. Given also the shifting fortunes of many would-be renters, new luxury apartments may prove a tough sell. As late as mid-1998, Feathered Nest, the exclusive broker for Tribeca Bridge Tower— a residential property owned by the BPCA—was still optimistic that renters would flock to the $2,000-a-month one-bedroom apartments. But downtown, streetwise pigeons knew they were in for tough times before the real estate brokers did. Peregrine falcons—birds of prey that can dive at 200 miles per hour—had returned to Lower Manhattan. After decades of absence, the raptors were building nests and multiplying in the ornamental spires of the old Wall Street towers.

BROTHER AGAINST BROTHER

Battery Park City's basic concept, though hardly its built realization, grew out of a 1966 scheme of Nelson Rockefeller's, proposed in what

Ada Louise Huxtable called "one of his Baron Haussmann moods." Nelson's plan envisaged a "coordinated community," retaining the marina as well as the residential and commercial components of the earlier Department of Marine and Aviation proposal—minus the piers. The original scheme featured rows of tall residential Corbusian slabs spaced at precise 400-foot intervals. It also reserved 20 percent of the housing units for low-income families. At the time, the federal Mitchell-Lama limited-profit law provided state subsidies for low-income units in developments where 80 percent of the apartments rented at market rates. This formula later was adapted to a tax-incentive program for luxury housing developers, and in 1998 an 80/20 building in BPC's so-called North Neighborhood finally joined its more elite brethren to the south. Nelson's satellite city would also have included three schools, two churches, a synagogue, a library and museum, a "civic center," and a 2,000-room hotel.

Mimicking the shape of things to come just across the highway at the trade center, Rockefeller family architect Wallace K. Harrison sketched out Nelson's futuristic "city" with a pair of twin flat-topped sixty-story towers anchoring each end of the landfill. If these four towers had been built, the Lower Manhattan skyline would have looked, for better or worse, as though the trade center had taken its quadruplets for a stroll along the Hudson. Had another of the surreal proposals floating around Lower Manhattan been realized, this clan of squared-off towers would have looked up at a "space needle"—an observation tower twice as high as the WTC proposed for a landfill extension of the tip of Manhattan.

Beyond indulging his family's legendary propensity for building with superblocks, Nelson's Battery Park City plan was also fueled by the political benefits associated with $600 million in state borrowing power pumping into a city whose resources for financing middle-income housing had been exhausted. The endorsements of Mayor Lindsay and city planning chairman Ballard—the latter pronounced the scheme "a good illustration of the way to use waterfront land"—were echoed by the *New York Times*, which lauded Nelson's "beguiling vision." But forward momentum on the landfill would prove short lived.

Haggling between the governor and mayor, primarily over the housing mix, was overshadowed by swiftly escalating public imbroglio between none other than Castor and Pollux themselves. David feared that the homunculus trade centers Nelson wanted to build at Battery Park City might prove "hurtfully competitive" with office space closer to Chase Plaza. Clearly Nelson's attempt at St. Petersburg–on-the-

Hudson could not be permitted to jeopardize the family's interests. Protesting the city's powerlessness in this battle of titans, one Lindsay official complained, "The question is whether we do Nelson's plan or David's plan. We can't fight those guys down there."

But this collision of fraternal agendas masked a wider convergence of goals that had grown out of the 1958 DLMA plan, and one on which David, Nelson Rockefeller, and Lindsay, the city's banker-mayor, could readily agree: There would be no piers or manufacturing to impede the growth—or threaten the value—of the downtown business district. As plans ground incrementally through the city process, hemorrhaging public funds at the rate of $4 million a month, Charles J. Urstadt, a longtime Nelson aide and now the BPCA's chair, boasted "we have thought big. We have thought beautiful and we have thought bold." Finally, in 1972, the political and economic interests sparring over the future of Battery Park City achieved a joint victory when Lindsay eliminated low- and middle-income housing from the landfill, pushing it to a safe remove in Harlem and the South Bronx.

MIRAGE-ON-HUDSON

"Will you be living here in 1974?" queried the headline of the Battery Park City Authority's ad in the June 5, 1969, *New York Times*, at a time when the landfill prairie still conjured up visions of a pioneer utopia.

> How would you like to live in a "town" the size of Greenwich, Connecticut, . . . yet still be in Manhattan?
>
> How would you like to be only 15 minutes from midtown? . . . To walk to work downtown? . . . To watch the sun set over the Statue of Liberty from your apartment?
>
> YOU WILL BE ABLE TO AT BATTERY PARK CITY.
>
> Battery Park City is a planned community being developed by a nonprofit public benefit corporation established by the New York State Legislature and will operate under a master lease from the City of New York.
>
> Battery Park City is rising from 118 acres of "urban wasteland" along the Hudson River in lower Manhattan. Eventually it will provide housing for 55,000 New Yorkers of all income levels. Some 35,000 people also will work in Battery Park City.
>
> Battery Park City will not just be a development on a bigger scale than others. It will be a complete community, designed by sociologists and city planners as well as architects and engineers. It will have

everything a self-contained community needs—schools, fire and police stations, stores, services, amusements, restaurants and parks.

Which may explain why the Citizens Budget Commission recently described Battery Park City as "by far the most dramatic illustration of the use of 'landfill' in New York to date," adding that such "new" land presents an "unparalleled opportunity to do something about New York City's housing shortage."

And why the *New York Times* editorialized . . . "Battery Park City's billion-dollar cost and its potential for jobs and housing are impressive even by New York standards. But most impressive of all is the sophisticated professional planning that combines a complete range of services and pleasures with massive amounts of construction and the optimum use of waterfront for a superior quality of New York life."

If you think you might like to live in Battery Park City, you can help us anticipate apartment demand by filling out the box below and returning it to the Battery Park City Authority. You will be placed under no obligation. In return, we will keep you informed of our progress.

"IS THIS ANY WAY TO PLAN A CITY? YOU BET IT IS."*

*Ada Louise Huxtable, noted architectural critic, commenting on Battery Park City.

Beneath a Wallace, Johnson, and Conklin rendering of what appears to be a lunar colony, an "apartment needs survey" coupon solicited information on a range of subjects including family income and apartment price range. But until low-income housing disappeared from the plan, the landfill would attract little active development. So no matter how you responded to the survey, if you were living in Battery Park City in 1974, you were living in the sand.

SAND CASTLES

Over the years, as the market for Lower Manhattan office space boomed, then collapsed in the wake of its two-hundredfold multiplication, and as financing alternately appeared and dematerialized, enormous quantities of public money and private expectations poured into the landfill, yet practically nothing grew there. In 1967, New York City leased the tract to the Battery Park City Authority until 2066, and the bonding money began to flow. But it wasn't until 1973 that Sam LeFrak, known for the huge middle-income development in Queens that bears his name, began developing infrastructure and enlarging the landfill. LeFrak initiated work

on Battery Park City's esplanade and ultimately built Gateway Plaza—an unlovely coupling of high rents with Brezhnev-era design, leveraged with $116 million in bonds intended for middle-income housing.

Committed as he was to building housing for New York's middle class, LeFrak's dogged efforts were hardly altruistic. He was hoping to get an inside track on building BPC's commercial core, for which nearly every major New York developer—among them Harry Helmsley, Paul Milstein, and Jerry Speyer—at one time or another submitted bids. Eventually, frustrated by the glacial pace of BPC's progress, LeFrak took his considerable energies westward across the Hudson. There, on a vast 600-acre swath of waterfront, he is building Newport City, the largest mixed-use project in the country and still growing—located, as his promotional slogan ran, "just a tube stop from Wall Street."

In the course of Battery Park City's fitful and scandal-plagued unfolding, the diverse proposals of at least a dozen city, county, state, and private agencies—as well as Harrison's original design and his joint efforts with Philip Johnson and William Conklin (familiarly known as the "Buck Rogers" plan)—vanished into the landfill without leaving a trace. In 1975, with LeFrak's housing construction finally set to begin, the fiscal implosion of Nelson's Urban Development Corporation made further public borrowing impossible, and again the project ground to a halt.

The development strategies that had produced the trade center and spilled over onto its landfill now culminated in a one-two punch to the city as a whole. As hundreds of thousands of manufacturing jobs left New York for lack of affordable space, construction virtually ceased. A superabundance of empty downtown offices—in the early 1970s, 130 brokerage firms merged, folded, or moved out of state—coincided with the disastrous, seemingly unstoppable loss of thirty thousand housing units per year.

In the wake of the city's fiscal crisis, its economic fortunes fell into the hands of the Municipal Assistance Corporation, known as Big Mac and chaired by Lazard Frères banker Felix Rohatyn. New York's political mythmakers credited Rohatyn with "turning the city around" and reestablishing its creditworthiness through a policy of rigorous austerity. But one of Rohatyn's strategies for demonstrating New York's fiscal rigor was bulldozing slums as part of an official city policy of "planned shrinkage" that also closed hospitals, police stations, and firehouses in some of the city's poorest communities. Planned shrinkage echoed

Robert Moses's schemes for emptying neighborhoods but made no provision for replacing the housing it destroyed.

Desperate now to build anything on the landfill, city and state officials considered moving what would eventually become the Jacob K. Javits Convention Center to Battery Park City. Had the center been brought into proximity with the WTC and its planned Vista Hotel, what the *Times* called the "mutuality of interest among [these] three faltering endeavors" might have produced a tripartite version of Dewey's 1947 trade mart scheme. But the convention center also lacked financing, and with the trade towers "still embarrassingly short of tenants," the PA was in no position to lend its support. As the landfill celebrated its tenth birthday, the only completed structures on it were the $25-a-seat bleachers that a private company had installed for viewing the Bicentennial tall ships procession.

One indication of how acute the city's construction crisis had become was that Peter J. Brennan, back from the Nixon White House to resume the presidency of the Building Trades Council, made the extraordinary promise of "labor peace" if only someone would start building high-rises on the empty beach. Brennan adopted a less conciliatory tone when he and Harry Van Arsdale, Nelson's labor boss and Central Labor Council head, along with several hundred hardhats, burst into a legislative session on the stalled project and seized the podium to demand that construction begin immediately.

For eleven years, BPC Authority chairman Urstadt kept the faith—and his job—completing the landfill and securing $82 million in federal mortgage insurance to indemnify possible losses by developers. Urstadt was fired by Governor Carey in 1979, the same year the BPC Authority was subsumed into the state Urban Development Corporation (UDC). Nearly two decades later, in 1998, Urstadt, by then CEO of a Greenwich, Connecticut, real estate development company, was reappointed to the BPCA board.

By the close of the 1970s, political maneuvering over the landfill brought the city around full cycle in the epic of lose-lose propositions that had started with the Port Authority's condemnation of Radio Row seventeen years before. Powerless to develop its "gift" from the Port Authority without state help, the city leased the landfill to the BPC Authority, another state agency, for ninety-nine years. With Battery Park City draining away precious municipal dollars and showing no discernible momentum toward revenue-producing construction, Mayor Edward I. Koch and Governor Hugh Carey worked out a deal. The state

would condemn the landfill and assume responsibility for its development. Under the terms of the agreement, ownership of the land would revert to the city at an unspecified point in the future when all of its development costs were paid off.

Koch, in an early demonstration of his legendary philanthropy toward developers, announced a special 50 percent tax abatement for whoever built Battery Park City's first two million square feet of office space. Carey, for his part, prevailed upon the legislature to appropriate $65 million to keep the landfill from sliding into default on its $200 million in "moral obligation" bond debt. The mayor-governor tag team used the anticipated construction of a new American Stock Exchange at BPC to leverage additional federal and state moneys. By the time Amex pulled out of the deal, a new $293 million BPC bond issue had been awarded a triple-A rating from Standard & Poor's, based on a highly unusual pledge by the federal government to settle any claims within six months.

With the landfill now under the state's aegis, a set of comprehensive new architectural guidelines that radically revised Wallace, Johnson, and Conklin's "Buck Rogers" plan was issued by Cooper Eckstut Associates. Decisively repudiating modernist principles in favor of a style *Times* architecture critic Herbert Muschamp termed "past-o-rama," the Cooper Eckstut guidelines advocated that "variety [should be] purposely sought to avoid any appearance of a 'project' look or superblocks, and instead provide the complexity and interest normally associated with older and more established neighborhoods."

In 1981 *Times* critic Paul Goldberger observed without irony that BPC's mix of town houses, low-rise apartment buildings, and high-rise towers anchored by an office core billed as "Rockefeller Center II" would "create by artificial means the sort of urban design that tended to occur naturally in the apartment buildings of the 1920s in places such as Central Park West, Gracie Square and Gramercy Park." What had unquestionably occurred, by natural means or otherwise, was the disappearance of any mention of "affordable" housing in the BPC plan.

ART ON THE BEACH

Into the mid-1980s, the fenced-off landfill played host to a variety of illicit uses as well as two officially sanctioned cultural projects. The first, Art on the Beach, initiated in 1980 by the not-for-profit arts organization Creative Time, turned the landfill's northern acres into a sculpture

park, open-air concert hall, and experimental theater. In retrospect, Art on the Beach—or perhaps the undeveloped beach itself—may have been Battery Park City's shining moment, since the dunes lent themselves to imaginative flights that the subsequent architecture foreclosed.

In 1982, Agnes Denes, under the sponsorship of the Public Art Fund, spread topsoil and planted two acres of North Dakota wheat at the southern end of the beach. Her idea was to create "an intrusion of the country into the metropolis, the world's richest real estate." One subversive effect of Denes's "urban waves of grain" rippling at the water's edge was to nudge those who saw them into questioning their assumptions about what land, and the city, are for. Walking on the sand along the Hudson, in the shadow of the trade towers, one could imagine, however fleetingly, that New York's future was an open field—a land-ocean of possible cities.

Though it would be hard to mistake today's aesthetically muted Battery Park City for the fantastical proposals of the 1960s and 1970s, it bears—no less than does the trade center—the indelible brand of Lower Manhattan's factory of real estate ironies. Its residential clusters (Gateway Plaza, Rector Place, Marina Towers, Cove Club) and the World Financial Center office core—so reassuring visually, even toy-like when set against the scaleless columns of the twin towers—nonetheless serve as a built index of "supply-side" economic ideology sculpting the city after its own image. But in order to appreciate the Battery Park City environment fully, one must journey there.

DOWN BY THE RIVERSIDE

Though it is served by city bus lines, Battery Park City lies at some remove from the subways converging around the World Trade Center, so most people come here by private car or taxicab, on foot, or by bicycle or rollerblade. In the early 1990s, a new ferry service was instituted between the foot of the World Financial Center and the venerable copper-roofed Lackawanna railroad terminal in Hoboken.

Approaching via Chambers Street, just before crossing West Street—here a six-lane street-level highway—one sees a single boarded-up four-story brick building. Standing in an otherwise vacant lot covering the entire block, this is the only surviving holdout from the great Washington Market clearances of the early 1960s. Across West Street, the northern edge of the landfill is anchored by Stuyvesant High

School, an elite public math and sciences academy, housed in a new $300 million facility. From here, a graceful staircase and ramp wind downward to the expanse of Hudson River Park. In temperate weather, the curving stone balustrades become a daredevil rollerblading course, offering some of the most exciting unofficial sporting thrills to be witnessed downtown. Until residential construction began here in 1997, the whole of BPC's northern tip felt like a vast waterfront refuge—its expansiveness contrasting with the density of the built-up city to the east.

The park itself is divided into an adroit matrix of coherent, eminently approachable spaces—open yet intimate. No frozen idealizations of civic virtue or equestrian heroism claim our veneration from atop their pedestals. Instead, we are urged to relax and have fun. Small, rotund bronze sculptures by Tom Otterness crop up, seemingly at random, lending their subversive antimonumental edge to spaces that might otherwise feel too calculatedly benign. Amid a cartoonish cat stalking an equally stylized bird perched on the stone balustrade, near a bulldog tethered to a water fountain, and polymorphous creatures cavorting on the ground among miniature, anatomically correct humanoids, it is possible to imagine for a moment that you are a child, inhabiting a conspicuously playful world, and that the immense, rigid towers looming in the background are an embarrassing mistake made by "the adults"—the kind of error it is best not to let them know you noticed.

Ironically, this view from the north end of the park is the only spot from which the World Trade Center approaches being in scale with anything at all. This effect is due to the mass and sloping roofs of Cesar Peli's World Financial Center towers, which, from this perspective, act as foothills, almost managing to bring the gigantic twins rising behind them into a unified visual field. It is a tribute to Peli's interpretation of the Cooper Eckstut guidelines that this effort nearly works. Yet the enduring legacy of Yamasaki's design is that Peli's attempt toward integrating the trade towers only brings their isolation into sharper relief. For its part, the Port Authority made sure its monumental towers would continue to be "noticed" by mandating that commercial buildings on the landfill rise to only half the height of the WTC or less.

Between the esplanade and World Financial Center 4, Merrill Lynch's north tower, stand the headquarters and trading floors of the Mercantile Exchange, relocated from the trade center in the late 1990s. Walking south along the esplanade toward the North Cove marina on a temperate evening, even well into the fall, we hear a strange and unfamiliar noise building gradually in volume. Are we approach-

ing the preserve of some great flock of maritime birds? As we round the corner, the cause of this acoustic mystery becomes clear: A multitude of people have gathered, their voices mingling at the water's edge, as the after-work crowds overflow Edward Moran's Bar and Grill and pour into North Cove Park. This is indeed a lovely place to sit over drinks and conversation, particularly at sunset, as varicolored neon reflections of the giant Colgate clock begin to ripple toward Manhattan from the waves by the New Jersey shore. Illuminated by the glow spilling through the glass panels of the Winter Garden, one can read the Walt Whitman poem woven in iron letters along the marina railing:

> City of ships!
> (O the black ships! O the fierce ships!
> O the beautiful, sharp-bow'd steam-ships and sail ships!)
> City of the world (for all races are here;
> All the lands of the earth make contributions here;)
> City of the sea! city of hurried and glittering tides!
> City whose gleeful tides continually rush or recede,
> whirling in
> and out, with eddies and foam!
> City of wharves and stores! city of tall facades of marble
> and iron!
> Proud and passionate city! mettlesome, mad, extravagant city!

CITY WITHOUT A BIOGRAPHY

Viewed in early morning light, the housing blocks of Battery Park City south of the World Financial Center roll out in a nearly flawless simulation of an "organic" New York streetscape. Seven thousand people live here now in more than four thousand residential units. Along South End Avenue, BPC's main thoroughfare, shops and signage are set back discreetly behind colonnades. Here and on the side streets, stone facings at ground-floor level, combined with earth-toned brickwork, occasional terra cotta detailing, and roof pediments, recapitulate building conventions of bygone eras and provide textural evidence of urban authenticity. Lending credibility to the ruse that BPC's streetscapes are "preserved" rather than newly hatched are the black cast-iron lampposts, particularly the "shepherd's crooks" that in popular iconography have come to signify Old New York.

Though the imposture of timelessness almost works, the sense of Battery Park City as an implant rather than an interweave of the urban fabric cannot entirely be masked. In some measure this is because it is severed from the body of Lower Manhattan by the six-lane highway called West Street. Plans to detour the highway along the Hudson's new shoreline determined the orientation of the 1979 Cooper Ekstut scheme. But the highway stayed in place, and now Stanton Ekstut, one of BPC's principal architects, admits that at present "the project essentially turns its back to the city."

In this shunned city on the World Trade Center side of the highway, an urban conglomerate has accumulated, however haphazardly or inequitably, through generations of territorial struggle between classes and urban ideologies. But on the landfill to the west, a latecomer has risen, a city out of whole cloth, pretending it has been here all the time. A sincere and well-meaning attempt to plan the unplannable, the result is a cityscape without a biography, a perfected urban surface bearing no "distinguishing marks or scars."

East of the highway, entire streets—among them Fulton, Dey, and Cortlandt—disappeared beneath the World Trade Center's superblock. But Battery Park City serves as a terrain of incongruous appropriation rather than obliteration. Nowhere is this clearer than in the case of Thames Street. Running just south of the trade center, this venerable lane edged by mostly older office buildings terminates at Greenwich Street only to reemerge three blocks farther downtown on the BPC side of the highway as *West* Thames Street, now spanking new—if aesthetically antiqued—tree-lined and residential.

Here on the streets of the South Neighborhood, human presence legitimizes what for now remains a simulacrum of urban life. And despite, or perhaps because of, BPC's painstakingly thought-out design and fastidious maintenance—sidewalks nearly unpeopled and virtually spotless, and roads too broad for their traffic—a sense of desolation pervades the streetscape. It is as though a ravaging event occurred here that sucked up the vibrating energies of the city but left its visible form in place.

In the mid-1990s, the Museum of Jewish Heritage, A Living Memorial to the Holocaust, was built at the southern tip of the landfill. This somber, hexagonal gray granite structure, taken as a triad with the Statue of Liberty and Ellis Island, acknowledges in architectural language the displacement, immigrant aspirations, and assembly-line annihilation that marked social procession toward a city of towers. From this vantage point, one can also triangulate the residential units of Bat-

tery Park City, the World Trade Center, and Chase Plaza: three distinct iterations of the rational, corporate-minded planning promise to transform, or at least contain, the city's propensity for uncontrolled development. But one does not have to venture far from these emblems of the city's postindustrial ideal to encounter a striking visual throwback to the era of Morgan's fortress, never entirely left behind.

CITY OF STONE, CITY OF PAPER, CITY OF AIR

Straddling Liberty Street where it extends onto the Battery Park City landfill, just across West Street from the southwest corner of the trade center, stand two nine-story octagonal turrets. These twin buildings, connected to one another via a walkway, form the World Financial Center's "Gatehouses." The turrets serve to link the Dow Jones tower with the Merrill Lynch tower in a figurative bastion guarding the entrance to the Gateway Plaza residential development.

Enter the Gatehouses or any of the World Financial Center (WFC) buildings and one is immediately struck by the richness of the materials used and applied with a level of craftsmanship that would seem to predate their construction by a century. The application of diverse patterns and colorations of stone facing to nearly every surface works to emphasize rather than undercut the proportions of Peli's design.

The formal elegance of the WFC's architecture—its "monumentality with a human face," as *Times* critic John Russell put it—presents an extraordinary backdrop for the multiplicity of paradoxical images and sensations to be found there. As waves of Merrill Lynch employees rushing toward the elevator banks dip their magnetic identity cards into turnstile slots, a woman in a ragged coat with a battered Fairway shopping bag sits nearby on a six-inch-thick travertine bench picking scabs off her leg and dropping them onto the white marble floor. Mounted on the ceilings of passageways lined with upscale shops and restaurants, monitors flash news of luncheon specials, clothing sales, booksignings at Rizzoli's, and Alvin Ailey concerts in the Winter Garden—Peli's barrel-vaulted homage to Paxton's Crystal Palace, replete with a grove of forty-foot palm trees and a semicircular marble staircase that doubles as an amphitheater. Today, midway up on the landing, two just-married Asian couples waltz silently before their relative's video cameras as though atop a wedding cake, the brides' trains sweeping the polished floor. From this vantage, the Hudson River and the ever-burgeoning development on

the Jersey shore are strikingly framed through the arc of the Winter Garden's transparent frontage.

Descending to pause amid the palm trees, surrounded by gentle luminescence, the hum of voices, and wafting aromas of food from a nearby grill, it is possible for a moment to convince oneself that if the World Trade Center, however indirectly, made way for the building of this magnificent space, then perhaps it was worthwhile after all. Perhaps New York's bygone midcentury master builders, with all their immense power, *did* know how to plan for the future—how to build for the well-being of a great city and its people.

But underpinning the grace and apparent solidity of the World Financial Center and the expansive beauty of Battery Park City's public spaces is a history of specious planning and even shakier economics. Emblematic of these contradictions are the Winter Garden's palm trees, which in their habitat can live up to a century. Here, the original trees lasted less than a decade before they weakened from lack of natural light and threatened to topple over, prompting replacement of the entire grove. And at Battery Park City, the effort to keep any structure vertical requires extraordinary engineering efforts as well. One former Cooper Eckstut consultant complained that the landfill had "no bearing capacity because it was so poorly laid." Harking back to Manhattan Landing's platforms, he conceded that it would have been easier simply to "build on the river," since bedrock is seventy feet down.

The bench on which we sit, looking out over the river, seems solid. But it was supplied by Olympia and York, the company that financed the glass above and the acres of polished stone around us. In the late 1980s, O&Y nearly collapsed, incapable of paying interest on $5 billion on office complexes it leveraged from commercial paper futures. Narrowly skirting outright bankruptcy, O&Y presides over an empire of imploded real estate speculations in Canada and England and 17 million square feet of high-risk commercial space in Lower Manhattan.

O&Y closed the deal to develop the World Financial Center because—of all the BPCA's many suitors—it was the only one who, finally, said the right words. In a mid-1980 meeting, O&Y's codirector Paul Reichmann went straight to the heart of the matter by asking BPCA president Richard Kahan, "If I were to guarantee these bond repayments, would I be on the right track?" The giant Toronto-based developer had made Kahan an offer he could not afford to refuse, and the BPCA rewarded O&Y with $20 million in annual tax abatements. Of course, neither Kahan nor anyone else asked Reichmann, *Guarantee the bonds with what?*

As much as the World Trade Center and, later, Battery Park City served as architectural symbols of the financial district's manifest destiny in Lower Manhattan, they also represented publicly funded acts of faith in an infinitely expanding symbolic economy. During the bust of the early 1990s, the developers of BPC's Cove Club condominiums sold 57 of 163 units at auction, receiving only 75 percent of the asking price and leaving 78 units unsold. Between 1987 and 1994, the price of a one-bedroom condominium in the Hudson View West development dropped by half, while maintenance costs doubled.

Will Battery Park City continue to generate the revenue to keep up its bond payments, with thousands of new luxury apartments coming on the market in the early years of the new century? What happens if American Express or another of the WFC's big tenants decides to move to Sam LeFrak's Newport, the development the *Times* called a "rival skyline across from Lower Manhattan?" What if Merrill Lynch continues downsizing?

Just prior to the collapse of the Soviet Union, a state dignitary taking in the sights of Battery Park City asked then-governor Mario Cuomo why he was proud that the government built houses for rich people. Cuomo countered that "from the wealth we derive from the wealthy people who live there, we will rip off as much as we can and put it into affordable housing." Walking down the esplanade on a warm spring afternoon, one hears the Hudson lapping at the breakwater, the shouts and laughter of children in the playground, and the sound of the ferry horn as the boat casts off for New Jersey. Gazing over the lawns dotted with sunbathers, watching as a setter leaps to catch a Frisbee, one is tempted, as *Empire State Report* editor Jeff Plungis put it in 1992, to be "glad the state got into the luxury housing business."

Until, that is, one sits down, does the math, and tallies the economic and social cost. Since the inception of Battery Park City thirty years ago, its bond issues have generated several hundred million dollars for the city's use. But only a fraction of this revenue found its way toward rehabilitation or building of low- and moderate-income dwellings. After twenty-five years, BPC began making its first in-lieu-of tax payments to the city in 1989. Through the 1990s, this eventually increased to approximately $37 million. But during the same period, the city was granting abatements to the World Financial Center and the BPC residential properties at the rate of $126.3 million every year—

and this before a spate of building in the North Neighborhood pushed developer subsidies even higher.

ILLUMINATION, THE DEVASTATORS

One morning in March 1992, you stared up at the World Trade Center towers and asked them for the first time: *Who are you?* Though in one way or another you had been having a conversation with the city where you were born for as long as you could remember, you had never addressed the towers directly before. This absence of dialogue was odd, because you saw them every day—and because you and the World Trade Center were children of the same moment in the life of the city. The twins had risen on the skyline just as you were beginning your momentum toward adulthood.

New York, the city of towers, the city always in the process of extraordinary transformations, had already woven many of its stories into yours by the time you started writing about the WTC. In years past, on weekends, you had bicycled through the deserted canyons of Wall Street. Later on as a messenger, you had maneuvered your bike through the weekday traffic, down the same streets, your bag filled with prospectuses, contracts, and the legal instruments necessary for invoking mergers and leveraged buyouts.

When you switched to driving a taxicab, you inched along the city's clogged arterial highways in the afternoon rush hour trying to get your passengers to Kennedy in time. Picking up at International Arrivals, you sped a fare home to Staten Island across the ribbon of the Verrazano Bridge. Stuck two blocks from Times Square on New Year's Eve, you got your first and only hundred-dollar tip. At 2 P.M. you drove an aide from a hospital on the upper East Side to her home on 145th Street. And in the earliest dawn light, you rumbled the cab over the planks of a pier in South Brooklyn, bringing four passed-out sailors on shore leave back to their drydocked ship. From the end of the pier, the Statue of Liberty seemed to stand heads above the tallest towers.

When you stopped driving cabs, you played with your band in the city's parks and public spaces—even at the foot of the World Trade Center. Playing music was how you met Ellen Haag. Now she's married and a mother of three children, raising them in Flushing where the jets landing at LaGuardia practically graze the TV aerials. Back then, Ellen was a musician, teaching at Marta Valle JHS 25 on Manhattan's Lower East Side. Some of her students told her they were interested in

studying music too, but since there was no official program at the school, Ellen started a drum and percussion ensemble that the students named the Devastators.

One weekday at noontime in the late 1980s, a city-sponsored program called KidsArt brought the Devastators down to the Battery Park City esplanade to display their talents. Governor Cuomo, anticipating that the World Financial Center was poised to begin generating cash for the city and state, had recently told BPCA president Meyer S. "Sandy" Frucher that the time was right to "give the project a soul." As the Devastators, first hesitantly and then with increasing bravado, laid down their samba-inspired rhythm grooves, the lunchtime crowd gathered in front of the Winter Garden danced and applauded. When the concert was over, the Devastators packed up their instruments and headed back to school, two miles northeast of Battery Park City's South Neighborhood. "Some people argue that there is a moral obligation to include affordable housing," Frucher said in a 1992 interview, "but every community does not need to be economically integrated."

Walking back to the World Trade Center, across the footbridge over the streams of West Street traffic, you suddenly remember a slogan you saw written on a wall in Paris in 1968: *sous les pavés, la plage*—beneath the cobblestones, the beach.

CITY OF A MILLION CENTERS

The beach beneath the cobblestones—it is just such a free play of the associative mind that advertisers and icon makers of all kinds have invoked in the proliferating images that rippled out from the trade center almost from the moment it was built. Many of the mass-mediated images of the World Trade Center appropriate it as a symbol of supreme power, while others deal with the towers' enormity by transforming them into playthings, to be manipulated by the imaginative will.

Thus, from the great factory of consumer culture, millions of World Trade Centers have emerged. Early on, New York television station WPIX used the twin towers as an emblem of its channel designation: the number 11. Over the years the trade towers made cameo appearances in the form of novelty license plates and on countless postcards—including one featuring a photo of a hard-hatted steelworker atop the transmission mast mooning the region from a great height. Rendered in silhouette form, the towers' symmetrical doubling has

been used as a kind of visual shorthand signifying "New York" and painted on the sides of scores of commercial vehicles. Cartoonist R. O. Blechman drew the trade towers as gigantic twin windmills, a gently ironic comment on the gulf separating the twentieth-century city from its roots in Nieuw Amsterdam.

After the explosion that claimed six lives, bookstores in the East Village sold packages of mordantly satirical "postage stamps" depicting the twin towers billowing smoke and haloed by the trope "Welcome to New York." And on at least one occasion, the trade center's image was appropriated for an ironic usage all the more unsettling for its lack of intentionality. As part of a national campaign for Makers Mark bourbon, the trade towers' upper floors, along with those of the World Financial Center, were "dipped" in red sealing wax by photo retouchers to create a visual association with their product's distinctive branding scheme. Montaged into the high-rise real estate, a gigantic amber liquor bottle took its place among the towers of Lower Manhattan, all dripping thick red liquid from their tips. In local ads and billboards, this unwittingly ghoulish skyline, rendered in photorealistic detail, was surmounted by the slogan "Mark of a Great Town."

In the main, though, the postbombing status of the trade towers as the site of a publicly acknowledged tragedy served to soften images of their rigidity. Having become "human" in a new sense, their iconic value was appropriated for playful messages ranging from satirically humorous to erotically charged. In 1994, The Gap advertised its spring line of espadrilles by standing two canvas shoes up next to one another under the headline "New Twin Towers with Water View." The next year, on a *New Yorker* magazine cover, the towers served as the high points on a punk rocker's mohawk hairstyle.

These, among many other appropriations, served to raise in the imagination a host of alternative trade centers. But the towers' irreconcilable scale pushed some image makers, intent on using Lower Manhattan itself as an icon, into taking new liberties with the cityscape. In a subway poster campaign for a "lite" jazz station, a popular chanteuse in a gold lamé dress emerged from the harbor waters, colossal as a goddess set against the downtown skyscrapers arrayed behind her. The ad's headline invited radio listeners to enter her beneficent domain, billed as "the smoothest place on earth." And indeed, the once-jagged skyline of the financial district appeared wondrously leveled. Beneath the station's logo, the great twin towers had been compressed into a single structure shrunk to the height of the Woolworth Building and Chase Plaza.

But the scale of the towers, combined with their dynamic pairing, inspired the most potent and imaginative appropriations of the trade center's architecture. Bacardi Rum zigzagged the towers against a midnight-blue starscape, replete with a hanging lemon-slice moon, as though the WTC had transformed into its own liquid reflection. The visual transformation of the World Trade Center from a noun into a verb, suggested by the Bacardi ad, as well as its full-scale identification with the Caribbean, was pushed even further when, in the mid-1990s, the twin towers starred in a Latin music video. Broadcast on local Spanish-language television, a compulsively danceable merengue song served as a pretext for animating cartoon musicians against the background of a "real" nocturnal cityscape. The video jump-cut among several of New York's urban icons, including Times Square and the Empire State Building, syncopating with traffic lights and pulsating neon signs. Suddenly the scene shifted to the skyline of Lower Manhattan and its unmistakable twin towers. As if seized by the force of an irresistible rhythm, Yamasaki's pillars morphed into a dancing couple, ecstatically gyrating, ringed by a vast field of motionless skyscrapers.

But though its iconic power links the dancefloor to the skyline, the World Trade Center remains, at heart, a homebody. Last and also least in the great parade of its rippling images comes the WTC we can take off the shelf and hold in the palm of our hands. These tokens are the snow globes: the tallest towers of the little world submerged in water, miniaturized, rendered in painted plastic against deep blue, and often seen in the company of an equally Lilliputian Lady of the Harbor. These are the trade centers of the domestic sphere—shorn of all grandiosity, pretension, and awe. These are the towers made to be shaken, even overturned, with only the most magical and deeply soothing consequences. One can buy these unlimited edition, pocket-sized trinkets at the concession stand at the top of Tower 2, in the pushcarts near the Church Street entrance to Austin Tobin Plaza, and just about anywhere in greater New York, wherever World Trade Centers are sold.

Downsized and upbeat: A "human scale" World Trade Center visits Austin Tobin Plaza during the Buskers Fare of June 1993.

DETAILS: FOR ART'S SAKE

Where among myriad images and words can one find what remains to be told of the World Trade Center's biography? Much of the story continues to unfold in the details inhabiting the spaces within, around, and between the towers. Other threads of its narrative will be woven together as the ongoing stories of the Port Authority, the financial district, and the city continue to unfold.

If, on a day in the late 1990s, one had gone looking for Alexander Calder's bright red-orange *World Trade Center Stabile*, it would not have been found where it was originally installed in 1971, at the WTC's traffic entrance on West Street. Nor did it occupy the shady spot beneath the overhanging arches of 5WTC at the northeast corner of the complex, where it was moved in 1979. In fact one might have had quite a time locating it at all. But the *Stabile* had not traveled far— just down the block, across the street, and up one story to a second-story micro-plaza connecting Larry Silverstein's 7WTC via an overpass with Austin Tobin Plaza to the south. Here, Calder's three intersecting steel arcs flared upward in their familiar, ever euphoric dance.

Shortly after the *Stabile* was moved here, it took on a temporary utilitarian function for the crew repaving the plaza. The only alterations required were to enclose the spaces between the sculpture's uprights with plywood, paint them a bright persimmon color that almost matched the steel, slap a padlock on the door, *et voilà!*—instant tool shed.

The PA, after all, owns the *Stabile*, and its sanctioning of this usage might well have amused Calder, who began his career as a mechanical engineer. But what of his wish that, rather than isolate the *Stabile* as "an aloof monument" in a plaza, it be placed where it would serve as an "animating catalyst for the surrounding life of an active street corner"?

Though Joan Miró's 20-by-35-foot wool and hemp *World Trade Center Tapestry* has not yet been pressed into service as a plaza-sized mop, its vibrant colors have faded over the years from sunlight pouring through the windows of Tower 2. Louise Nevelson's *Sky Gate, New York*, a 17-by-35-foot black-painted

relief, assembled from hundreds of pieces of wood, is mounted starkly against Tower 1's white marble interior wall. But *Sky Gate* often cannot be viewed, because the mezzanine level is roped off when the plaza is closed.

If we took the elevator upstairs, we would find Robert Motherwell's austere tapestry *Elegy to the Spanish Republic, No. 116,* half obscured by furniture in the Port Authority offices. If Le Corbusier's presence lives on in the trade center's design, it also occupies a space within in the form of three tapestries: *Nature Morte, Les Dés Sont Jetés (The Throw of the Dice),* and *La Canapé (The Sofa).* This last piece, a starkly rendered abstract nude, was leased to Marriott along with other PA artworks from the former Vista Hotel and was hung near the coat check, marooned in a sea of flashy detailing.

Outside, tucked nearly against the rear wall of the hotel, directly over the spot where the bomb detonated, stands the memorial for the victims. But there are days when the plaza winds blow garbage into its concentric marble rings faster than the maintenance crews can clean them out, and some visitors apparently do not realize—despite the inscription in English and Spanish around its rim recording the names of the seven fatalities—that the memorial is not a Dumpster.

Can any larger significance be attached to the accumulation of these details? The Port Authority has, it might be argued, more urgent concerns than the fastidious maintenance of its art collection. But the PA's art portfolio is, aside from its aesthetic value, a corporate asset once evaluated at nearly $27 million. Several of the works were commissioned in the late 1960s and early 1970s with matching grants from the National Endowment's Art in Public Places program and David Rockefeller's Business Committee for the Arts. In early 1996, New York City Mayor Rudolph Giuliani opened up his campaign to privatize the trade center and many of its other assets by accusing the PA of hiding its artworks from the public. What business, the mayor asked—albeit rhetorically—did a port agency have amassing and collecting art in the first place? And why was it spending public money decorating a real estate asset that, by rights, it should not own?

DETAILS: THE PHYSICAL PLANT

Pacing out the periphery of the trade towers in the late 1990s, one navigated a cracked badlands of sidewalk crudely patched with mismatching cement. The weathered, gray (originally white) Italian marble

paving on the plaza was a spiderweb of cracks, a condition that under-mined the addition of benches and flowerbeds and the tinkling medley of new-age harmonics emanating from a score of tiny speakers mounted beneath Yamasaki's arcades. Construction equipment and barricades around the site appeared to have been deployed and then abandoned by a retreating army.

And up in the towers, where asbestos removal was still under way, a host of details pointed toward a rift opening up within the trade cen-ter itself. In 1985, when New York State moved most of its offices out, Dean Witter consolidated its operations in twenty-four floors of Tower 2 under a twenty-year lease. Visiting the brokerage and investment firm's offices and cafeterias, one invariably found them spotlessly maintained. But on adjacent floors, particularly those with multiple tenants, the paint was dingy, the carpets were stained, fixtures re-mained broken, and burned-out fluorescent lights went unreplaced, as did discolored ceiling tiles. And the listing of a company on the direc-tory did not reliably indicate that a company was still there.

And who indeed *was* there, inhabiting the self-proclaimed heart of world trade? In 1966, as the PA was bulldozing Radio Row, the City Planning Commission reported that "the prime objective of the WTC is to simplify and expand international trade by centralizing and consoli-dating within the Center essential world trade services and activi-ties. . . . The Center will contain *only government agencies and private firms which play a part in international marketing and in the adminis-trative processing of world trade."* [Italics mine.] Yet according to its own 1993 occupancy survey, the Port Authority found that trade service and import-export tenants accounted for only 5 percent of its leases.

The Port Authority closed out the 1990s with a stream of press re-leases announcing the rental of unimaginably huge quantities of trade center office space to "cutting-edge" firms like Sun Microsystems. Yet around the complex a million square feet stood empty, and the build-ings originally intended as great catalyzing chambers of world trade were, by degrees, transforming into a kind of disjunctive real estate layer-cake. One story above the carpeted, wood-paneled offices of a Japanese securities firm, a group of artists filled bare walls with boldly colored images and hung sculptures from the exposed ceiling girders of a vast echoing cavern. As part of a Lower Manhattan Cultural Council program that turned some of the vacant space in the towers over to artists rent-free, 40,000 square feet of concrete floor lay paint-spattered and strewn with the raw materials of a creative urge that has never been easily reconciled with the imperatives of a bottom line.

Under such conditions, one could begin to read in the trade center symptoms of an internal fragmentation quite at odds with the image of a thriving, Class-A Lower Manhattan office complex. Myriad signs of neglect, along with simple wear and tear, pointed to the encroachment of contradictions that had come to characterize the city as a whole. But did the presence of the artists signify that, in some sense, the WTC might be drawing closer to the ideal of the *Stadtkrone*—assuming its destiny as harbor for all the generative energies, secular and spiritual, converging in postindustrial New York?

In the aftermath of the 1993 explosion, security procedures throughout the trade center's basement and superstructure were vastly enhanced, with the objective of preventing another bomb from finding its way in. But incrementally, irresistibly, the city that surrounded the trade center had begun seeping in—claiming the space as its own.

CONTRADICTIONS: DOWN THE STREET

In the depths of the downtown real estate crash of the late 1980s to mid-1990s, a new sign of the times emerged on Broad Street just across from the Stock Exchange. In the two blocks between Morgan's venerable blockhouse and the recently refurbished thirty-one-story New York Information Technology Center, a pair of adjacent buildings, the massive Broad Exchange and the smaller 41 Broad Street, stood empty and desolate. Signs on 41 Broad's facade promised that it was "under complete renovation" and offered prime retail space with thirty-foot ceilings in the shell of what was built as a palatial ground-floor bank.

It was here, the day after the blizzard of 1996, that a work crew from the Alliance for Downtown New York—the area's business improvement organization—bravely cleared the sidewalks in front of the derelict buildings. The eight young black and Latino men shoveling snow wore stylishly coordinated outfits: persimmon-colored parkas emblazoned with the alliance's logo. Matching piping ran up the seams of their midnight-blue trousers. These festive uniforms, however, belied the urgency of their mission. With nothing less than the fate of Lower Manhattan at stake, this animated display of coordinated manpower created an occasion for the street-level broadcast of the alliance's message: *Downtown is looking up! We will not be snowed under! The city's ancient core still hums with youthful, disciplined, energetic spirit! If we all shovel together, we cannot but triumph!*

If, on such a crystalline morning, one could blur one's social vision and again drift into the city of the past, these youthful laborers might momentarily cease to be members of New York City's marginal working class. Viewed in historical soft focus, the alliance's snow-clearing crew would instead be dredging the Prinsengracht, the canal that Broad Street used to be, allowing Nieuw Amsterdam's commerce to flow on unimpeded. But in contemporary New York, the alliance workers served as drum majors for a hoped-for parade celebrating the financial district's victory over the downside of its looming contradictions. Spirits lifted by the sight of the crew's bright costumes—their orchestrated energy clearing a path through the snowfall—an observer might be tempted to shout, however prematurely, *Hooray! Hooray for the Grand Alliance!*

As the young men finished their task and leaned against their shovels surveying the results of their labors, a supervisor, distinguishable by his peaked hat, hoisted his walkie-talkie to his ear. Then, having received orders from headquarters, he marched his column of workers down Broad Street toward their next mission. The sidewalks they left behind were cleared now so passersby would not have to detour onto the street—an act that might have jogged their thinking toward the question of why so many buildings stood vacant in the financial center of the world.

RUIN VALUE

Is it possible to imagine the World Trade Center as a ruin? In one sense, this would be very difficult, for even an enormous explosion failed to compromise the towers structurally. Moreover, the Port Authority found hundreds of millions of dollars to rebuild the bomb damage. And it mustered the administrative and public relations resources necessary to deal with a reversal that could have precipitated a wholesale flight by tenants and transformed the WTC into a symbol of terrorism ascendant.

But a state of ruin cannot be measured in terms of physical failure alone. Its meaning goes far deeper, for even a leveled building may be brought up again from rubble. To avoid becoming a ruin, a structure must retain or be able to transform itself as a site of active social practice, as a repository of the imagination, and preferably both. It must remain an adaptable, integral agent of a living, mutable culture. Like planning and constructing a building, the process of creating a ruin is an accumulation of incremental social acts. A structure begins to fall

into a state of ruin when it is no longer supported by the productive relations that created it. But its transformation is complete when it is no longer physically viable *and* the social imagination that gave it purpose has fled or been banished. Once a building is abandoned at the level of meaning, it is only a matter of time before physical decay upholds its end of the bargain.

In this sense, the World Trade Center came prepackaged as a ruin that has slowly been moving in the direction of becoming a living building. But even in the wake of the bombing, New Yorkers have never been able to successfully fill Yamasaki's twin silos with the kind of psychological investment freely poured into the Empire State, the Chrysler Building, the Woolworth Building, or even Rockefeller Center. From an economic standpoint, the trade center—subsidized since its inception—has never functioned, nor was it intended to function, unprotected in the rough-and-tumble real estate marketplace. And in the thirty years since it was built, the social forces of which it remains so highly visible an artifact have definitively realigned. Relationships among banks and developers, public corporations, the city government, the statehouses of New York and New Jersey, and even the federal government have all been transformed to a point where it is inconceivable that the World Trade Center could be built today—or even for a moment considered a workable or desirable project. Having escaped destruction at the hands of terrorists seeking to demodernize the world, the trade towers now offer themselves as blunt evidence of the maxing out of the North American skyscraper city. Viewed as a crowning ruin, the towers take on a new symbolic power—they become eloquent in transmitting the drama of their own vanished moment.

The pages above have traced the World Trade Center's lineage, the forces that gave it shape, and some of the consequences of its coming. And a narrative has unfolded of the political and economic culture of the village it took to raise this troubled child. Unlike human offspring, however, real estate developments never outgrow the watchful guardianship of institutions, and the WTC's caregiver of record had always been the Port Authority. How, then, as the twin towers moved into their third decade, was this filial bond playing out?

THE SECOND BOMBING

When the World Trade Center was bombed in February 1993, at the age of twenty, it had finally begun generating profits to offset the

chronic losses the PA sustained running the PATH commuter line. But it was already passing its prime as office space, overtaken by a generation of more recent, cybernetically "smart" buildings with higher ceilings and greater built-in electrical capacity. To maintain the trade center as class-A office space commanding top rents, the PA would have had to spend $800 million rebuilding its electrical, electronic communications, and cooling systems. Then came the bombing and, according to Charles Maikish, former director of the PA's World Trade Center Department, a repair bill of $700 million and hundreds of millions in lost revenues. The Port Authority, however, possessed capacities far beyond those of a commercial landlord, among them a $2.6 billion annual budget and the ability to generate capital through bonds, tolls, fares, and airport disembarkation tariffs. The PA had the wherewithal in 1993 to rebuild the trade center and perform the necessary renovations—but then came another assault, one far more devastating to its institutional integrity.

The adversary faced by the PA was not a cabal of terrorists. The threat originated in a realignment of social powers represented by a triumvirate of officials elected in the early 1990s: George Pataki, Christie Todd Whitman, and Rudolph Giuliani, respectively the governors of New York and New Jersey and the mayor of New York City. Although differing on many issues, all three vigorously pursued policies of cutting social services while consolidating and privatizing public agencies. At its most ideologically distilled, their shared doctrine—popularly associated with Republican conservatives but espoused by many Democrats—sought to re-create the public sector as a function of the marketplace. Ironically, the agency found itself in an especially vulnerable position precisely because it had already undermined its claim to a public purpose so deeply.

Advocates of privatizing the public sector assert that the free market—like Adam Smith's hidden hand—knows better than government how to meet social needs. Left to its own devices, the market grows naturally, fosters competition, and self-corrects its downturns. Thus viewed, the market is, or could under ideal circumstances be, a law unto itself—a beneficent wellspring of all social good. Government intervention only impedes natural economic growth, competition, and innovation by overregulating business activity. Further, government depletes the nation's wealth through taxation in the service of building and entrenching its perennially bloated and ineffective bureaucracies. In this view, true social well-being can be achieved only when federal, state, and municipal governments reconstitute themselves in the image

of competitive businesses: downsizing, eliminating less productive departments, and trimming their budgets and personnel.

A central strategy toward accomplishing this shrinkage is privatization: delivering public functions and institutions—including schools, hospitals, and prisons—into the hands of private enterprise on the theory that only profit motive and competition can assure efficient management and provision of high-quality services. In its new partnership with business, the minimized government takes as its role the facilitation rather than the regulation or organization of economic activity. Governments are left to perform only those functions that cannot, as yet, be profitably turned over to the private sector, such as maintaining a national military and security agencies, regulating the supply of money and interest rates, subsidizing large enterprises, and guaranteeing loans. Government interventions into public housing, medical care, and education ought, in this view, to be eliminated outright, consolidated, or privatized.

In the mid and late 1990s, this notion of "reinvented" government harmonized well with the goals of conservative politicians—particularly in industrial states with large urban concentrations. The rhetoric of tax slashing and governmental downsizing—the new litmus test of "business-friendly" states and municipalities—afforded elected officials the appearance of responding decisively to tough economic realities while at the same time reining in "entitlements" presumably being squandered on the undeserving poor. Privatization emerged as one of the key political strategies of the early Pataki, Whitman, and Giuliani administrations as they faced widening budget gaps, shrinking federal assistance, and reduced local tax revenues.

Imitating their corporate counterparts, they embraced the belief that governmental functions should be reduced to a series of inexorable bottom lines. This new standard became the basis for a sweeping reevaluation of public agencies. They would be judged not by their objective performance level or their contribution to the public good but according to whether their disassembled parts might profitably be sold, merged, or eliminated. Discussing the disposition of the Port Authority's bus terminal, Charles Gargano, Governor Pataki's appointee to the PA's vice chairmanship and the head of New York State's economic development agency, put the issue succinctly when he asked, "Why not let private industry in to develop what is clearly an extremely valuable property?"

The values underlying such policies spring into high relief at the level of language. A privatization model developed for the District of

Columbia referred to residents and visitors as "customers" and divided government functions into "wholesale" and "retail" categories. In 1998, a senior editor at the *Wall Street Journal* urged Republican party leadership to "view itself very much like, let's say, a corporation, a Daimler-Benz, a Chrysler . . . to change its corporate culture [and] go through a wrenching transformation, because the cars are coming back from the lot unsold." Viewed from this perspective, the Port Authority ceases to exist as a public institution created to address the New York region's economic and social needs and becomes instead an assemblage of assets, to be broken up according to the dictates of the market. But "capturing" the value of such assets, of course, is predicated upon the dismemberment of the whole.

"THE FATTEST SACRED COW IN AMERICA"

While the PA slumbered Rip Van Winkle–like through the 1980s— dreaming up unrealized mixed-use development projects in New Jersey and Queens—the regional port continued its decline, and the two New York airports languished amid a series of corruption and mismanagement scandals. When the PA awoke, to a loud report from beneath its flagship enterprise, it found that its failure to plan or advocate policy successfully for the region's future transport needs—or even to maintain adequately the facilities under its aegis—left it with a weakened basis for authority over anything. In the interim, the corporatist political conservatives who would challenge the PA's mandate, functional integrity, and economic foundation had been honing their fat-cutting knives.

Early in their administrations, the two officials who exercised direct control over the fate of the PA, Governors Pataki and Whitman, signaled their intention to greatly reduce both the agency's budget and scope. Their respective appointments of George Marlin as executive director and Lewis Eisenberg as chairman signified, in effect, the introduction of human wrenches into the armature of the PA—their mission, to disassemble the organization from within. Both men were investment bankers who shared a strong antipathy toward big government. Marlin received 10,000 votes as a right-to-life mayoral candidate in 1993 and was a political protégé of Senator Alphonse D'Amato. For Marlin, dismantling public agencies signified an important first step toward reclaiming society from the arrogant governance of those he dismissed as "social engineers." His political instincts may be gleaned

from his fondness for the G. K. Chesterton dictum "what we need, as the ancients understood, is not a politician who is a business man, but a king who is a philosopher."

Unlike previous PA directors, Marlin had no experience in public administration—which qualified him well for the job at hand. Shortly after his appointment, Marlin made it clear that he had not allowed himself to be seduced by his new intimacy with the public sector, asserting through his deputy that "the instructions we have from both administrations and the board is that there are no sacred cows here. We have to look at everything. The Port Authority has what is a traditional militaristic structure that is heavily layered [with] management. What we are doing is examining all that."

A critical review of the PA's raison d'être had previously been initiated by former New York Governor Mario Cuomo in response to embarrassing media disclosure of the infamous $21 million "tunnel to nowhere" and a virtually unused $56 million garage, both built at Kennedy airport. But Cuomo's probings were radically escalated by his successor. Pataki's assault on the PA was also of a qualitatively different order and reflected the antiurban—and particularly anti-Manhattan—sentiments he shared with his political mentor, Senator D'Amato. None of Pataki's close political associates lived in Manhattan, and the governor availed himself of numerous opportunities to move state jobs out of New York City. Whitman, for her part, strongly supported privatization of the PA but muted her criticism because New Jersey benefited from the agency's transit subsidies and Newark airport had expanded and modernized dramatically under its management.

The proponent of PA privatization with the most at stake—and consequently the official most volubly spearheading the attack—was New York City's Mayor Rudolph Giuliani, who leaped at the agency's throat virtually the morning after his inauguration in January 1993. In contrast to the relatively measured tones of the two governors and their supernumeraries, Giuliani's vehemence ratcheted higher in pitch as early in his administration he slashed city agencies and services in an attempt to avoid a multibillion-dollar budget gap. In early 1996, the mayor's right-hand man derided the PA as "the fattest sacred cow in America."

The immediate aim of Giuliani's attack was to pressure the PA into paying $400 million in rents he contended the agency owed the city on LaGuardia and Kennedy airports. This sum constituted a significant fraction of the city's projected $2 billion shortfall. But Giuliani's wider

grievance was directed against what he saw as the agency's skewed allocations in favor of New Jersey. Repeatedly, embarrassed city and state officials of varying political stripes decried the "third world" conditions prevailing at Kennedy and LaGuardia—in contrast to the sleek terminals and monorail systems at Newark. And Mark Green, the city's left-leaning public advocate, who generally found little common cause with the mayor, denounced the Port Authority as "a giant transfer machine that forces New York to cross-subsidize New Jersey's economic development and low taxes."

Such criticisms of the PA gestured toward but did not directly address the city's ever-slipping control over its political and fiscal destiny. The underlying causes of this predicament could not, however, be described in the language of official politics, for they went to the heart of the power relations that, for generations, had shaped the life of New York City. No mayor, Republican or Democrat, would dare to rein in the developer incentives programs that annually drained billions of the municipality's tax revenues. Or seek to impose taxes on some of New York's hugely wealthy nonprofit organizations. Or invoke any of a hundred strategies to ensure that a more equitable portion of the profits generated in the city were directed toward economically sustainable development and the long-term benefit of its inhabitants. During the lifespan of the World Trade Center, Walt Whitman's "proud, passionate, mad, mettlesome" city had arrived, by degrees, at an economic relationship to state and federal governments, and to its finance, insurance, and real estate oligarchy, that could only be termed abject.

The sense of desperation that had come to pervade the city's political discourse even in times of modest budget surpluses and Wall Street upswings helped fuel a broad, sustained, multilateral attack on the "fat" and entrenched Port Authority. The city advocate's meticulously compiled indictment of the agency's practices and a Giuliani-commissioned study by a private consultant of "how New York would fare without the Authority" battered the PA from opposite ends of the political spectrum. Congressman Gerald Nadler's persistent criticism of the PA's deindustrialization policies—scoffed at for years as nostalgic and fanciful—were echoed in the most unlikely quarters. In early 1996, the New York Times, which for generations stood editorially foursquare behind the efforts of the PA, lent its support to Guiliani's "declared war" on the agency, urging the mayor to "remind the Authority that it was formed in the 1920s to build a rail freight tunnel under the Hudson, a job not yet done."

Early in 1996, the Regional Plan Association issued its third plan, officially titled *A Region at Risk*. Underwritten by Chase, Chemical, Goldman Sachs, The New York Times Company, Nynex, IBM, and other corporations heavily invested in the region, the third plan followed in the footsteps of its 1930s and 1968 predecessors, encompassing the thirty-one counties in and around New York City. But unlike those earlier assessments, the third plan sounded a distinctly jeremiad tone. Peering two decades into the twenty-first century, its authors predicted dire consequences unless the region invested $75 billion in its economic infrastructure and streamlined its administrative agencies. The RPA recommended dismantling both the Port Authority and the Metropolitan Transit Authority and reconstituting their salvageable parts in a comprehensive mega-agency: the tristate Regional Transportation Authority. In addition, it advocated building the network of rail links its previous plans had consigned to obsolescence—this at a cost of $25 billion: $1 billion per mile.

There was a time, not long past, when such an analysis could be read as a scientifically based and therefore potentially reliable description of things to come. But in the "postpublic" late 1990s, RPA proposals resonated as the teasing afterimage of a nearly forgotten vision: the city within its region, economically and socially interdependent, subject to a beneficent and rational plan. The RPA plan sounded less like an economic prescription than an echo of a vanished utopian ideal. How was it possible that anyone was still thinking that way? During the long forty-year World Trade Center moment, such sweeping visions had been jettisoned in favor of realities that began and ended with the plus or minus sign at the bottom of the next quarter's balance sheet. What profit could there possibly be in pumping $75 billion into the New York region's "public good"?

DISARTICULATING THE AUTHORITY

Let us assume that we wish to begin taking apart a powerful institution such as the Port Authority. Where would we begin? First, we would attempt to damage its public perception, casting it as poorly managed, ineffective, and out of control of its own destiny. As we attack the organization externally, we would simultaneously seek to compromise the integrity of its internal culture. Our strategy aims at demonstrating—

both to its staff and to the outside world—the impossibility of the organization continuing to operate in anything resembling its accustomed form. We will then work toward making this transformation inevitable by exploiting existing vulnerabilities and, if necessary, creating weaknesses not already present.

In dismantling or radically restructuring an organization, a key step is the excision of its institutional memory: the repository of its history and traditions distributed among the minds of its staff. If the institutional memory can be sufficiently compromised, the organization will be unable to understand what it is, to make rational decisions about what it might become, or even to invoke effective measures to protect its core functions. An effective method of compromising institutional memory is to get rid of people who have worked for the organization for a long time by buying them out or firing them. Regardless of their status or level of ability, long-term employees tend to be more inculcated with the organization's culture. They are inclined to base their actions on established, time-honored policies.

At the closely knit Port Authority, the first significant downsizing since the Depression occurred in September 1995. Out of a total staff of 8,800, 300 jobs were eliminated, with an equivalent number following in 1996. The *New York Times* headlined its article "Era Ends at Port Authority" and termed the retrenchment "a prelude to more drastic steps indicating that the agency may soon be forced to scale back its historical role as a power in the region's economic development." Those departing included senior economic and policy analysts and members of the world trade staff, including several whose entire professional careers had been spent at the agency. One fired worker, speaking to the political motives behind the downsizing, commented, "They want to be able to say 'we broke the back of the fat, arrogant Port Authority.'"

Aside from disrupting traditional channels of power, information sharing, and decisionmaking, downsizing works toward undermining a sense of well-being among those retained by demonstrating that they live in an unstable universe, where their efforts are of questionable value and job performance has no relationship to their prospects for survival. This infusion of uncertainty encourages swings between paranoia and psychological paralysis, between hyperactivity and grim fatalism. The introduction of cultural outsiders like George Marlin, for the express purpose of presiding over the restructuring process, furthers the sense that the organization has abdicated the right to control its own destiny. Staff members feel they are being punished for crimes they were unaware of having committed.

With its sense of loyalty, cohesion, and esprit de corps shaken, the organizational environment becomes permeated with free-floating anxiety. This sense of instability is reinforced when relative newcomers are thrown unprepared into positions of heightened responsibility. Lacking either practical experience or a concrete sense of how their actions accord with the organization's mission, they will face great difficulty in making informed decisions. Their attempts to grapple with tasks for which they are unfitted helps further undermine both objective organizational performance and public perception. Unless stemmed, the trajectory of disarticulation, like the physiological spiral of shock, takes on a self-reinforcing momentum. If the organization survives, it does so in a greatly weakened condition.

At the Port Authority, this process escalated rapidly in the mid-1990s. A longtime WTC tenant with close ties to the PA leadership commented in early 1996 on the absence of the new managers' sense of responsibility to anything beyond their own political survival and observed that the "real people are bailing out." Among these "real people" she counted Charles Maikish, head of the World Trade Center Department, and Mark Marchese, director of the PA's media relations department. Both had begun their careers at the PA, and both played key roles in bringing the towers back "on line" and successfully resurrecting—however fleetingly—the agency's public image in the aftermath of the February 1993 bombing. But Maikish and Marchese were only two of hundreds of PA staffers who took early retirement or were laid off, among them the former first deputy director, the executive director for capital programs, the chief financial officer, and the director of aviation. One PA commissioner, alarmed by Marlin's draconian restructuring, warned that "you can't eliminate people like that . . . and have a stable organization."

In his two years of ax-wielding—before being nudged out in early 1997 in favor of Robert E. Boyle, another Pataki crony—Marlin replaced 80 percent of the agency's directors, eliminated 1,800 jobs, sold the Vista Hotel and the PA language school, auctioned off much of the art collection, and privatized the International Arrivals building at JFK airport. The stage was set for the trade center itself to go on the block.

Lost in the dramatic sweep of Marlin's "rightsizing" campaign was the closing of the PA library in late 1995 and the firing of the librarians who had presided over a comprehensive collection of speech transcriptions by PA officials, policy statements in various drafts, internal memos, and reports. Seventy-five years of the preeminent American

public corporation's autobiography have, at least for the present, disappeared from view. For months after the library was closed, if an employee at a PA workstation looked up a document, its title would appear on-screen indexed as before. But because the documents themselves had not been put on-line, all one could read in this disarticulated library was a vast electronic bibliography of inaccessible texts.

WHALE OF A SALE

Well before anyone seriously considered dismantling the PA, the idea of putting the World Trade Center on the market captured the imaginations of developers and politicians alike. In their heyday, the twin towers had been courted variously by Deutsche Bank, Donald Trump, and Prudential Life. At the beginning of the 1980s real estate upswing, the *Times* optimistically predicted that the WTC was poised, after years of running deficits, to become a "cash cow" for the states of New York and New Jersey. But selling the trade center was strongly advocated by Mayor Koch, whose deputy mayor for economic development, Kenneth Lipper—later coauthor of the Hollywood thriller *City Hall*—argued that "the Port Authority would do much better to have $2 billion in proceeds from a sale available to it and the city to help its people, than to have a passive asset that sits like a jewel glittering but producing nothing."

In 1984, as the boom accelerated, Governors Cuomo and Kean studied the feasibility of liquidating the PA's "jewel" but decided against it, partly because federal tax law would require the PA to pay off its $2.1 billion in outstanding debt on the complex. Cuomo was succeeded as governor by George Pataki, whose tax advisers believed that the state could make an end run around immediately retiring the trade center's bonds, valued in 1999 at $800 million—a move that would greatly enhance the property's attraction of potential buyers.

But to the city's political leadership, the argument for selling the trade center has always boiled down to simple math. In 1998, when the WTC was at last put up for long-term lease, the *New York Post* proclaimed with characteristic flair, "Rudi Wants WTC's Towering Taxes." For a mayor of any political stripe, it is irresistibly tantalizing to imagine the tens of millions of tax dollars, from which the PA is exempted, flowing into the metropolitan coffers under terms of private ownership, management, or lease. But the "privatization experts" consulted in the early 1990s by the Giuliani administration to study carving up the PA

concluded that the tax burden—particularly in a real estate slump—made it "difficult on the numbers to sell the entire property."

It might, of course, be possible to deal with the center in parcels—a tower here and a tower there, spinning off the low-rise buildings either individually or as a group. But, to paraphrase the 1960s Broadway musical *Oliver*, "Who will buy this wonderful morning?" Without tax abatements so large that they might neutralize any gain for the city, who would take on, even divided into chunks, a complex that needs hundreds of millions of dollars in ongoing investments to secure its rent base?

Ever since Nelson Rockefeller made the WTC viable by pouring 20,000 state office workers into the entirety of Tower 2, New York State had maintained a continuous presence there. In January 1996, Governor Pataki announced that he was moving the trade center's last state tenant, the governor's office itself, to cheaper, more convenient space in midtown.

ACCENTUATE THE POSITIVE

The February 1993 blast in the basement of the World Trade Center killed 6 people, injured 1,000 others, displaced 50,000 workers, and threw 900 Vista Hotel and Windows on the World employees out of work, but it also provided a modest boost for the regional economy. This, at any rate, was the conclusion the Port Authority came to in an April 1993 report released six weeks after the bombing.

Admitting that its analysis did not account for "intangible losses"—such as the 2,300 cases of post–traumatic stress disorder diagnosed by the PA's chief psychologist—the agency predicted that the jobs and economic activity generated by the explosion would result in a net gain of $200 million. Wage losses from the closing of trade center facilities would be offset by the earnings of thousands of workers undertaking what the PA termed a "fast-track" reconstruction effort.

For the agency, this silver lining was due in part to the ease with which the 350 bombed-out trade center tenants could be moved into abundant vacant office space nearby. Breathing an almost palpable sigh of relief, then-PA chair Richard Leone noted that relocating tenants would have been far more protracted and expensive had the explosion occurred in the boom year of 1985. Ironically, that was the year the PA's antiterrorist unit, the Office for Special Planning (OSP), ana-

lyzed the state of security at the World Trade Center. This internal report became part of the evidence in the lawsuits brought on behalf of 800 bombing victims on grounds that the PA neglected to protect them adequately. But one section of the OSP analysis, made public in a legislative report issued six months after the blast, described how "a time bomb–laden vehicle could be driven into the W.T.C. and parked in the public parking area. . . . At a predetermined time, the bomb could be exploded in the basement. . . . The Assistant Deputy Director for the F.B.I. thinks this is a very likely scenario for the W.T.C and has described it graphically in conversations with OSP staff."

By the time this scenario gave way to an actual rubble-filled chasm beneath the trade center, the Lower Manhattan office market had already peaked, then dropped through the floor into a basement of its own.

TRIAGING DOWNTOWN

If the ghost of Le Corbusier returns to Lower Manhattan on the centennial of his first visit, he may find the skyline more to his liking than the jumbled, tightly clustered towers he had disparaged in the 1930s. This thinning out of high-rise density would not mean that the towers had physically collapsed, but that the market for them had.

In the early 1990s, following the stock crash of 1987, Manhattan's midtown and downtown central business districts found themselves afflicted with a severe case of what real estate insiders call "negative absorption." Over 60 million square feet of office space, equivalent to a half dozen World Trade Centers or to the total rentable area of all the New York skyscrapers built during the preceding boom, stood vacant. Dan Rose, patriarch of the legendary developer family, estimated that in order to fill the vacant commercial space, the city would need to create 300,000 jobs.

Manhattan south of Chambers Street was hit proportionally even harder than midtown—financial services firms had downsized 100,000 workers since 1988. Given the exodus of back-office jobs to New Jersey combined with 20 million square feet built downtown in the speculative 1980s, Lower Manhattan accounted for approximately 44 percent of the city's see-through office buildings. So acute was the crisis that one Regional Plan Association official echoed the old billion-dollar-plan-era rallying cry, commenting that "the most important thing we kept hearing from business is that we not let downtown die."

What was to be done with this superabundance of empty office space? The Downtown Lower Manhattan Association and Department of City Planning, in their joint 1993 *Plan for Lower Manhattan,* proposed radically culling the herd of older buildings. The suggestion of even broader plazas, in place of obsolete skyscrapers, put a positive spin on an off-the-record observation by a DLMA spokesperson that in order to stabilize property values, several dozen downtown office buildings would simply have to be razed.

But the general thrust of ongoing efforts to "revitalize" Lower Manhattan represented a significant departure from the time-honored calls to bring on the bulldozers. Even some of the DLMA's remedies sounded a distinctly preservationist note. Before it was subsumed into a new power configuration known as the Alliance for Downtown New York, the DLMA floated a short-lived 1991 planning initiative bearing the deadpan title "The Lower Manhattan Project." Headed by John Zuccotti, a former chair of the City Planning Commission and then president of the teetering Olympia and York, the DLMA project prescribed increased tax abatements tied to residential conversion of former office space as the new magic pill for turning downtown's affliction around. Thus opened up heady new vistas for the wondrous leveraging of the next generation of state and city subsidies: Developers who had built new office space under the existing commercial incentives programs might now receive additional tax breaks for converting into apartments the older buildings they had helped empty.

With the launching of the Alliance for Downtown New York in 1995, these revitalization efforts broadened and intensified. Combining the roles of local planning body and business improvement district (BID), the alliance was initially funded by an $8.6 million assessment on local property owners. Carl Weisbrod, a longtime public official who enjoyed an unusually high degree of trust among the city's developers and business leadership, was signed on as head of the new organization. Weisbrod's eclectic career began in the early 1960s with Mobilization for Youth, a politically radical nonprofit agency advocating on behalf of the city's poor. Recruited into city government by Mayor Lindsay, Weisbrod had gone on to fight the Times Square pornography industry as director of the Office of Midtown Enforcement and serve as executive director of the City Planning Commission. In 1987 he was appointed director of the Times Square redevelopment project and later—demonstrating his skill in increasing government efficiency—consolidated several agencies under the umbrella of the Economic Development Corporation.

As the city's economic development director, he guided the "crossroads of the world" through roller-coaster real estate cycles and byzantine politics toward its rebirth in the form of a media conglomerate theme park overshadowed by the immense towers of Disney, Viacom, Bertelsmann, and Condé Nast. Along the way Weisbrod negotiated agreements from large employers—the Mercantile Exchange, Morgan Stanley, and Kidder, Peabody, among others—to remain in New York in exchange for tax breaks worth hundreds of millions of dollars. So it was hardly surprising that so many developers and corporate CEOs considered Weisbrod a solid ally. Said developer and alliance board member William Rudin, "I negotiate with tenants to stay in my buildings, he negotiates with companies to stay in the city. We both must understand the corporate mentality." Unwittingly paraphrasing Black Panther leader Eldridge Cleaver, David W. Singleton, the alliance's chairman and a senior vice president of J. P. Morgan, observed that "in his public-sector life [Weisbrod] was always part of the solution, not part of the problem."

DEFIBRILLATING THE ANCIENT HEART

The formation of the Alliance for Downtown New York was followed a few months later by legislative passage of a joint state-city Plan for the Revitalization of Lower Manhattan. The plan offered a new iteration of traditional Lower Manhattan real estate double vision game: It broadened the existing commercial incentives program for the construction of new "smart" office buildings while adding lucrative abatements for residential conversions. In addition, the plan authorized zoning changes intended to complete the transformation of what it termed "the capital of capitalism" into a twenty-four-hour mixed-use community.

Initially proposed by Mayor Giuliani in 1994 soon after he took office, the bill enabling the plan was signed by Governor Pataki at a ceremony on Broad Street in front of the newly renovated New York Information Technology Center (ITC). Though architecturally nondescript and modest in size for a financial center tower, the retrofitted building nonetheless spoke volumes about the shifting fortunes of Lower Manhattan life in the long thirty-year shadow of the World Trade Center. Once described as the "heart pump of capital blood," downtown Manhattan was attempting to recast itself as the cerebral cortex of the world's postindustrial *mind*.

Built by the Rudin family in 1977, the thirty-one-story tower at 55 Broad Street became suddenly vacant in 1990 with the collapse of its sole tenant, junk-bond peddlers Drexel Burnham Lambert. For the Rudins, the upside to having 55 Broad totally empty was that it kept the cost of asbestos removal down to $70 million. Though this was five times the building's construction cost thirteen years before, it was still less than the price tag for replacing 55 Broad as a "smart" tower. With the Rudins' resources estimated at over $1 billion, it seemed a worthwhile bet that given a further $15 million in renovations and a creative marketing plan, the property would come into its own. Indeed, that is what happened. Five years after Drexel's evaporation, the once-dowdy property emerged from its makeover as ITC@55Broad: centerpiece of what the alliance slogan called "The World's Downtown."

Just plug in! [to] a virtual fountain of technology and information access for firms on the cutting edge, proclaimed ITC@55Broad's lavish promotional brochure. *NY's ultimate global connection* offered prospective tenants *Manhattan's "hottest-wired" office building,* rebuilt for the era of networking and high-bandwidth communications. Beneath this flood of infomercial-style sell lay more pragmatic inducements. Under the terms of the new Lower Manhattan revitalization plan, "even the smallest" information technology companies moving to ITC@55Broad would be eligible to benefit from real estate tax abatements, commercial rent tax exemptions, and "up to 47% energy rate reductions."

Whatever the fates of the real estate market might hold in store for ITC@55Broad, its positioning as the flagship of a revitalized downtown indicated the degree to which the alliance, the city, and the state had attempted to revise previously held conceptions about what Lower Manhattan was for. Sandy Frucher, an alliance board member and executive vice president of Olympia and York—who as former head of the Battery Park City Authority had seen no "moral obligation" to provide affordable housing—urged business leaders to "identify industries other than the traditional FIRE industries [finance, insurance, real estate] . . . that have traditionally made the Wall Street area home" and to "figure out a strategy to attract those industries down here."

The alliance, said Weisbrod, was "aiming to locate a software and information technology center downtown, which should end up not only serving the financial industry but also helping to attract new types of business." Among the businesses the alliance hoped to attract were upscale restaurants and shops as well as brand-name chain stores qualitatively different from Syms, Century 21, Duane Reade, J&R Music World, and other homegrown retail discounters.

Along Broad Street, now transformed into the district's putative Champs Élysées, the new mix would include a four-star restaurant and a "cyber café," for upstairs, the alliance's goal was to create 5,000 residential units by the year 2000—a new crop of extravagantly expensive, tax-subsidized apartments with spectacular views of New York's harbor.

Lending his efforts to the cause of reviving the financial district was Bruce Menin, known for the condominium conversion of dilapidated apartments and hotels in Miami Beach. Menin pumped $100 million into 25 Broad Street—one of the vacant buildings the alliance's snow crew had shoveled out during the blizzard of 1996—converting the turn-of-the-century office tower into 345 luxury apartments but keeping the name incised above its stone entrance: The Broad Exchange.

But in late 1998, soon after it was opened for occupancy, city and state officials threatened to condemn The Broad Exchange and tear down Menin's investment. The converted building had suddenly become a bargaining chip in a much higher stakes game. Scrambling to keep the ever-restive Stock Exchange from making good on its threat to move to New Jersey, the city was assembling properties so that its keystone Wall Street institution could expand in situ. In the end, Broad Exchange's newly arrived tenants did not have to relocate. Nor was the stolid granite-faced tower replaced, as initially planned, by a glassed-in trading floor extending across Broad Street. In December 1998, the city made the Exchange a gift of several other nearby properties, including a Wall Street residential conversion completed the year before. The trophy in the parcel, though, was J. P. Morgan's landmark bank. An ebullient Mayor Giuliani described the Exchange's decision to stay as "a Christmas gift to the city."

But, as they say, it is better to give than receive, and for city officials, no price was too high to keep the Stock Exchange "committed" to Lower Manhattan into the twenty-first century. The $900 million the city and state shelled out to keep the Exchange from becoming a LeFrak tenant in Jersey City was the highest dose of subsidy yet pumped into capital's heart, but it was neither the first nor the last. By late 1999, Giuliani had showered incentives on a score of corporations and financial institutions—going through two billion dollars like it was tickertape confetti.

"Financial services are the key to our economic health and future," commented Weisbrod. From where he sat, incentives were not "simply corporate retention deals" but rather "public investments, . . . infrastructure deals, no different than the Erie Canal."

In late 1995, at the bottom of the market, Donald Trump purchased 40 Wall Street, a nearly empty 1.4-million-square-foot tower that when built in 1929 by Shreve and Lamb had briefly held the title of New York's tallest. Trump committed $100 million to bringing 40 Wall "back to greatness again," seeking a Landmarks Commission variance to gild its oxidized copper crown, which he saw as "an important element from a marketing standpoint."

40 Wall's checkered pattern of ownership had included a brief stint as part of the New York real estate portfolio of Ferdinand Marcos. But earlier the building had served as the headquarters of the Manhattan Bank, which in 1955 merged with David Rockefeller's Chase. The Manhattan Bank's institutional roots lay deep in downtown's richly ironic speculative soil, having been founded by Aaron Burr in 1799 as the Manhattan Company. Using a yellow-fever panic as cover, Burr obtained a legislative charter for a company to dig new, unpolluted wells. The charter's fine print allowed for the company's excess assets to be funneled into additional, unspecified investments. Burr's Manhattan Company dug only one well, which murderers promptly used to dispose of a corpse. But the Manhattan Company went on to serve as the capital base for a new Republican bank intended to break the Federalist monopoly on New York's finance while furthering Burr's considerable personal ambitions.

In 1958 Chase sold 40 Wall Street to help finance David's ultramodern headquarters two blocks away. Forty years later, Chemical Bank swallowed Chase, retaining the latter bank's more prestigious name. And in a consolidation that trimmed thousands of jobs, workers now began to drain out of David's tower. At 985 tons, however, the 35,000-square-foot vault in Chase Plaza's basement was too heavy to float uptown to the new megabank's midtown headquarters. And the tower Bunshaft designed atop the vault was built to stay put also. Chase Plaza's columns were anchored to bedrock to secure the building in case a repetition of the legendary 1807 Lower Manhattan tidal wave should strike again.

No natural force dislodged Chase from the skyscraper that had long served as its flagship and had instigated the World Trade Center moment. Rather, Chase was carried northward by the same shifting tides of finance that caused Nasdaq to acquire the American Stock Exchange in 1998 and float it from the financial district to Times Square—the sanitized, reinvented "crossroads of the world."

During the mid-1990s bust, the cloudier the crystal ball for "The World's Downtown" became, the more its would-be rescuers focused on its past. Given the unreliable future, why not make use of what one already had and cash in on nostalgic images of illustrious yesteryears? Thus, the second leg of Lower Manhattan's revitalization plans rested upon the commodification of its history—a process that began in 1960 when the trade center moved west and the South Street Seaport Historic District's sentence of demolition was commuted to life as a shopping mall.

Since 1997, the Heritage Trails project, a joint effort of the Alliance for Downtown New York and the not-for-profit J. M. Kaplan Fund, has sought to conjure visions of downtown's "proud, passionate, mettlesome" days. Color-coded dots embedded in the sidewalk guide visitors along four walking tours to significant historic sites like Morgan's bank and the African Burial Ground. Heritage Trails' soft-sell approach harmonizes well with the alliance's effort to use tourism to diversify the district's economic base. Carl Weisbrod went on record endorsing this strategy in a 1994 *New York Times* article titled "Trying to Turn Downtown Around."

> [Lower Manhattan] is the birthplace of the city and . . . technically the birthplace of the nation. Just look around these four corners of Wall and Broad Streets. It's where George Washington took the oath of office; it's where the anarchists tried to bomb out the House of Morgan. It's where John Peter Zenger was acquitted of criminal libel and established for the first time the legal principle that truth is an absolute defense. What we can do is market downtown's history more clearly, market it in different languages. . . . We also have one of the most magnificent harbors and waterfronts in the world. . . . It's legendary, it's majestic.

And here the man who had invoked the clout of Mickey Mouse to leverage investor confidence in the new Times Square seems to have stopped just short of saying "it's a small world after all."

Forty years prior, Austin Tobin had invoked the cityscape of Venice to turn his listeners' imaginations toward visions of Lower Manhattan in the era of the coming trade towers. In appropriating the image of the serene republic that annually reconsecrated its "marriage to the sea," Tobin may have been prescient in ways he could not have anticipated. Once at the center of a great maritime culture, New York at the close of the skyscraper century was increasingly coming to trade on images of its past.

During a visit to the Alliance for Downtown New York's warmly appointed offices on the thirty-third floor of the Equitable Building in the late 1990s, it was difficult while perusing the BID's handsome promotional material not to be captivated by visions of a new, vibrant downtown to come. The alliance's board read like a who's who of Lower Manhattan power players. It encompassed representatives of the New York Stock Exchange, real estate brokers Cushman and Wakefield, Goldman Sachs, Morgan Guaranty Trust, the Battery Park City Authority, Olympia and York, Metropolitan Life, the Rudin family, the Marriott and Woolworth corporations, and notable downtown law and architectural firms. Larry Silverstein, owner of the Equitable Building and developer of 7WTC and the Teleport, was also a director. And so was Charles Maikish, then head of the PA's World Trade Center Department. The twin towers had even been integrated into the BID's playful skyline logo design, forming the double "l" in "Alliance."

One alliance initiative was a genuine street-level amenity: a shuttle bus that wended its way through the entire district—stopping at the Equitable Building and the foot of the twin towers. Thirty-five floors up in Tower 1 was the PA office of Charles Maikish. Until 1996, when he left the Port Authority in the wake of the Marlin shake-up, Maikish firmly espoused the doctrine that bringing Lower Manhattan back was an all-or-nothing effort. Tax incentives alone could not do the whole job, he said. Millions more would be required in public and private investment, particularly in transport infrastructure, in order to prevent downtown from becoming a lifeless, hollowed-out center. Maikish acknowledged too that the fate of Lower Manhattan was inextricably linked to the huge office buildings he had overseen since 1990.

In order to "capture the value" of this huge "asset," he was planning to pump $100 million a year for eight years into the trade center, transforming it into a "village square" for globalized, information-age trade. He proposed putting $100 million toward 300 "smart" elevators and another $100 million for doubling electrical capacity. More money would go toward a huge new pumping station to bring twice as much water in from the Hudson, so that the trade center's air conditioners could offset the heat generated by hundreds of thousands of electronic devices—technologies undreamed of in Austin Tobin's day. More yet would be needed for completing asbestos abatement. Meanwhile, Maikish planned to privatize everything except the WTC's office space, which he conceded would be a long time coming back up to prime

value. If Lower Manhattan became great again, he said, it would be re-tail, residential space, services, and the arts and entertainment that had to take the lead. Commercial space would be the caboose on the revi-talization train. During the office market downturn, the financial core it-self had suffered the highest vacancy rate downtown—over 35 percent.

But Maikish remained committed to doing everything possible to keep the WTC's value from sliding so that the PA's options could be kept open: PA ownership and continued operation, PA ownership and leasing to an outside entity, or, eventually, outright sale. Several months after the bombing, Governor Cuomo came down from Albany for an inspection of the trade center Makish had helped bring back to "better than new."

"Is it time to sell now, Charlie?" Cuomo had asked. "Not now, Mr. Governor," Maikish replied. "The timing's not right." Four years later, under pressure from the Pataki administration to off-load its salable as-sets, the Port Authority would agree that the time had come.

Charles Maikish and the World Trade Center had known each other for a long time. He had joined the PA in 1967 when its engineers were pouring the bathtub's slurry. Austin Tobin put the recent engi-neering graduate to work at the trade center site, then sent him to law school to help handle the legal fallout from scores of contractor dis-putes. In the 1980s, Maikish reestablished PA ferry service to Hobo-ken, which he later privatized. Then he returned to head the WTC Department. In a cabinet in his office, Maikish kept a black and white eight-by-ten-inch photo taken when he first went to work for the PA. It shows him wearing long sideburns and a fitted 1960s suit, standing next to a model of the twin towers set up in the soon-to-be-demolished Hudson Terminal building. One wall of his office was decorated with a poster-sized color picture that magnetically drew the eye toward its jagged central ellipse. Was it an abstract print? Some sort of collage? On closer examination it revealed itself to be a photo of the crater in the bombed-out garage: a portrait of catastrophic archaeology.

Would the downsizings continue? "They're not over," Maikish said. Taped to the outside of his door was a computer printout that read SMILE in foot-high letters. The security guard sitting at the reception-ist's desk looked up from her phone call, waved good-bye, then went back to her conversation. In even tones she informed her mother that at the end of the week she was being laid off and would have to register with unemployment and apply for food stamps.

Back at street level, the shuttle bus headed east down Maiden Lane, back into the Wall Street canyons. Here the landscape had been

"improved" in the early eighteenth century by leveling the hills northward toward City Hall Park and planting rows of shade trees. In the long shadows of early evening, the financial center was shutting down for the night. As the army of daytime office workers retreated into the subways, red-jacketed alliance supervisors patrolled the streets with their walkie-talkies, watching their subordinates collect the day's refuse and head east wheeling their receptacles toward the trash collection center near the Seaport. Suddenly the nearly deserted canyons came alive with whoops and shouts as first one and then another alliance worker leaped atop his garbage bin and rode it, like a go-cart, down the Fulton Street hill.

BACK TO THE FUTURE

Between 1988 and 1995, when Carl Weisbrod took on his mission of "transforming downtown from the hub of the Age of Capitalism to the prototypical center of the Information Age," New York City lost 57,000 jobs in the banking industry alone. In 1988, city negotiators settled with Chase on a $235 million incentives package to keep the bank's back-office jobs from going out of state. Eight years later, the Chase-Chemical consolidation shed 12,000 workers, many from Chase Plaza, newly renovated at a cost of $30 million. Lower Manhattan stalwarts Morgan Stanley and First Boston soon followed in an exodus to midtown where J. P. Morgan had opened a tower on Fifth Avenue, just up the street from Bunshaft's transparent bank. Downtown, at the corner of Wall and Broad Streets, above the lively Heritage Trail display recounting the exploits of the House of Morgan, J. P.'s legendary fortress stood empty, the shades drawn. "The old star . . . exploded and moved out," said Henry Raimando, then chief economist for the Port Authority. "Now a new star is forming at the core."

Before the merger of Chase and Chemical, Citicorp was the largest of New York's "money center" banks. Soon after Rudy Giuliani's election in 1994, Walter Wriston, Citicorp's former chairman, offered his candid "Advice to the New Mayor."

> The advent of the Information Age makes capital even more mobile than
> in the past; it will go where it is wanted and stay where it is well
> treated. It will flee onerous regulations and high taxes. Since capital,
> both financial and intellectual, is what produces jobs, New York has to

create a climate to attract capital. The high-tax, overregulated environment you inherited repels capital.

. . . For years, many Latin American countries motivated even their own citizens to employ their capital abroad, not at home. Today, our neighbors to the south have opened their borders, adopted free-market ideas, reduced unnecessary regulations. . . . New York should take a leaf out of their book and start disassembling the apparatus of what is becoming the last remaining center of socialist economics in the world.

When "futurist" author George Gilder was interviewed by *Forbes* magazine in 1995, his description of New York as "dirty, dangerous and pestilential" echoed the language of the nineteenth-century urban reformers. But the afflictions of large cities could no longer be attributed to their uncontrolled expansion in response to an industrial revolution. For Gilder, cities at the close of the skyscraper century had become "centers of value subtraction"—millstones around the neck of a Third Wave economy reinventing itself as fluid, flexible, and globally competitive. "The problem with cities today is that they are parasites. We've got these big parasite cities sucking the lifeblood out of America today. And those cities will have to go off the dole."

SLOUCHING FROM BETHLEHEM

"If we go bust, we'll go bust big," predicted Charles M. Schwab, Bethlehem Steel's president, in the early years of the twentieth century. Schwab was gambling millions, building a new plant in the Lehigh Valley to produce single-piece H girders—jumbo beams for ever-taller skyscrapers. Before his mills started rolling these wide-flange beams, H-shaped girders had to be bolted together from plates and angles.

But Schwab and his company didn't go bust. The H girders, bigger and broader than I-beams, were so successful that they became known as "Bethlehem sections." High-steel workers riveted them by the thousands into nearly every large-scale structure from Othmar Ammann's George Washington Bridge to Bunshaft's Chase Plaza. In 1966, Bethlehem and its biggest competitor, U.S. Steel, both bid within $4 million of each other on the hundreds of tons of steelwork that would be required to build the World Trade Center. So close were the bids that they sparked an investigation by the U.S. Justice Department's antitrust division. Eventually, the PA awarded steel contracts for the trade

towers to fifteen smaller firms, saving $37 million over the two giant manufacturers' bids.

In late 1995, Bethlehem shut down its H girder plant, "rightsizing" by 1,800 workers and effectively ending 120 years of steelmaking in the Lehigh Valley. "Companies today are decentralizing," a Bethlehem manager said. "You don't need the Sears tower any more." And Bethlehem chairman Curtis H. Barnette's statement noted that "we have to make our investments wisely and we decided to put our investment dollars elsewhere." But the company retained the wide-flange H girder as its corporate symbol.

AT RISK

No H girder bids were needed for the trade center that never got built—the one originally proposed as an alternative to the twin towers by then-assemblymen Percy Sutton and David Dinkins in the early 1960s. Though the idea of a Harlem WTC remained moribund, it was revived in the late 1970s by Congressman Charles Rangel as the Harlem International Trade Center (ITC)—one element in a broad revitalization effort called the 125th Street Corridor Project. Under the Carter administration, a federal "working group" was formed to assist in funding the center, whose stated purpose was to promote U.S. trade with Asian, Caribbean, and Latin American countries and serve as a symbol of "economic cooperation between African nations and black America."

Under the Reagan and Bush administrations, the uptown trade center languished, but Rangel kept the project on life support under the aegis of the Harlem subsidiary of the Urban Development Corporation. In its most recent brush with life, the Harlem International Trade Center stood as the centerpiece of a $300 million Upper Manhattan and Bronx Empowerment Zone—one of six districts across the nation chosen to receive a federally funded package for job training, day care, business loans, and tax incentives. But in late 1995, New York State Governor Pataki withdrew a $64 million Port Authority grant to build the ITC.

Had it been built as planned, the Harlem trade center would have risen forty-four stories above 125th Street and Malcolm X Boulevard, encompassing a hotel, offices for trade missions and government agencies, an international trade mart, a shopping mall, and a garage. Three days after Pataki withdrew the PA funds, an acrimonious ongoing

protest against Freddy's—a white-owned store on 125th Street that had evicted a popular subtenant—turned deadly. A deranged demonstrator firebombed the store, killing himself and six others.

Early the following year, the Regional Plan Association issued its third report, *A Region at Risk,* which estimated the city's loss of revenue from real estate tax exemptions at $800 million a year. Well before the Stock Exchange's municipal suitors spent $100 million more securing Wall Street's keystone institution, RPA director Robert Yaro was quoted as saying that New York's corporate retention programs constituted "a very expensive hobby"—especially when set against an alarming backdrop of regional job flight and economic polarization.

What sorts of comforting images might be conjured up to counter the bleak vistas of a city dividing more deeply along race and class lines and overshadowed by economic forces beyond its control? In the summer of 1995, New Yorkers witnessed the birth of a new corporate partnership with the municipal government that took the form of a massive construction project carried out on the soccer field in Central Park. The sheer magnitude of the enterprise and the crowds it drew lent the site the aura of a Robert Moses–style urban renewal project, as huge cranes stacked modular freight containers eight stories high. But this series of regularly spaced towering slabs was neither a public works project designed to awe the masses nor the long-delayed birth of Le Corbusier's ideal "city in a park." The container city rose to invoke a spectacle of a quite different order. Covered with Mylar, its walls became screens for the premiere of *Pocahontas*—the Walt Disney company's animated flickerings of a mythic past.

The presentation of *Pocahontas,* however, was hardly a gathering in the spirit of the traditional wait-in-line performances of Shakespeare in the Park or a midsummer bring-a-blanket-and-some-wine Metropolitan Opera recital. Chosen by lottery and invitation, an audience limited to 50,000 witnessed the screening encapsulated within a cordon of New York City police and Disney security guards.

A week later the container city had vanished from the park, leaving only a chewed-up soccer field as evidence of its presence. But through its gesture, Disney had earned the city government's goodwill. This was expressed in the form of generous incentives to build a hotel, time-share condos, and an entertainment complex in Times Square, diagonally across "The Deuce" from the Port Authority bus terminal. Charles Gargano and the PA made no secret of their desire to sell the development rights above the terminal property. If the presence of Disney on Forty-second Street could contribute to the furtherance of the

Times Square real estate boom, then collecting millions for a new tower over an old bus terminal might prove as easy as wishing upon a star.

EVERYTHING'S HAPPENING AT THE TURN OF THE CENTURY

At the close of New York's skyline century, Skidmore, Owings, and Merrill, architects of Chase Plaza and the billion-dollar plan, finally got to build its own World Trade Center—though this one is in Kaneohe, Hawaii. A recent addition to the international association of World Trade Centers founded by Guy Tozzoli, it resembles nothing so much as the trylon and perisphere Wallace K. Harrison designed for the 1939 World's Fair.

The city of towers also journeyed west, pausing briefly in Chicago for Sears, then heading straight across the Pacific Ocean to attain new heights in the "superheated" soil of Asia's expanding economies. Into the late 1990s, Shanghai was building the equivalent of five Empire State Buildings worth of high-rise office space every year. There, the Jin Mao building, completed in 1998, eclipsed New York's World Trade Center by seventeen feet. Central Plaza and the Bank of China Tower, both in Hong Kong, and the T&C Tower in Taiwan are nearly as extravagant in scale. Even in traditionally low-rise Hanoi, Nguyen Thanh Thuy, a dressmaker, gave voice to the sentiment sweeping Asia. "I don't like these ugly old houses. . . . I like beautiful tall, tall buildings. Tall, tall is beautiful, beautiful. The people who live here want to live in tall new buildings."

In 1999, the world's tallest buildings were the twin Petronas Towers in Kuala Lumpur, designed by World Financial Center architect, Cesar Peli and built by Malaysia's state-run oil company to, as Prime Minister Mahathin Mohamed declared, "express our towering ambition." But their great height was not always matched by correspondingly spectacular views, since smoke from forests being burned for farmland often made it difficult to see very far. On the plaza level, clouds of tear gas enveloped riot police battling demonstrators in the wake of the country's financial implosion and austerity measures imposed by the International Monetary Fund.

Even as the Petronas twins took the title, the Shanghai World Financial Center prepared to surpass them. And Nina Wang, a flamboyant Hong Kong developer, declared herself intent on reigning supreme via the Nina Tower, a 1,640-foot skyscraper inspired by the Chrysler

Building. "We want this to be the highest building in the world," said Wang. "We need this kind of landmark for Hong Kong." Asked how the billion-dollar Nina Tower would be financed, she replied "cash."

Maharishi Mahesh Yogi's towers were not to be the tallest in the world—only the tallest in India. But they would be twins, designed by an American firm with an established reputation for skyscraper building. Though the architect who gave the partnership its name had died in 1986, Minoru Yamasaki and Associates lived on.

Back in New York City, on the border of Harlem, the close of the 1990s saw the Cathedral of St. John the Divine—the world's largest Gothic church—continuing its sporadic, century-long journey toward completion. Carving one of the limestone blocks that arch over the main entrance, the sculptor Simon Verity, a master of traditional techniques, updated an ancient parable. Henceforth, visitors passing through the Portal of Paradise would encounter his flamboyant rendering of the fall of Jerusalem depicted as a Lower Manhattan skyline with mushroom clouds looming over the World Trade Center.

WHEEL OF TIME

In the fall of 1993, nine months after the World Trade Center bombing, the Samaya Foundation, the Lower Manhattan Cultural Council, and the Port Authority jointly sponsored the Wheel of Time Sand Mandala, or Circle of Peace, in the lobby of Tower 1. Drawing on an ancient Tibetan Buddhist tradition, the monks of the Dalai Lama's Namgayal Monastery invited trade center workers and visitors to participate in constructing a "visually enacted" scripture. Built over thirty days, the mandala signified impermanence and served as a collective expression of public humility. Its shape symbolized nature's unending cycle of creation and destruction, and in the countless grains of its material, it celebrated life's energy taking ephemeral form, then returning to its source. At the end of the mandala's monthlong lifespan, the monks swept up the sand and "offered it to the Hudson River." This ritual, they believed, purified the environment.

WHEELS WITHIN WHEELS

"Eventually," said Robert Yaro, the RPA's chief planning officer, "you have no choice but to have an equitable system. There's a different

thrust to this plan than 20 years ago. This is not a Great Society plan. It's not altruism. It's enlightened self-interest." As though attempting to rouse the New York region from a deep and troubled sleep, the RPA's third report, *A Region at Risk,* issued in 1996, called for a $17 billion "Centers Plan" aimed at counteracting the centrifugal effects of the suburbanization its two predecessor plans had zealously advocated. The report advocated a massive effort to reintegrate New York's metropolitan area into a cohesive economic organism—one that facilitates the flow of people and goods, and that manufactures and transports actual things.

Like RPA reports of the 1930s and 1960s, *A Region at Risk* drew its conclusion from a painstaking evaluation of empirical, quantitative evidence. But this most recent survey moved beyond time-honored scientific method and into the realm of cosmology. It folded concrete prescriptions for regional policy into a meditation on planning that seeks a harmonious balance among "Environment, Economy, and Equity." Graphed in overlapping circles, the "three E's" were purportedly improvised by Yaro one evening on a cocktail napkin. Unlike its ghostly paternalistic forebears, *A Region at Risk* made no claim to being an all-inclusive, rational formula for progress. It concerned itself with the integration of complex energies, the play of intangibles—with the region achieving a sustainable "Quality of Life."

ILLUMINATION, URBAN MIGRATIONS

As you stand in Chase Plaza, looking across a half-acre vacant lot, you face a huge blowup of Georges Seurat's *Sunday on La Grand Jatte* painted on the side of a William Street building. The mural was created as a backdrop for a scene in the action movie *Die Hard with a Vengeance.* On this relatively temperate fall afternoon, the lush two-dimensional vegetation of the painting merges nearly seamlessly with the acutal flora growing wild beneath it. Since two turn-of-the-century buildings that occupied the site were torn down in 1994, forty plant species, including four types of trees, have taken root here, growing rapidly in the now-overgrown rubble. Conceivably next spring, if new towers have not begun to rise here, anyone passing by might gather the makings of a poke salad from the tender shoots growing through the chain link at the lot's Cedar Street edge. The lot's wormseed might be harvested as a remedy for intestinal parasites.

And if someone were to throw open the gates, bulls could graze on the spiky leaves of the thistles.

The fastest climbing trees on the lot are the *Ailanthus altissima*, "trees of heaven," so hardy they will even grow in the soot and refuse of subway ventilation coffers, poking above the surface of the sidewalk until trodden down by people walking over the gratings, often unaware of the forest beneath their feet. Today, the young trees at the William Street lot are half a head taller than you are—tall enough for the city's ubiquitous house sparrows to share branches with warblers taking a breather on their annual migration to winter quarters.

Turning away from this unintended nature preserve, you head in the direction of the trade towers and walk west on Liberty Street. In front of the Federal Reserve building—designed to resemble a massive Florentine palazzo—a dozen idling black limousines are pulled up to the curb. You ask a guard what's going on inside. A flock of investment bankers, it seems, has gathered there to arrange the multibillion-dollar bailout of a bankrupt hedge fund.

Reaching Broadway, you walk north, looping around St. Paul's, then into your favorite discount clothing store at the foot of the World Trade Center. First you look at the silk ties. Some beautiful patterns, but they're still too wide. Perhaps next year. There are some new styles among the shirts though, and you want to look for some new shoes downstairs in the basement of Century 21. After that you'll get a bite to eat, then walk across Church Street to the plaza—newly repaved in soothing tones of pink and gray granite—to talk with your towers again.

When your house trembles in its beams and turns on its
keel, you think you are a sailor, rocked by the breeze.

—Gaston Bachelard, from *The Poetics of Space*

SELECTED BIBLIOGRAPHY

Adler, Jerry. *High Rise*. New York: HarperCollins, 1993.

Alcady, Roger E., and David Marmelstein, eds. *The Fiscal Crisis of American Cities.* New York: Vintage, 1977.

Allen, Frederick Lewis. *The Great Pierpont Morgan.* New York: Harper & Row, 1948.

Anderson, Martin. *The Federal Bulldozer: A Critical Analysis of Urban Renewal 1949–1962.* Cambridge, MA: MIT Press, 1964.

Bachelard, Gaston. *The Poetics of Space.* Boston: Beacon Press, 1964.

Balfour, Alan. *Rockefeller Center: Architecture as Theater.* New York: McGraw-Hill, 1978.

Berman, Marshall. *All That Is Solid Melts into Air.* New York: Penguin, 1982.

Bleecker, Samuel E. *The Politics of Architecture: A Perspective on Nelson Rockefeller.* New York: Rutledge Press, 1981.

Boyer, Christine M. *Dreaming the Rational City: The Myth of American Planning.* Cambridge, MA: MIT Press, 1983.

———. *Manhattan Manners, Architecture, and Style, 1850–1900.* New York: Rizzoli, 1985.

Building Research Board, National Research Council. *The Fourth Dimension in Building: Strategies for Minimizing Obsolescence.* Washington, DC: National Academy Press, 1993.

———. *The Role of Public Agencies in Fostering New Technology and Innovation in Building.* Washington, DC: National Academy Press, 1992.

Burnette, Jonathan. *The Elusive City: Five Centuries of Design, Ambition, and Miscalculation.* New York: Harper & Row, 1986.

Caro, Robert. *The Power Broker: Robert Moses and the Fall of New York.* New York: Knopf, 1974.

Castells, Manuel. *The Informational City: Information Technology, Economy, Restructuring, and the Urban-Regional Process.* Cambridge, MA: Blackwell, 1989.

Cohen, Julius Henry. *They Builded Better Than They Knew.* New York: Messner, 1946.

Collier, P., and D. Horowitz. *The Rockefellers: An American Dynasty.* New York: Holt Rinehart Winston, 1976.

Commission on the Year 2000. *New York Ascendant.* New York: Commission on the Year 2000, 1997.

Corbusier, Le. *The Radiant City.* New York: Orion Press, 1967.

_____. *Towards a New Architecture.* New York: Dover, 1981.

Davis, Mike. *City of Quartz: Excavating the Future in Los Angeles.* New York: Vintage, 1992.

Dogan, Mattei, and John D. Kasarda. *The Metropolis Era, Volume 1: A World of Giant Cities.* Newberry Park, CA: Sage, 1988.

Doig, Jameson W. *Metropolitan Transportation Politics and the New York Region.* New York: Columbia University Press, 1966.

Dolkart, Andrew S. *Forging a Metropolis.* New York: Whitney Museum, 1990.

Douglas, Ann. *Terrible Honesty: Mongrel Manhattan in the 1920s.* New York: Noonday, 1996.

Dwyer, Jim, et al. *Two Seconds Under the World.* New York: Crown, 1994.

Ellis, Edward Robb. *The Epic of New York City.* New York: Old Town Books, 1966.

Ewen, Stuart. *All-Consuming Images: The Politics of Style in Contemporary Culture.* New York: Basic Books, 1988.

Fitch, Robert. *The Assassination of New York.* New York: Verso, 1993.

Foner, Philip S. *Business and Slavery: The New York Merchants and the Irrepressible Conflict.* New York: Russell and Russell, 1941.

Foster, Peter. *The Master Builders: How the Reichmanns Reached for an Empire.* Toronto: Key Porter, 1986.

Fulvio, Irace. *The Emerging Skyline: New American Skyscrapers.* New York: Whitney Library of Design, 1988.

Gans, Herbert J. *People and Plans.* New York: Basic Books, 1968.

Geddes, Patrick. *Cities in Evolution.* London: Williams and Norgate, 1915.

Giedion, Sigfried. *Space, Time, and Architecture.* Cambridge, MA: Harvard University Press, 1970.

Gold, Joyce. *From Windmills to The World Trade Center.* New York: Old Warren Road Press, 1988.

Goldberger, Paul. *On The Rise: Architecture and Design in a Postmodern Age.* New York: Penguin, 1985.

Goodman, Robert. *After the Planners.* New York: Simon & Schuster, 1971.

Gordon, David L. A. *Battery Park City: Politics and Planning on the New York Waterfront.* Amsterdam, Netherlands: Gordon & Breach, 1997.

Granick, Harry. *Underneath New York.* New York: Fordham University Press, 1991.

Grant, James. *Money of the Mind: Borrowing and Lending in America from the Civil War to Michael Milken.* New York: Farrar, Straus & Giroux, 1991.

Greider, William. *The Trouble with Money.* Knoxville, TN: Whittle, 1989.

Griffin, John I. *Industrial Location in the New York Area.* New York: City College, New York Area Research Council, 1956.

Gropius, Walter. *The New Architecture and The Bauhaus.* Cambridge, MA: MIT Press, 1968.

Hall, Peter. *Great Planning Disasters.* Berkeley, CA: University of California Press, 1982.

_____. *The World Cities.* 3d ed. New York: St. Martin's Press, 1984.

_____. *Cities of Tomorrow.* Cambridge, MA: Blackwell, 1988.

Harvey, David. *The Condition of Post-Modernity.* Cambridge, MA: Basil Blackwell, 1989.

Hejduk, John, with G. Patestri. "Berlin Masque," *Architectural Design* 53, 1/2, 1993.

Heyer, Paul. *Architects on Architecture: New Directions in America.* New York: Walker & Co., 1966.

Hoffman, William. *David.* New York: Lyle Stuart, 1971.

Howard, Ebinezer. *To-morrow: A Peaceful Path to Real Reform.* London: Swan Sonnenschein, 1898.

Huxtable, Ada L. *The Tall Building Artistically Reconsidered: The Search for a Skyscraper Style.* New York: Pantheon, 1984.

Jacobs, Jane. *The Death and Life of Great American Cities.* New York: Random House, 1961.

_____. *The Economy of Cities.* New York: Vintage, 1969.

Jencks, Charles. *Modern Movements in Architecture.* Garden City, NY: Anchor Doubleday, 1973.

_____. *The Language of Post-Modern Architecture.* New York: Rizzoli, 1984.

_____. *The New Moderns, from Late to Neo-Modern.* New York: Rizzoli, 1990.

Josephson, Matthew. *The Robber Barons: The Great American Capitalists 1861–1901.* New York: Harcourt, Brace and Co., 1934.

Kahn, Roger. *The Boys of Summer.* New York: Harper & Row, 1972.

Kindleberger, Charles R. *Manias, Panics, and Crashes.* New York: Basic Books, 1989.

Klotz, Heinrich, ed. *New York Architecture 1970–1990.* New York: Rizzoli, 1989.

Koolhaas, Rem. *Delirious New York: A Retroactive Manifesto for Manhattan.* New York: Monacelli Press, 1994.

Kostof, Spiro. *The City Shaped: Urban Patterns and Meanings Through History.* Boston: Bullfinch, 1991.

Kramer, Michael, and Sam Roberts. *"I Never Wanted to Be Vice-President of Anything!" An Investigative Biography of Nelson Rockefeller.* New York: Basic Books, 1976.

Kropotkin, Peter. *Fields, Factories, and Workshops; or Industry Combined with Agriculture and Brain Work with Manual Work.* New revised and enlarged edition. New York: G. P. Putnam's Sons, 1913.

Le Corbusier. *See* Corbusier.

Lissitzky, El. *Russia: An Architecture for World Revolution.* Cambridge, MA: MIT Press, 1984.

Lundberg, Ferdinand. *The Rich and the Super Rich.* New York: Lyle Stuart, 1968.

_____. *The Rockefeller Syndrome.* New York: Lyle Stuart, 1975.

Lyon, Danny. *The Destruction of Lower Manhattan.* New York: Macmillan, 1969.

Maki, Fumihiko. *Investigations in Collective Form*, no. 2. St. Louis, MO: Washington University, 1964.

Makielski, S. J. *The Politics of Zoning*. New York: Columbia University Press, 1966.

Manhattan Land Book of the City of New York. New York: G. W. Bromley, 1955.

Marrey, Bernard. *The Extraordinary Life and Work of Monsieur Gustave Eiffel: The Engineer Who Built the Statue of Liberty, the Porto Bridge, the Nice Observatory, the Garabit Viaduct, the Panama Locks, the Eiffel Tower, Etc. . . .* Paris: Graphite, 1984.

McDarrah, Fred W. *New York, N.Y.* New York: Corinth, 1964.

Meikle, Jeffrey L. *Twentieth Century Limited: Industrial Design in America 1925–1939.* Philadelphia: Temple University Press, 1979.

Miller, Dorothy, and Sam Hunter. *Art for the Public: The Collection of the Port Authority of NY & NJ.* New York: Port Authority of New York and New Jersey, 1985.

Miller, Ross. *Here's The Deal: The Buying and Selling of a Great American City.* New York: Knopf, 1996.

MIT Center for Real Estate. *WTC Study: Amsterdam; Curacao; New York City; Portland, Oregon; Taipei.* Cambridge, MA: MIT Press, 1993.

Mitchell, Joseph. *The Bottom of the Harbor.* Boston: Little Brown & Co., 1959.

_____. "The Mohawks in High Steel" (1949), in Edmund Wilson, ed., *Apologies to the Iroquois.* New York: Farrar, Straus, Cudahy, 1959.

Morris, Jan. *Great Port: A Passage Through New York.* New York: Oxford, 1985.

Moses, Robert. *Public Works: A Dangerous Trade.* New York: McGraw-Hill, 1970.

Moss, Mitchell L., and Hugh O'Neil. *Reinventing New York: Competing in the Next Century's Global Economy.* New York: Urban Research Center, Robert F. Wagner Graduate School of Public Service, New York University, 1991.

Mumford, Lewis. *The Culture of Cities.* New York: Harcourt Brace Jovanovich, 1938.

_____. *The City in History: Its Origins, Its Transformations, and Its Prospects.* New York: Harcourt Brace Jovanovich, 1961.

_____. *Sidewalk Critic.* New York: Princeton University Press, 1998.

Mysak, Joe, with Judith Schiffer. *Perpetual Motion: An Ilustrated History of the Port Authority of New York and New Jersey.* Santa Monica, CA: General Publishing Group, 1997.

Newfield, Jack, and Wayne Barrett. *City for Sale.* New York: Harper & Row, 1988.

Newhouse, Victoria. *Wallace K. Harrison, Architect.* New York: Rizzoli, 1989.

Newman, Oscar. *Defensible Space: Crime Prevention and Urban Design.* New York: Macmillan, 1972.

New York City Department of City Planning. *New York City Comprehensive Waterfront Plan: Reclaiming the City's Edge.* New York, 1992.

_____. *Plan for Lower Manhattan.* New York, 1993.

New York City Planning Commission. *The World Trade Center: An Evaluation.* New York: Department of City Planning, 1966.

_____. *Plan for New York City 1969: A Proposal for Manhattan*, vol. 6. New York, 1969.

_____. *Plan for New York City 1969: Critical Issues*, vol. 1. New York, 1969.

New York State Telephone Association Infrastructure Task Force. *Tomorrow's Information Highways: A Telecommunications-Based Development Strategy for New York State.* New York, 1992.

Peter, John. *Oral History of Modern Architecture.* New York: Abrams, 1994.

Pevsner, Nikolaus. *A History of Building Types.* Princeton, NJ: Princeton University Press, 1976.

Plunz, Richard. *A History of Housing in New York City.* New York: Columbia University Press, 1990.

Port Authority of New York and New Jersey. *Regional Recovery: The Business of the Eighties.* New York: Port Authority of New York and New Jersey, 1979.

_____. *The World Trade Center: A Building Project Like No Other.* New York: Port Authority of New York and New Jersey, 1982.

Port of New York Authority. *The Port of New York.* New York: Port of New York Authority, 1958.

_____. *A World Trade Center in the Port of New York.* New York: Port of New York Authority, 1961.

_____. *A Selected Bibliography of the Port of New York Authority 1921–1966.* New York: Port of New York Authority Library, 1966.

Regional Plan Association. *The Region in the Global Economy.* New York, 1988.

Regional Plan of New York and Its Environs. *Regional Survey of New York and Its Environs.* 8 vols. (in 10). I, Major Economic Factors in Metropolitan Growth and Development. IB, Food, Clothing and Textile Industries, Wholesale Markets and Retail Shopping, and Financial Districts. II, Population Land Values and Government. New York: Regional Plan Association, 1927–1931.

Reviving Lower Manhattan: Preserving the Past to Ensure the Future. New York: Columbia University Historical Preservation Program, Graduate School of Architecture, Planning, and Preservation, 1996.

Reynolds, Donald M. *The Architecture of New York.* New York: Macmillan, 1984.

Robbins, Sidney M., and Nestor E. Terleckyj. *Money Metropolis: A Locational Study of Financial Activities in the New York Region.* Cambridge, MA: Harvard University Press, 1960.

Robins, Anthony. *The World Trade Center.* Englewood, FL: Pineapple Press, 1987.

Robison, Maynard T. *Rebuilding Lower Manhattan 1955–1974.* Dissertation. New York: City University of New York, 1976.

Rodgers, William. *Rockefeller's Follies: An Unauthorized View of Nelson A. Rockefeller.* New York: Stein and Day, 1966.

Rogers, Richard. *Architecture: A Modern View.* London: Thames and Hudson, 1991.

Rowe, Colin. *Architecture of Good Intentions: Toward a Possible Retrospect*. London: Academy Editions, 1994.

Rowe, Colin, and Fred Koetter. *Collage City*. Cambridge, MA: MIT Press, 1980.

Ruchelman, Leonard I. *The World Trade Center: Politics and Policies of Skyscraper Development*. Syracuse, NY: Syracuse University Press, 1977.

Sassen, Saskia. *The Global City: New York, London, Tokyo*. Princeton, NJ: Princeton University Press, 1991.

Savitch, H. V. *Post-Industrial Cities: Politics and Planning in New York, Paris, and London*. Princeton, NJ: Princeton University Press, 1988.

Schivelbusch, Wolfgang. *The Railway Journey: The Industrialization of Time and Space in the 19th Century*. Berkeley: University of California Press, 1986.

Scuri, Piera. *Late Twentieth Century Skyscrapers*. New York: Van Nostrand Reinhold, 1990.

Sennett, Richard. *The Conscience of the Eye: The Design and Social Life of Cities*. New York: W. W. Norton, 1992.

_____. *Flesh and Stone: The Body and the City in Western Civilization*. New York: W. W. Norton, 1994.

Severini, Lois. *The Architecture of Early Wall Street*. Ann Arbor, MI: University of Michigan Research Press, 1983.

Shachtman, Tom. *Skyscraper Dreams: The Great Real Estate Dynasties of New York*. Boston: Little, Brown, 1991.

Shanor, Rebecca Read. *The City That Never Was*. New York: Viking, 1988.

Sky, Alison, and Michele Stone. *Unbuilt America*. New York: McGraw-Hill, 1976.

Starr, Roger. *The Rise and Fall of New York*. New York: Basic Books, 1985.

Stein, Abraham. *The Port Authority of New York and New Jersey and the 1962 PATH–World Trade Center Project*. Dissertation. New York University, 1980.

Stern, Robert A. M. *New York 1930: Architecture and Urbanism Between the Two World Wars*. New York: Rizzoli, 1987.

Stern, Robert A. M., Gregory Gilmartin, and John M. Massengale. *New York 1900: Metropolitan Architecture and Urbanism 1890–1915*. New York: Rizzoli, 1983.

Sullivan, Louis H. *Kindergarten Chats*. New York: Wittenborn Schultz, 1947.

Tafuri, Manfredo. *Architecture and Utopia: Design and Capitalist Development*. Cambridge, MA: MIT Press, 1976.

Tafuri, Manfredo, and Francesco Dal Co. *Modern Architecture*. New York: Harry N. Abrams, 1979.

Taut, Bruno. *Modern Architecture*. London: The Studio Limited, undated.

Unwin, Raymond. *Town Planning in Practice: An Introduction to the Art of Designing Cities and Suburbs*. London: T. Fisher Unwin, 1920 (1911).

Urban Research Center. *An Urban Agenda for the 1990s*. New York: Urban Research Center, New York University, 1988.

van Leeuven, Thomas A. P. *The Skyward Trend of Thought: The Metaphysics of the American Skyscraper.* Cambridge, MA: MIT Press, 1989.

Von Moos, Stanislaus. "Le Corbusier, the Monument, and the Metropolis." *Columbia Documents of Architecture and Theory, Vol. III.* New York: Columbia University Graduate School of Architecture, Planning, and Preservation, 1993.

Walsh, Annemarie Hauk. *The Public's Business: The Policies and Practices of Government Corporations.* Cambridge, MA: MIT Press, 1977.

Whyte, Iain Boyd, ed. and trans. *The Crystal Chain Letters: Architectural Fantasies by Bruno Taut and His Circle.* Cambridge, MA: MIT Press, 1985.

Whyte, William H. *The Exploding Metropolis.* Berkeley: University of California Press, 1993.

Willis, Carol. *Form Follows Finance: Skyscrapers and Skylines in New York and Chicago.* New York: Princeton Architectural Press, 1993.

Wilson, John Donald. *The Chase: The Chase Manhattan Bank, N.A., 1945–1985.* Boston: Harvard Business School Press, 1986.

WPA Guide to New York City. New York: New Press, 1992.

Yamasaki, Minoru. *A Life in Architecture.* New York: Weatherhill, 1979.

INDEX

ABOUT THE AUTHOR

Eric Darton was born in New York City in 1950. He began chronicling the transformation of Lower Manhattan in the late 1970s as art and performance editor for the *East Village Eye*. In recent years Darton has contributed articles on urban culture and institutions, as well as essays based on the material in this book, to *Metropolis* and *Culturefront*.

Darton's 1996 novel *Free City* was critically acclaimed in the United States and published abroad in German and Spanish editions. His short-fiction collection *Radio Tiranë* appeared in *Conjunctions*, where he served as an editor for two years. He is currently fiction editor of *American Letters & Commentary*.

Darton received his master's degree from Hunter College in 1994, where he subsequently taught media studies. He now teaches at New York University in addition to leading ongoing writing workshops. The recipient of a New York Foundation for the Arts Fellowship in Fiction, Darton was also awarded a Bread Loaf Fiction Fellowship. He lives in Manhattan with his wife and daughter.